PLAY BY PLAY

LOS ANGELES SPORTS PHOTOGRAPHY 1889–1989

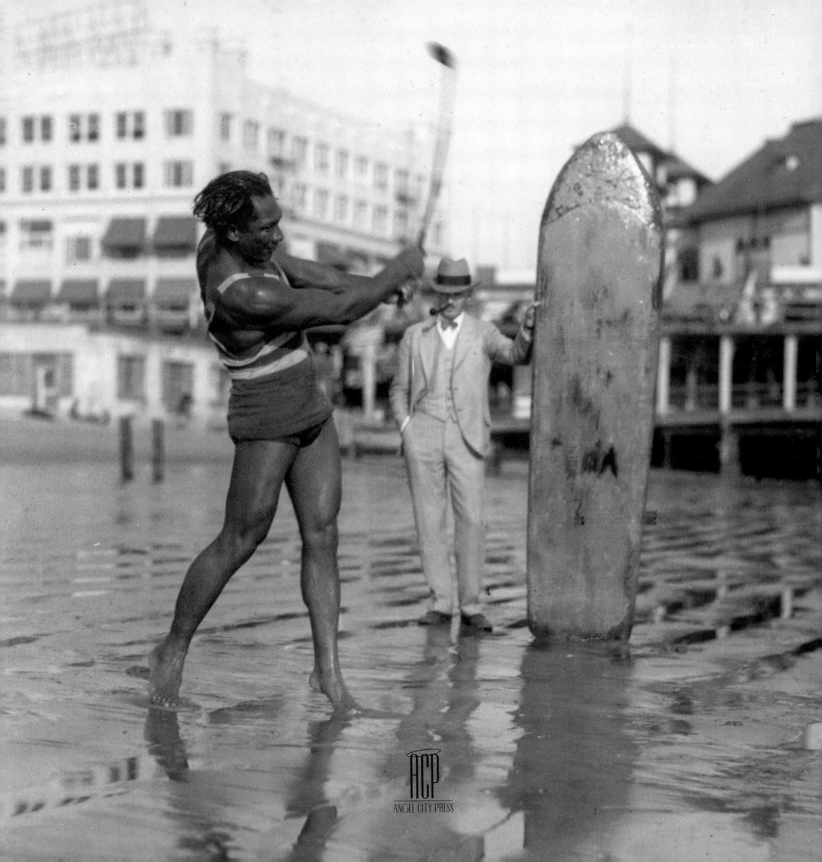

PLAY BY PLAY

LOS ANGELES SPORTS PHOTOGRAPHY 1889–1989

FROM THE PHOTOGRAPHY COLLECTION OF THE LOS ANGELES PUBLIC LIBRARY

DAVID DAVIS

DESIGN BY AMY INOUYE

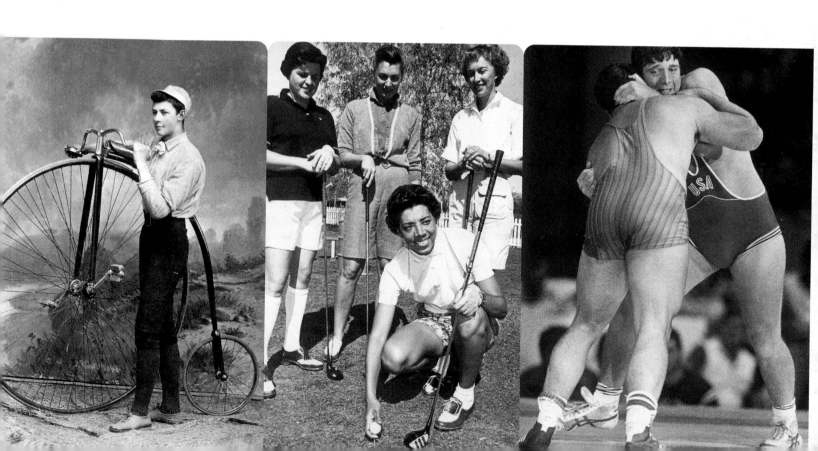

Cover: Clockwise from upper left: May Sutton, Muscle Beach, Kirk Gibson, Freddie Blassie and Lou Thesz, Tracie Ruiz and Candy Costie, "Sugar" Ray Robinson and Carl "Bobo" Olson, the Crenshaw High School offensive line, Bill Walton and Ron Riley, Jeannette Bolden and Evelyn Ashford (middle photo).

Frontispiece: Olympic swimmer and surfer Duke Kahanamoku, Santa Monica, circa 1925.

Title page: From left to right: Bicyclist, circa 1885; Tennis star-turned-golfer Althea Gibson with fellow golfers, 1961; Greco-Roman wrestler Jeff Blatnick wins Olympic gold. Anaheim Convention Center, 1984.

Back Cover: Clockwise from upper left: Andre the Giant and Willie Shoemaker, Marcus Allen, Fernando Valenzuela, Dan Gurney, Wilt Chamberlain and Kareem Abdul-Jabbar, Jackie Robinson, semi-pro soccer action in the Greater Los Angeles Soccer League, Lilly Rodriguez (middle photo).

The photographs in *Play by Play: Los Angeles Sports Photography 1889-1989* are from the Photography Collection of the Los Angeles Public Library. This remarkable archive of almost three million images is available to the public, and 57,000 of the images may be viewed online at the Library's website: www.lapl.org.

Play by Play: Los Angeles Sports Photography 1889-1989
by David Davis
Text copyright © 2004 by David Davis
Design by Amy Inouye, www.futurestudio.com

First edition
10 9 8 7 6 5 4 3 2 1

ISBN 1-883318-50-5

Library of Congress Cataloging-in-Publication Data

Davis, David 1962-
 Play by play : Los Angeles sports photography 1889-1989 : from the photography collection of the Los Angeles Public Library / by David Davis.– 1st ed.
 p. cm.
 Includes index.
 ISBN 1-883318-50-5 (trade pbk. : alk. paper)
1. Sports–California–Los Angeles–History–20th century. 2. Sports–California–Los Angeles–History–20th century–Pictorial works. 3. Sports–California–Los Angeles–History–19th century. 4. Sports–California–Los Angeles–History–19th century–Pictorial works. I. Los Angeles Public Library. II. Title.
 GV584.5.L7D38 2004
 796'.09794'94–dc22

2004019908

Printed in the United States of America

ANGEL CITY PRESS
2118 Wilshire Boulevard #880
Santa Monica, California 90403
310.395.9982
www.angelcitypress.com

To My Family

Contents

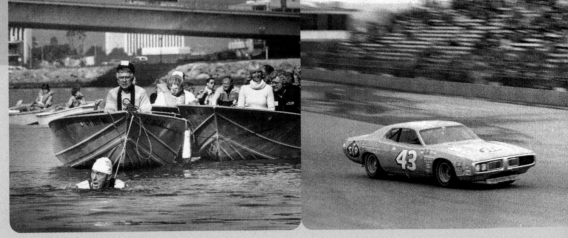

Jack LaLanne, Long Beach, 1984.

Richard Petty, Riverside International Raceway, 1974.

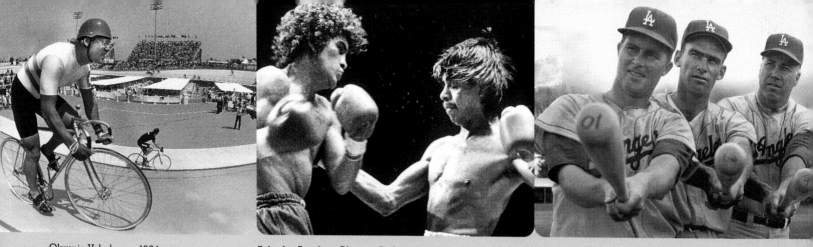

Olympic Velodrome, 1984.

Salvador Sanchez, Olympic Auditorium, 1981.

Ron Fairly, Wally Moon and Duke Snider, 1962.

Dodgers outfielder Kirk Gibson, his fist aloft after hitting the game-winning home run in the 1988 World Series. Track star Babe Didrikson, leaning at the finish to win gold at the 1932 Los Angeles Olympic Games. Jackie Robinson playing baseball at Pasadena Junior College, Arnold Schwarzenegger pumping iron at Joe Gold's Gym, Fernandomania, Magic Johnson, and Mary Lou Retton, too.

Images of greatness, images to remember. *Play by Play* turns back the clock to tell the story of Los Angeles sports history through black-and-white photography. Selected from the Los Angeles Public Library's photo collection, most of these are the work of staff photographers at the now-defunct *Los Angeles Herald Examiner*. Photos from the LAPL's Security Pacific Collection, with images from (among others) the *Hollywood Citizen News* and the Chamber of Commerce, are also included.

And what stories these photographs tell. Southern California has hosted seven Super Bowls— including the first one—as well as two Olympiads. L.A. teams have played for the World Series, the NBA title, the Stanley Cup, and college champion-ships of every type. For decades, fans have flocked to world-renowned stadiums and arenas—the Los Angeles Memorial Coliseum, the Rose Bowl, Santa Anita Race Track, Dodger Stadium, Riviera Country Club, the Olympic Auditorium and others—to watch the athletes who made or burnished their reputations here: Walter Johnson, Jackie Robinson, Steve Bilko, Don Drysdale, Lisa Fernandez, James Jeffries, Jimmy McLarnin, Henry Armstrong, Bobby Chacon, Frank Lubin, Elgin Baylor, Kareem Abdul-Jabbar, Earvin "Magic" Johnson, Lisa Leslie, May Sutton, Ricardo "Pancho" Gonzalez, Billie Jean King, Arthur Ashe, Frank Gifford, David "Deacon" Jones, Eric Dickerson, Marcus Allen, Wayne Gretzky.

And that's just the starting lineup.

But sports in Los Angeles has always been about more than touchdowns and strikeouts. Raised in Pasadena, Jackie Robinson excelled at Muir High, Pasadena Junior College and UCLA before joining the Brooklyn Dodgers and breaking major league baseball's color barrier. In the modern era of the NFL, Kenny Washington became the league's first African American player when he signed with the L.A. Rams, and L.A. Raiders coach Art Shell became the league's first African American coach. The first Asian American to win an Olympic gold medal—diver Sammy Lee—overcame prejudice.

L.A. also has been an innovative force within the sports-business community. The 1984 Los Angeles Olympics were the first Games to be privately organized and financed; organizers reaped a whopping $232.5-million surplus and an athletic and aesthetic triumph. While Dodgers owner Walter O'Malley wasn't the first to plant a major league franchise in L.A., his move from Brooklyn in 1958 triggered the westward-ho expansion of professional sports. Former NFL commissioner Pete Rozelle, who cut his executive teeth as general manager of the Rams, has been called the most influential sports figure of the twentieth century for his savvy marriage of television and football. The Kings' blockbuster trade for the Edmonton Oilers' Wayne Gretzky nudged the epicenter of the NHL from Canada to the U.S.

Hollywood has long mined the nexus between sports and entertainment. (This fascination predates the industry's move to Hollywood; in 1894, one of Thomas Edison's first experiments with motion pictures was to film heavyweight champ "Gentleman Jim" Corbett at his New Jersey studio.) Movies based on real-life personalities and events include *Knute Rockne, All American* (1940) and *Seabiscuit* (2003). Numerous athletes have become actors, including figure skater Sonja Henie, swimmer-turned-Tarzan Johnny Weissmuller, and Rams defensive linemen

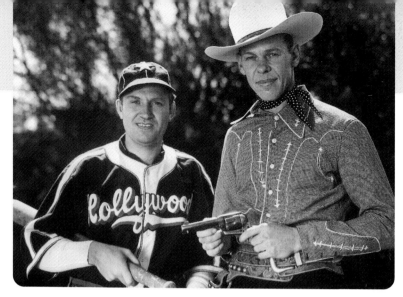

Singing cowboy star (and future Angels owner) Gene Autry exchanges uniforms with Hollywood Stars outfielder Babe Herman, 1938.

Merlin Olsen and Fred Dryer. Meanwhile, Bing Crosby built the Del Mar race track, singing cowboy Gene Autry owned the California Angels, and Crosby, Frank Sinatra and Bob Hope lent their celebrity to golf tourneys.

Southern California has introduced the world to "alternative" sports: fitness, skateboarding, beach volleyball (to name a few). Santa Monica is widely acknowledged to be the birthplace of the modern-day fitness movement. Our ever-changing perception and manipulation of the body beautiful began with the original Muscle Beach crew, that included "Pudgy" Stockton, Steve Reeves, Joe Gold and Jack LaLanne. Later, still on the sands of Santa Monica, athletic-minded beach goers invented beach volleyball (now an Olympic sport); decades after the first surfers rode waves along the southern California coast, surf culture morphed into the skateboard culture that became an international phenomenon.

Here, women athletes have found their niche. Discus thrower Lillian Copeland, a Los Angeles High School and USC graduate, competed in the first track and field event in Olympic history and won a silver medal. The world's first superstar female athlete, Mildred "Babe" Didrikson, earned her reputation by taking three medals at the 1932 Los Angeles Olympic Games. (After she turned to professional golf, she became the first woman to compete against men, at the L.A. Open.) At the 1984 Los Angeles Games, Joan Benoit won the first-ever women's marathon in the Olympics. A trio of local stars—Ann Meyers, Cheryl Miller and Lisa Leslie—have made basketball legend.

Like life, sports is sometimes imperfect and ugly, and photographers captured that angle, too. Here's the funeral of Angels outfielder Lyman Bostock, murdered in the prime of his life. Here's O.J. Simpson at USC before his image would be forever and irreversibly altered, here's Loyola Marymount's Hank Gathers before he died of a heart attack on the court, and Olympic hopeful Jill Kinmont after she was paralyzed in a skiing accident. And here's Dodgers vice president Al Campanis before he ruined years of his progressive work by stating that African Americans "may not have some of the necessities to be a field manager or general manager."

The birth of sports photography and the founding of the state of California occurred at approximately the same time. Scholars have traced the first sports photograph to 1845, when the portrait of an anonymous boxer was taken. The City of Los Angeles was incorporated in 1850, the same year that California joined the United States.

The first major advance in sports photography occurred in the 1870s, when Eadweard Muybridge used one of railroad-baron Leland Stanford's horses to capture high-speed motion photographically. Then, at the 1908 London Olympic Games, images of the dramatic finish of the marathon (featuring Italy's Dorando Pietri) were published around the world. According to Paul Wombell, the director of London-based Photographers' Gallery, "the photograph of Pietri crossing the finishing line is perhaps the first image of a sporting event to achieve the status of great sports photography."

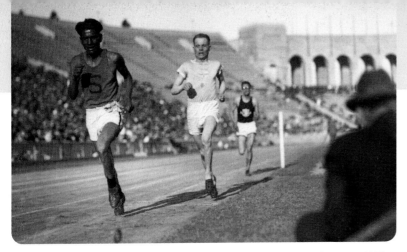

"Flying Finn" Paavo Nurmi, middle, races at the Los Angeles Memorial Coliseum, 1925.

Other innovators soon emerged. In New York City, for instance, Charles Conlon photographed the early stars of major league baseball before and after World War I. At this time, photographers were restricted by bulky cameras with huge lenses that impeded movement and restricted access. In the 1950s, camera, flash and film technology improved. Then, in 1954, when Time Inc. began publishing a new magazine called *Sports Illustrated*, sports photography changed forever. No longer would words alone describe sporting events; now, up-close-and-personal images were necessary to capture the drama—and, not so incidentally, the action—of sports.

The date was November 2, 1989. The all-bold, all-caps headline that ran across the front page was succinct: "SO LONG, L.A.!"

With that, the *Los Angeles Herald Examiner* ceased publication, leaving the city without one of its most insightful, energetic voices. The *HerEx* traced its roots to 1871, with the first edition of the *Los Angeles Express*. The paper was cobbled together by publisher William Randolph Hearst, who founded and purchased several morning and afternoon newspapers to compete against the *Los Angeles Times*. Hearst started the *Examiner* in 1903, before purchasing the *Herald* (in 1922) and the *Evening Express* (1931). In 1962, eleven years after Hearst's death, the Hearst

Corporation combined its Los Angeles holdings into the nation's largest afternoon paper: the *Los Angeles Herald Examiner*.

The consolidation of the *HerEx* occurred at a time of fierce expansion of professional sports in Los Angeles. Until 1958, L.A. had only one major league sports franchise: the Rams. College football, boxing, horse racing, track and field, and two minor league baseball teams—the Los Angeles Angels and the Hollywood Stars of the Pacific Coast League—were very popular.

That changed with the coming of the Dodgers (1958), followed by the Lakers (1960), the Angels (1961), and the Kings (1967). During this "great awakening," other stories gained national attention: the brilliant coaching reigns of John Wooden and John McKay; the opening of majestic Dodger Stadium and the flashy Forum; and the arrivals of the big jewels: the Heisman Trophy, the World Series, the NBA championships, and the biggest of them all—the Super Bowl.

During this era, sports coverage in the *HerEx* was palpable and dynamic because sports-writers Melvin Durslag, Bob Hunter, Bob Oates, Bud Furillo, Allan Malamud and others understood that their columns were about more than statistics. In an era before agents massaged their clients' images, their best work showed an innate understanding of the important interplay of sports and community.

When Furillo and Hunter wrote about Dodger pitcher Sandy Koufax abruptly retiring from baseball in 1966, they felt and communicated the city's sense of loss. "Koufax was our superstar," Furillo wrote. "He handled fame much better than most, he was kind to his fans, even though they almost barreled him over sometimes in search of his autograph and pieces of clothing. Now he leaves the stadium. We will miss him very much."

The announcement "drove Viet Nam off the

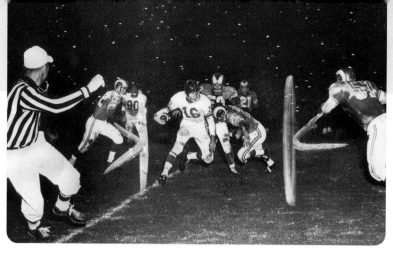

Former USC star Frank Gifford, center, with the New York Giants in an exhibition game against the Rams at the Los Angeles Memorial Coliseum, 1957.

front page banner line yesterday, and shoved both the Notre Dame-Michigan State and USC–UCLA television titanics back with the obituaries," Hunter wrote. "Personally, I have felt less shaken at some wakes."

Through it all, the *HerEx* valued visual imagery. Alongside sports cartoonist Karl Hubenthal, staff photographers Tom Courtney, James Roark, James Ruebsamen, Anne Knudsen, Paul Chinn and many others supplied award-winning photos that underscored every story. Lugging their lenses and flashes, they labored in all types of conditions: from hundred-degree heat on the Rose Bowl grass to the smoked-filled Olympic Auditorium.

They are the true heroes behind *Play by Play* because their best work went beyond mere reportage. Examine Bob Martin's poignant photo of boxer Jerry Quarry kissing his wife in the ring. Or James Roark's award-winning image of outfielder Rick Monday rescuing the American flag. Or Ken Papaleo's portrait of bodybuilder Lisa Lyon. If the best photographs capture the essence of a moment or a person—what the late French photographer Henri Cartier-Bresson described as the "decisive moment"—then these are Hall of Famers.

In this city's headlong rush to be on the cutting-edge, L.A. has largely forgotten its rich sports past. Few fans under a certain age remember the achievements of Lillian Copeland or Kenny Washington; few recall that boxing was once one of the city's most popular sports.

That's a pity. History tells us where we've been. It tabulates success and failure, it ties together seemingly random events, and it transforms our thoughts from the speculative to something approaching truth.

While it is hoped that *Play by Play* will revive interest in the past, this book does not purport to be an exhaustive L.A. sports history. These photos date only from about 1880 to 1989, the year the *HerEx* ceased

publication. (After the *HerEx* was shuttered, images from the *Herald* and the *Herald Examiner* were donated to LAPL by the Hearst Corporation.) In addition, time and attrition shrank the collection, and it has significant holes. Despite relentless searching, no image of George Freeth, the father of surfing in southern California, turned up. For some reason, there was no good photo of USC tailback Mike Garrett (who became the Trojans' athletic director). From recent times, no images of martial arts master Bruce Lee were in the collection. And so it goes.

The most vexing problem was space. Unfortunately, there is not sufficient room in these pages for the many amazing images in the archives. For those who wish to view more, the Library's Web site (www.lapl.org) offers such images.

A final note on the photographs: Photo credits are listed on page 158. Credits began appearing in the newspaper only in the 1950s, yet many photographs taken after that date do not include credits because the photos themselves were not labeled. Also, original markings—including "crop marks," the lines that editors drew to indicate which part of an image should be published—are retained to show the mechanics of deadline-driven journalism in the age before computerization and digital cameras.

Play ball!

Baseball

The national pastime first came to L.A. in the mid-1800s; organized club and semi-pro teams flourished at the end of the century. By 1903, with the establishment of the Pacific Coast League, baseball was a stable professional enterprise. Two PCL teams—the Los Angeles Angels and the Hollywood Stars— gave fans quality baseball for more than a half-century, until Brooklyn Dodgers owner Walter O'Malley shocked the world by moving his team west. That signaled the demise of the PCL, as the Angels were relocated to Spokane and the Stars to Salt Lake City. Later, O'Malley's Dodgers were joined by Gene Autry's Angels. Through it all, the region produced some of the finest talent in the land, from Walter Johnson to Jackie Robinson to Darryl Strawberry.

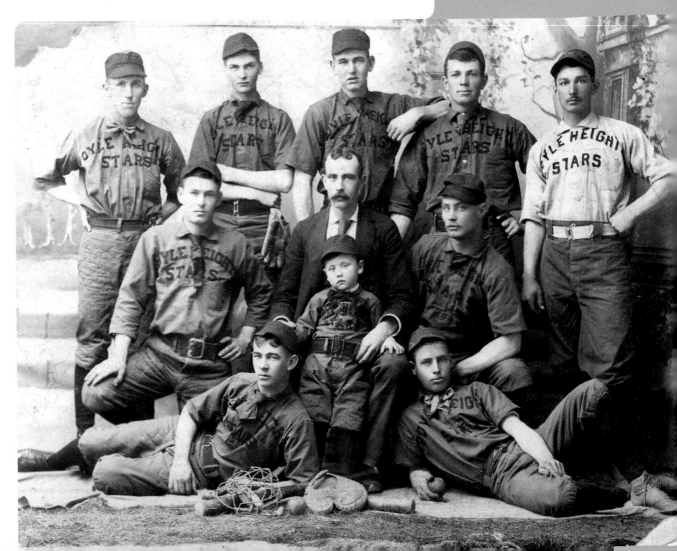

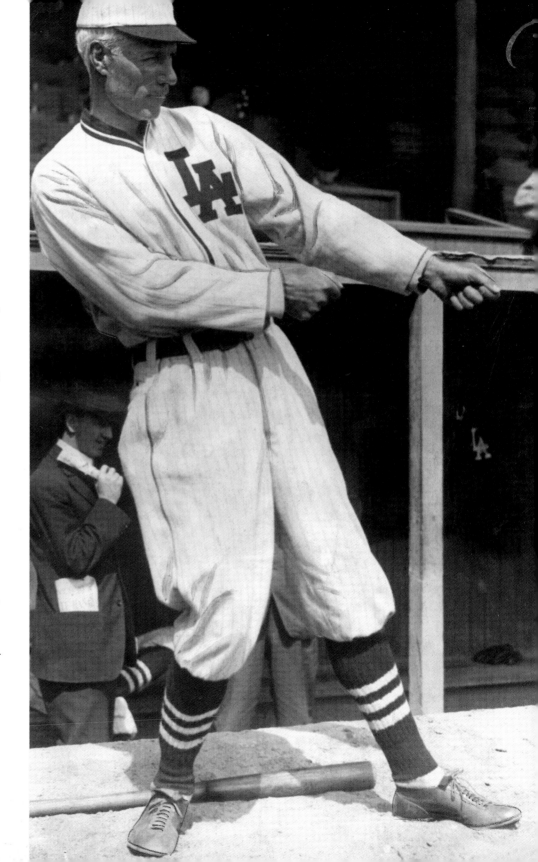

◀ Boyle Heights Stars Baseball Team circa 1895

Organized professional baseball came to Los Angeles in the early 1890s, with the Los Angeles Angels of the short-lived California League. In that era, neighborhood teams like the Boyle Heights Stars flourished throughout southern California.

Frank "Cap" Dillon, Chutes Park ▶ circa 1915

Frank "Cap" Dillon is well into his second decade with the Los Angeles Angels as he flashes a sign to one of his players. No professional team in L.A. had staying power until 1903, the first season of the newly re-organized Pacific Coast League. That year, player-manager Dillon banged out 274 hits and guided the Los Angeles Angels to a 133–78 record and a 27 1/2 game bulge over runner-up Sacramento. Playing at Chutes Park, just south of downtown Los Angeles, the Angels featured forty-one-year-old William "Dummy" Hoy, a deaf-mute outfielder who played in all 211 games, and pitcher Eustace "Doc" Newton, who went 34–12 and threw the PCL's—and L.A. baseball's—first-ever no-hitter.

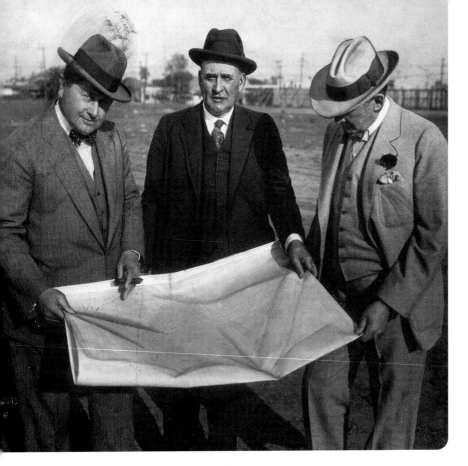

William Wrigley, Jr., and Partners ▪ circa 1924

William Wrigley, Jr., left, and his business partners look over blueprints for Wrigley Field. The chewing-gum magnate bought the Angels in 1921 for one hundred fifty thousand dollars as a farm team for his Chicago Cubs. So the Angels and would-be Cubs would have a suitable home stadium, he erected Wrigley Field in 1925 at 42nd Place and Avalon Boulevard. A 22,457-seat, home-run hitters' paradise, L.A.'s Wrigley was designed to be similar to—but smaller than—Chicago's Wrigley (originally built in 1914). The west coast Wrigley also doubled as the set for films such as *Pride of the Yankees* (1942) and *Alibi Ike* (1935) and the television show *Home Run Derby* (1959–1960). It was demolished in 1969.

**Wrigley Field
July 22, 1930**

Lights go on at Wrigley Field. The first night game at Wrigley Field in Los Angeles preceded the first night game in Chicago's Wrigley Field by fifty-eight years.

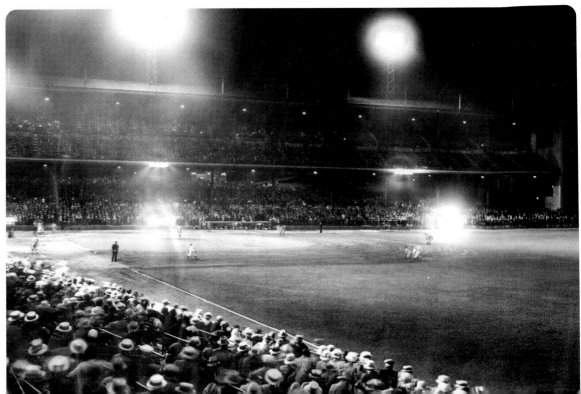

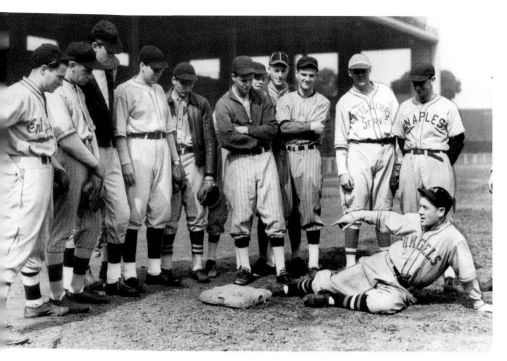

Arnold "Jigger" Statz
circa 1935

Dubbed the "Greatest Angel of Them All," Arnold "Jigger" Statz demonstrates his sliding technique to a group of aspiring ballplayers. The Angels won fourteen Pacific Coast League pennants, but their best team was the 1934 powerhouse (137-50), led by Triple Crown-winner Frank Demaree (he led the league in batting average, home runs and RBIs) and the mighty Statz, an excellent defensive center-fielder who used to cut a hole in the palm of his mitt to get a better feel for the ball. Statz played eighteen seasons in L.A. and owns most of the PCL records, including games played, hits and runs.

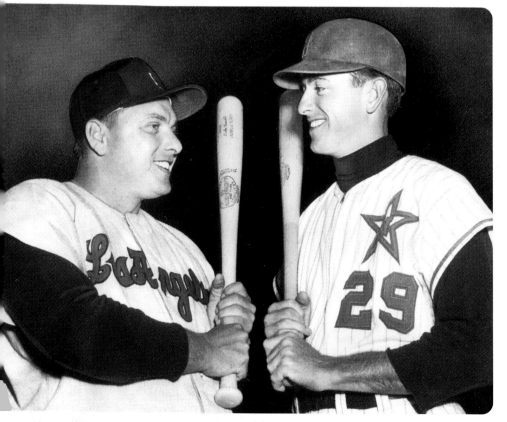

Steve Bilko and Dick Stuart
circa 1957

Steve Bilko, left, the Angels' greatest power hitter, poses with Dick Stuart, the Hollywood Stars first baseman. Stuart was nicknamed "Dr. Strangeglove" for his defensive deficiencies. From 1955 to 1957, the burly Bilko led the Pacific Coast League in home runs; he won the Triple Crown in 1956, leading the Angels to the pennant. So popular was Bilko that comedian Phil Silvers named his most famous character, Sergeant Bilko, after the first baseman. "I don't think Bilko talked too much," *Herald Examiner* columnist Allan Malamud once wrote, "but he hit the ball a mile."

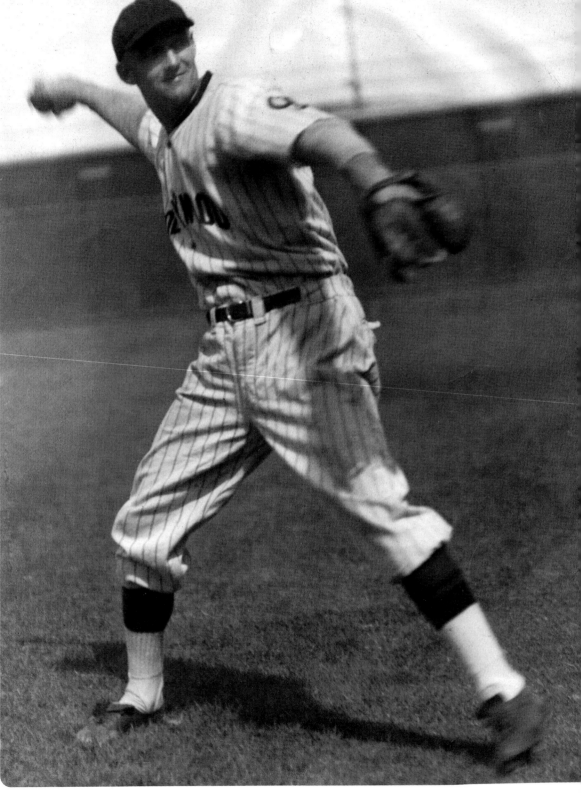

**Frank Shellenback
Wrigley Field
1928**

In 1926, owner Bill
Lane relocated his
Salt Lake City Bees to
Los Angeles, renamed
the team the Hollywood
Stars and shared
Wrigley Field with the
Angels. Pitcher Frank
Shellenback was a
Hollywood High
graduate who had
played for the Chicago
"Black Sox" (a label
given the White Sox
when eight members
were accused of
throwing the 1919
World Series). When
Shellenback returned
to Los Angeles to play
for the Stars, he was
one of the last of the
legal spit-ballers to
pitch in the Pacific
Coast League.
He ended his career
as the PCL leader in
career wins (295).

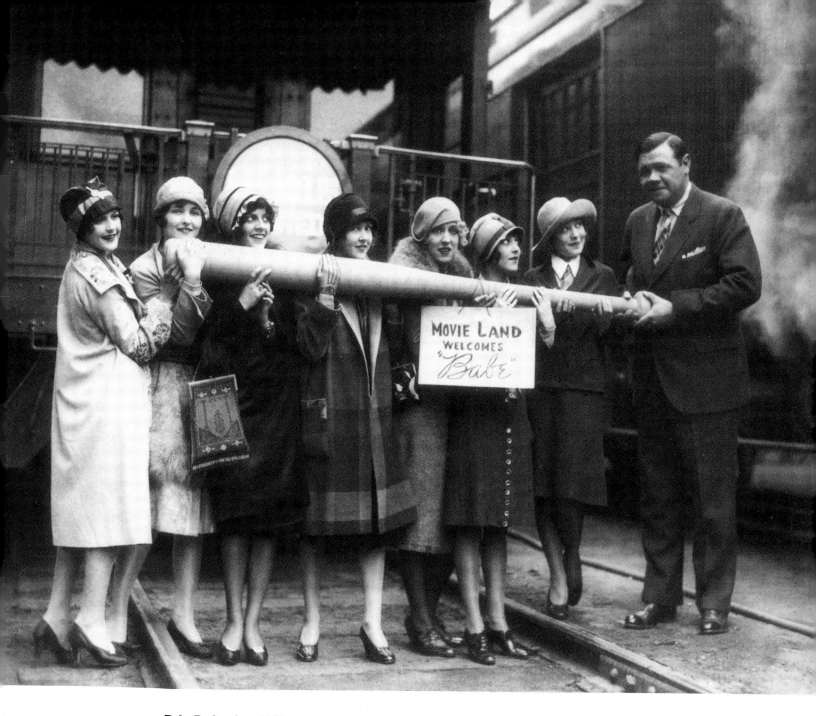

Babe Ruth · circa 1928

Movie producers hoping to capitalize on Babe Ruth's immense popularity lured him to Hollywood during the off-season, where he made several forgettable films (including a series of shorts for Universal). Here, in a staged publicity photo, starlets greet Ruth—and his mighty bat—upon his arrival.

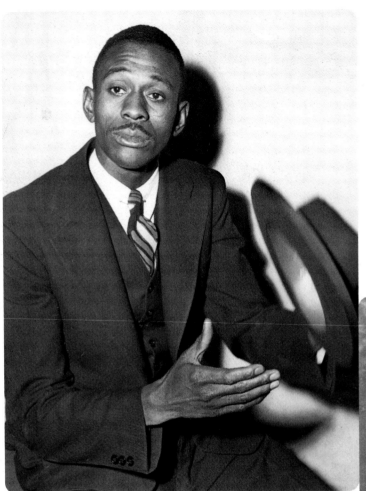

Leroy "Satchel" Paige • October 22, 1943

Beginning in 1931, the great Negro League pitcher Leroy "Satchel" Paige picked up extra money by playing in the California Winter League in L.A. (usually at White Sox Park, located at 38th and Compton Avenue). Paige's pitching duels with Cleveland Indians ace Bob Feller became Winter League legend—and not so incidentally showed that black ballplayers could compete with whites. In 1948, at age forty-two, Paige finally made it to the major leagues, helping Bill Veeck's Cleveland Indians win the 1948 World Series. He became the oldest Rookie of the Year; later, he became the first Negro League player to be inducted in the Hall of Fame. "I never threw an illegal pitch," he once said. "Once in a while I would toss one that ain't never been seen by this generation."

Jackie Robinson, Pasadena Junior College ▶
circa 1937

Long before he broke major league baseball's color line and signed with the Brooklyn Dodgers in 1945, Jackie Robinson starred at Pasadena's Muir High, then at Pasadena Junior College (he's pictured second from left), and then at UCLA, where he was the first athlete to letter in four sports (basketball, baseball, football and track). During the 1940s, he also played professionally, with the L.A. Bulldogs (football) and the L.A. Red Devils (basketball). He died in 1972 at age 53.

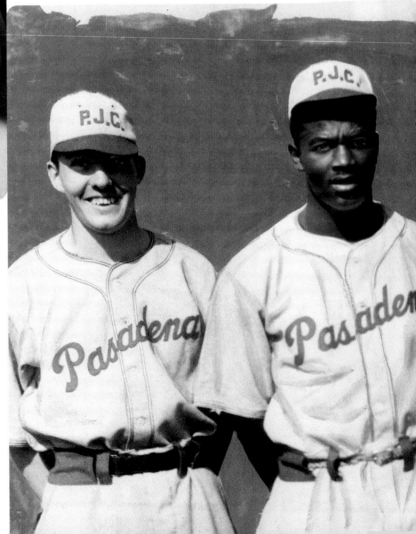

Frank Robinson and Al Campanis • January 12, 1972

Dodgers vice president Al Campanis, right, welcomes outfielder Frank Robinson to the team. Three years later, Robinson became the first African American manager in the major leagues, with the Cleveland Indians. Campanis must have forgotten about this: some fifteen years after this photo was taken, he appeared on ABC's *Nightline* celebrating the fortieth anniversary of Jackie Robinson breaking baseball's color line and said that blacks "may not have some of the necessities to be a field manager or general manager." Campanis, who had been Jackie Robinson's teammate in the minor leagues, was fired the same week the program aired.

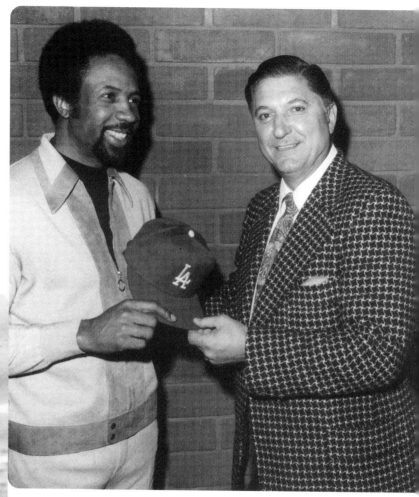

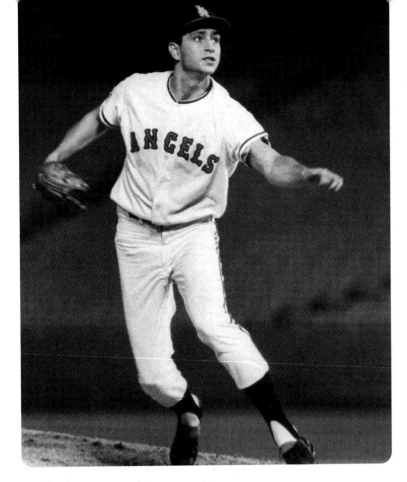

▲ Robert "Bo" Belinsky · August 15, 1964

For a split second, Los Angeles Angels pitcher Robert "Bo" Belinsky owned
L.A. In 1962, he started his career with four consecutive wins, the last one a no-
hitter. The twenty-five-year-old rookie was an instant celebrity and enjoyed it to
the fullest, dating Mamie Van Doren, Ann-Margret and other va-va-voom stars.
But nightlife proved ruinous to his pitching career, and the Angels eventually
banished the "raven-haired deceiver," as *Herald Examiner* columnist Bud
Furillo called him, for punching out *Los Angeles Times* sportswriter Braven
Dyer. Belinsky won just twenty-eight games in his career. He died in 2001.

Jimmy Reese · May 9, 1984 ▶

San Pedro High's Hymie Solomon, better known as Jimmy Reese, was a
baseball lifer, starting in 1917 as a bat boy for the Los Angeles Angels, then as
the second baseman for the 1934 Angels, which was considered the best minor
league team of all time. As an infielder with the New York Yankees, he roomed
with Babe Ruth, or, as he joked, with the Babe's suitcase. Later, as a coach with
the California Angels, he became known for his fungo-hitting skills. By then,
he had spent seventy-eight years in professional baseball. He died in 1994.

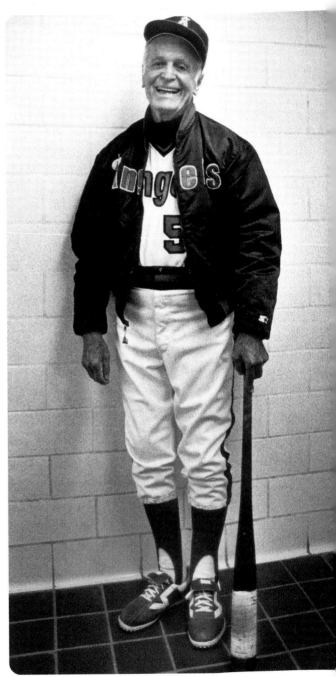

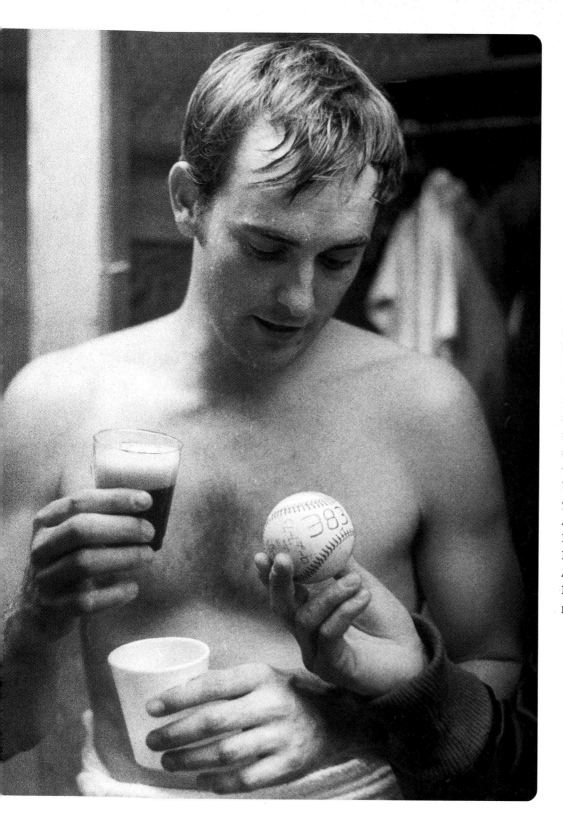

Nolan Ryan, Anaheim
September 9, 1973

California Angels ace Nolan Ryan enjoys a post-game toast after establishing major league baseball's single-season strikeout record with 383 Ks. Ryan broke Sandy Koufax's old mark of 382 (set in 1965). The 1973 season would prove to be one of Ryan's finest: along with the strikeout record, he won twenty-one games and threw the first two of his seven career no-hitters. In 1980, when Ryan left the Angels to sign baseball's first million-dollar-per-year contract with the Houston Astros, general manager Buzzie Bavasi said he would replace Ryan with "two 8-7 pitchers." As Ryan later said: "I wonder if Buzzie ever found those two pitchers."

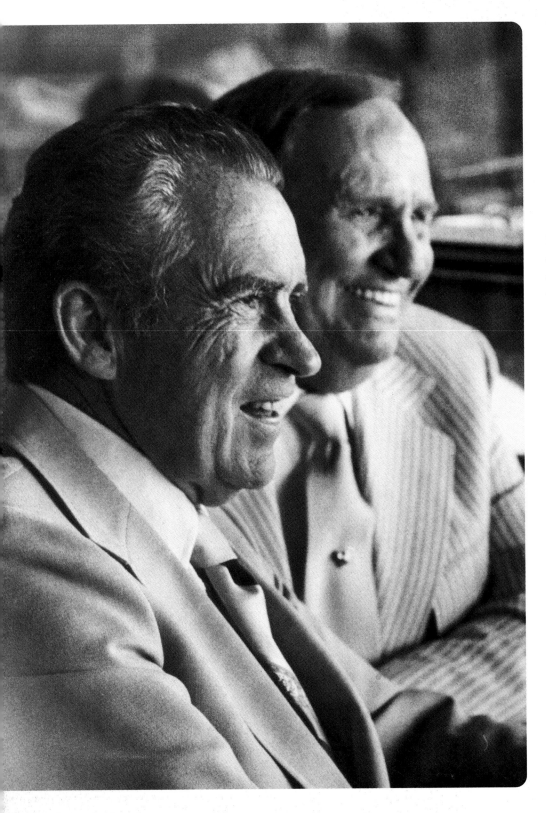

Richard Nixon and Gene Autry
Anaheim Stadium
June 27, 1978

Angels owner Gene Autry watches a game with former President Richard Nixon and, by the looks on their faces, the Angels must be winning. After making his fortune as the "Singing Cowboy" in film, radio and television, Autry purchased the rights to establish California's first American League team in 1960. The next year the Los Angeles Angels made their debut at Wrigley Field. Then, after playing for four seasons at Dodger Stadium, Autry moved the franchise to its own stadium in Anaheim, where the team officially became the California Angels in 1966. Autry died in 1998, four years before the Angels won their first World Series.

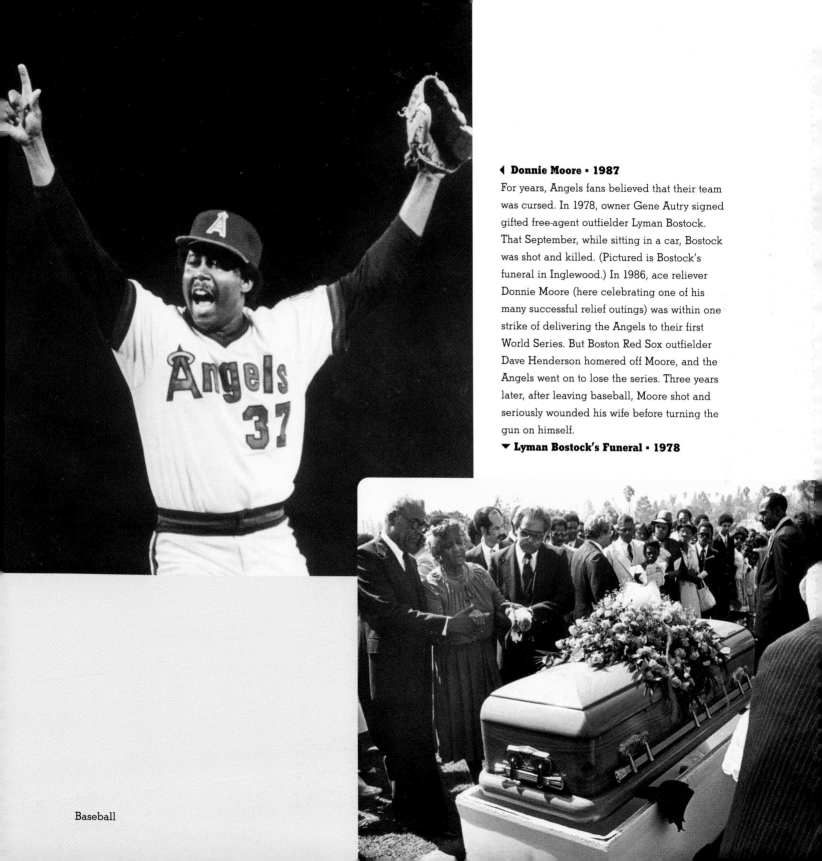

◀ Donnie Moore • 1987

For years, Angels fans believed that their team was cursed. In 1978, owner Gene Autry signed gifted free-agent outfielder Lyman Bostock. That September, while sitting in a car, Bostock was shot and killed. (Pictured is Bostock's funeral in Inglewood.) In 1986, ace reliever Donnie Moore (here celebrating one of his many successful relief outings) was within one strike of delivering the Angels to their first World Series. But Boston Red Sox outfielder Dave Henderson homered off Moore, and the Angels went on to lose the series. Three years later, after leaving baseball, Moore shot and seriously wounded his wife before turning the gun on himself.

▼ Lyman Bostock's Funeral • 1978

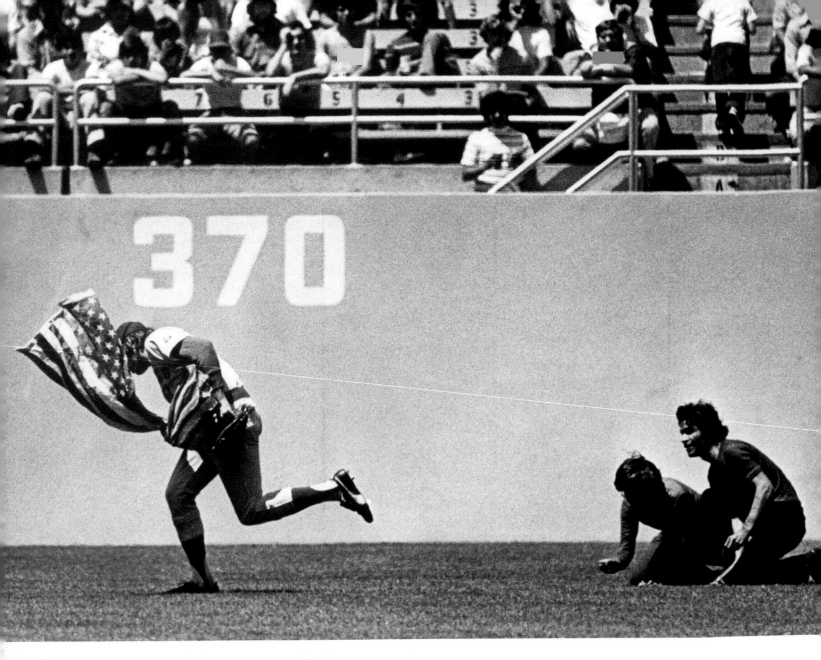

Rick Monday • April 25, 1976

When William Errol Thomas and his son jumped out of the stands at Dodger Stadium, sprinkled lighter fluid on an American flag, and attempted to light it, *Herald Examiner* photographer James Roark caught Chicago Cubs outfielder Rick Monday rescuing the flag. Monday was traded to the Dodgers for Bill Buckner before the next season. The Santa Monica High graduate hit the pennant-winning home run in 1981 and went on to work for the team as a TV-radio announcer. Roark, nominated for a Pulitzer Prize for the photo, lost his job when the paper shuttered in 1989 and eventually left journalism. He died in 1995.

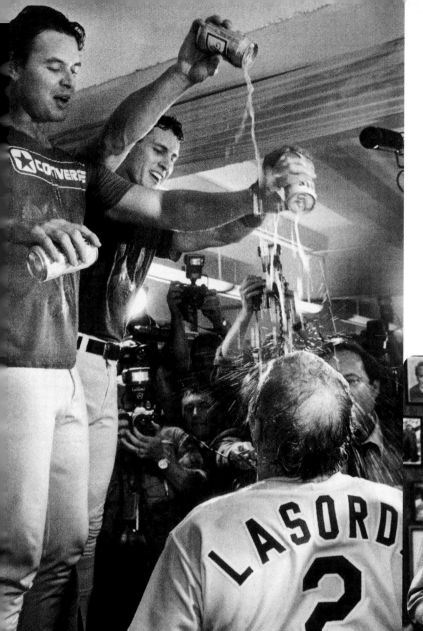

◀ **Rick Honeycutt, Steve Sax and Tommy Lasorda · 1983**
At left, pitcher Rick Honeycutt and second baseman Steve
Sax douse Lasorda after the Dodgers clinched the division
in 1983. Frank Sinatra and Dodgers manager Tommy Lasorda
chat before Opening Day of the 1981 season, the year
Lasorda managed the Dodgers to his first World Series title.
The crooner from New Jersey and the ballplayer from
Pennsylvania were *paisanos*. Some might say Sinatra was also
a good-luck charm. He sang the national anthem on Opening
Day in 1977 as well, which was Lasorda's first full season as
the Dodgers' manager.

▼ **Frank Sinatra and Tommy Lasorda · April 10, 1981**

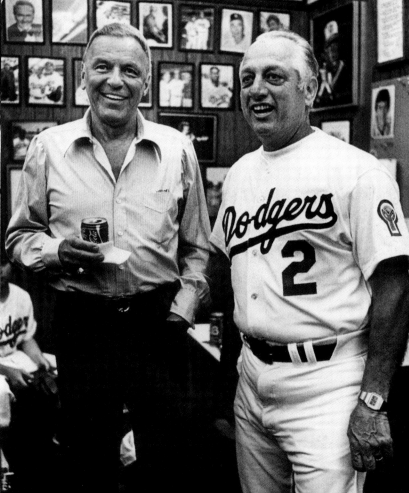

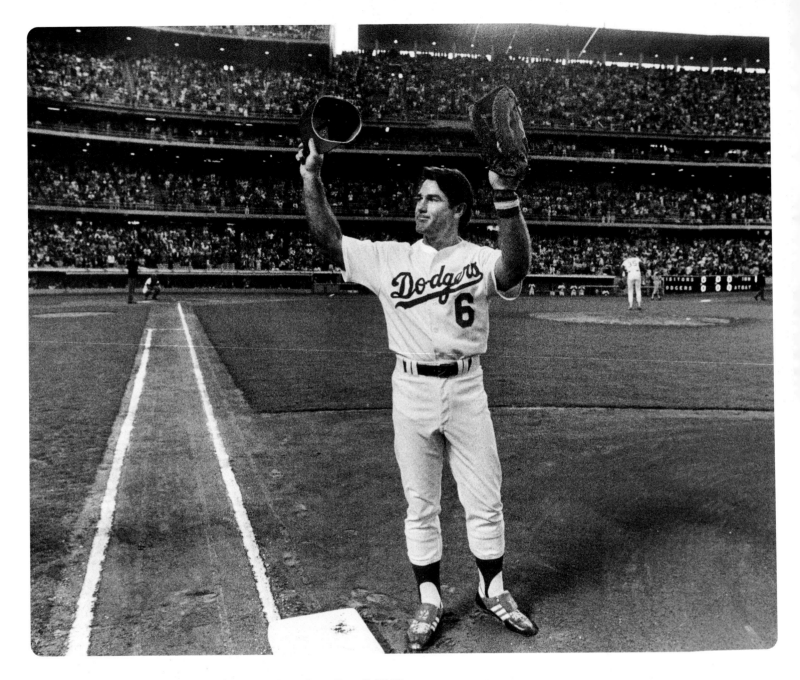

Steve Garvey, Dodger Stadium · June 6, 1982

Steve Garvey acknowledges the crowd as he starts his thousandth consecutive game. The streak reached 1,207 games, a National League record. The short-but-powerful first baseman anchored baseball's most enduring infield combination: Garvey, Bill Russell at second base, Davey Lopes as shortstop and Ron Cey at third played together as a unit for eight-and-a-half years, from 1973 to 1981, and led the Dodgers to three World Series appearances.

◀ **Fernando Valenzuela**
May 15, 1981

In 1981, Fernandomania swept through Los Angeles. Young Fernando Valenzuela, pictured here after pitching another gem, was known for his funky wind-up, "Pillsbury Doughboy" physique and drawing adoring crowds to Dodger Stadium. Valenzuela started the season 8-0, and led the Dodgers to the World Series in his first full year on the mound. For his efforts, he received both the Cy Young and Rookie of the Year awards. In the off-season, he served as the grand marshal of East L.A.'s annual parade.

Fernando Valenzuela
November 22, 1981 ▼

Orel Hershiser • July 30, 1984

Nicknamed "Bulldog," Orel Hershiser brought toughness to the mound with every start.
He enjoyed a magical season in 1988, when he broke Don Drysdale's record with fifty-nine
consecutive scoreless innings; led the league in wins, innings and complete games; and
capped the year by leading the Dodgers to the World Series.

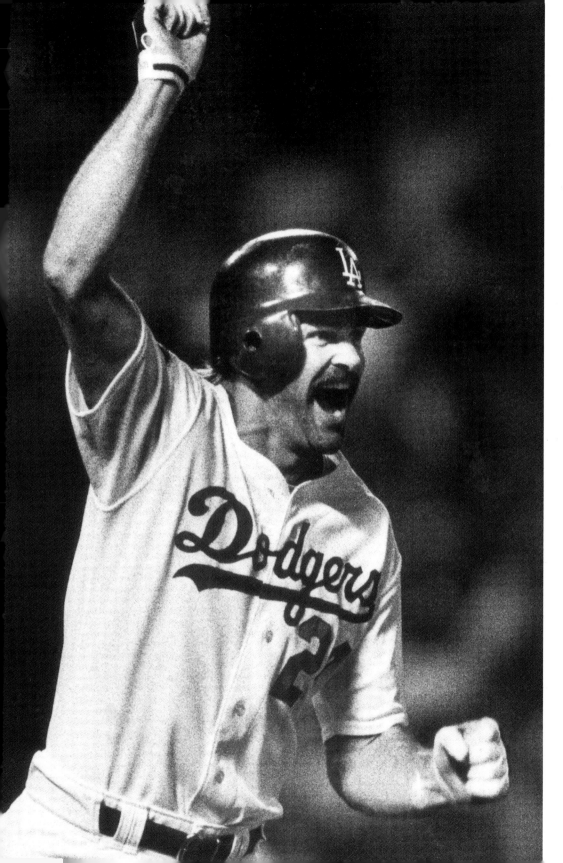

**Kirk Gibson, Dodger Stadium
October 15, 1988**
Kirk Gibson celebrates what
the Los Angeles Sports Council
calls "the greatest moment in
Los Angeles sports history."
Trailing 4–3 and down to their
last out in the bottom of the ninth
inning in Game 1 of the 1988
World Series, the Dodgers called
on Gibson to pinch-hit against
Oakland A's relief ace Dennis
Eckersley. His injured knee
heavily wrapped, Gibson limped
to home plate, then turned on a
3–2 slider and drove the ball over
the right-field wall for a two-run,
game-winning, jaw-dropping
homer. It was his only at-bat
during the Series, which the
Dodgers won in five games.

◀ **Darryl Strawberry, Crenshaw High School • May 6, 1980**
Darryl Strawberry pitches for Crenshaw High, the year the New York Mets selected him first in the amateur draft. The previous year, Strawberry's Cougars lost to Granada Hills (and a pitcher named John Elway) in the finals of the city championships. Despite his exceptional pitching skills, Strawberry went to the majors because of his powerful bat. Later, he played for the Dodgers for three seasons (1991-1993). Unfortunately, Strawberry became better known for his off-field behavior, including alcohol and drug addiction, and his wondrous talent never was fully realized.

▼ **Rod Dedeaux • May 8, 1984**
Manager Rod Dedeaux in the USC dugout. The Hollywood High graduate did a short stint with the Brooklyn Dodgers, then spent forty-five years at USC. He managed or co-managed eleven national championship teams—including an unheard-of five in a row from 1970-1974—and sent two hundred ballplayers to the majors, including Tom Seaver, Randy Johnson and Fred Lynn. In 1984, he coached the U.S. Olympic team to a silver medal.

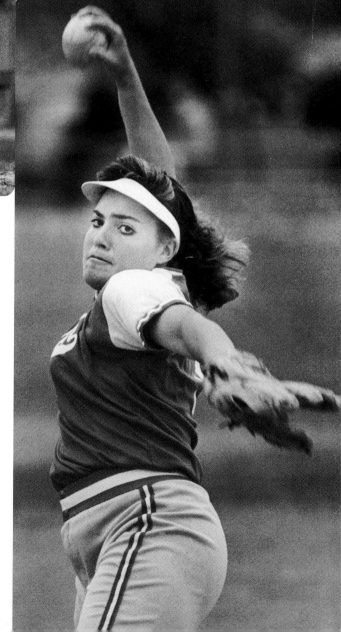

▲ Mark McGwire · circa 1984

Mark McGwire, left, leads off first for the USC Trojans in an exhibition game against the Dodgers. Born in Pomona and raised in Claremont, McGwire entered USC as a pitcher; he left as a first baseman with school slugging records. In 1984, the same year he was drafted by the Oakland A's, McGwire helped the U.S. win a silver medal at the L.A. Olympics.

Lisa Fernandez · April 12, 1989 ▶

Lisa Fernandez pitches for Lakewood's St. Joseph's High. Fernandez and her rising fastball have baffled opponents since her days at St. Joseph's, where she racked up sixty-nine shutouts, thirty-seven no-hitters and twelve perfect games. Fernandez then starred at UCLA, leading the Bruins to a 93–7 record, with two national titles, before she helped the U.S. win Olympic gold medals in Atlanta (1996) and Sydney (2000). At the 2004 Athens Olympics, Fernandez pitched a four-hitter to clinch the third consecutive gold medal for the U.S.

Baseball

The Dodgers Move to Los Angeles

Following in the footsteps of football's Cleveland Rams, who relocated to Los Angeles in 1946, the Brooklyn Dodgers moved to L.A. in 1958. At the time, major league baseball was far more popular than professional football. Indeed, owner Walter O'Malley's decision to move the Dodgers to L.A. remains the most significant—and most controversial—story in Los Angeles sports history.

Along with the New York Giants' move to San Francisco the same year, this launched major league baseball west of St. Louis. It established O'Malley as a powerbroker, a position he would occupy until his death in 1979. Dodger Stadium, meanwhile, emerged as a state-of-the-art masterpiece, a harbinger of modern stadium design.

But the move also generated civic strife on both coasts. "Da Bums" were an excellent, albeit aging, team—one that had won the World Series as recently as 1955. The players were an intrinsic part of Brooklyn's social fabric; in fact, the team took its name from the borough's "trolley dodging" denizens.

Repeatedly rebuffed in his effort to build a new stadium in Brooklyn, O'Malley was concerned that suburban flight and other factors were reducing attendance at Ebbets Field. He watched other teams move west, including the Boston Braves to Milwaukee (1953), and the Philadelphia A's to Kansas City (1954).

Meanwhile, L.A. politicians on the prowl for a major league team sensed an opportunity. In 1950, via the power of eminent domain, the Los Angeles City Housing Authority had purchased nearly two hundred acres of land in Chavez Ravine, a predominantly Mexican American neighborhood. The housing authority planned to bulldoze houses and build ten thousand low-income housing units. But powerful business interests rallied to quash the plan, sweeping Mayor Norris Poulson to power.

In 1957, Mayor Poulson offered O'Malley a deal he couldn't refuse: the city would provide approximately three hundred acres in Chavez Ravine (including the 185 acres originally set aside for public housing), if O'Malley promised to build a new stadium. The city and county also paid nearly five million dollars for grading, construction and access roads. In exchange, O'Malley, who had earlier obtained the PCL's Los Angeles Angels and Wrigley Field, agreed to turn over Wrigley Field to the city.

In May of 1958, after the Dodgers began playing in the renovated Los Angeles Memorial Coliseum, voters narrowly passed a citywide referendum, known as Proposition B, which cleared the way for construction of a new stadium. The groundbreaking for Dodger Stadium commenced in 1959.

That same year, the last remaining residents of Chavez Ravine were evicted, and the neighborhood that photographer-essayist Don Normark called "a poor man's Shangri-la" disappeared forever.

Chavez Ravine • October 7, 1957

A *Herald Examiner* reporter points out the future location of home plate in the Dodgers' new stadium to be built on land in Chavez Ravine. Walter O'Malley made the announcement that he was moving the Dodgers west the day this photograph was taken. In the background of the image, the police academy is visible.

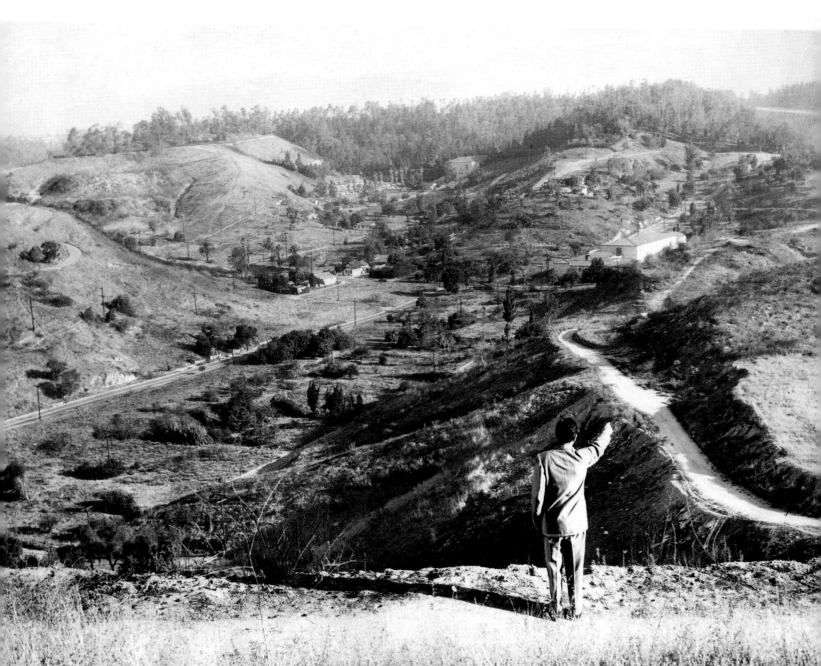

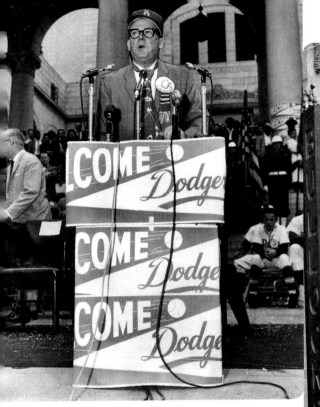

▲ Norris Poulson, City Hall
April 18, 1958

Mayor Norris Poulson introduces the city's new major league baseball team, the Los Angeles Dodgers, to the public on Opening Day.

Motorcade to the First Game ▶
April 18, 1958

After leaving City Hall, the Dodgers ride in a motorcade parade down Broadway, en route to the Los Angeles Memorial Coliseum and their first game in Los Angeles: a 6-5 win over the San Francisco Giants before 78,672 fans. Despite their inept play and seventh-place finish, the Dodgers drew a franchise record of 1,845,556 fans in their first year in L.A.

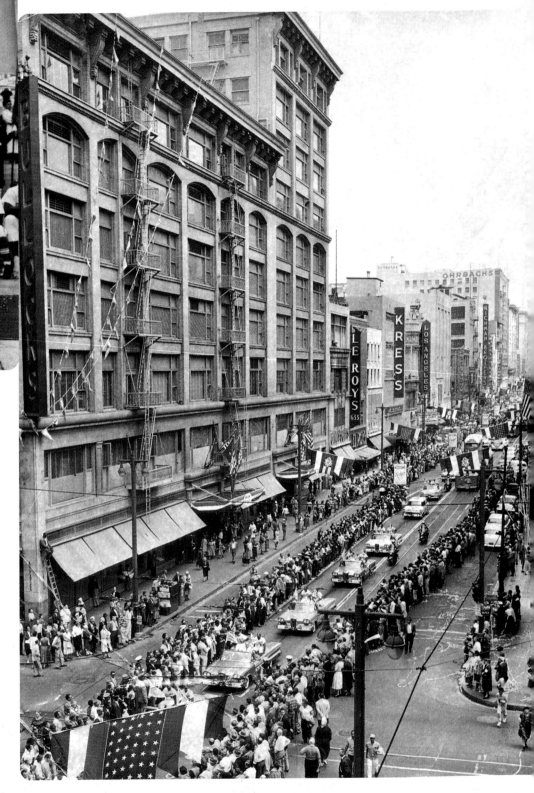

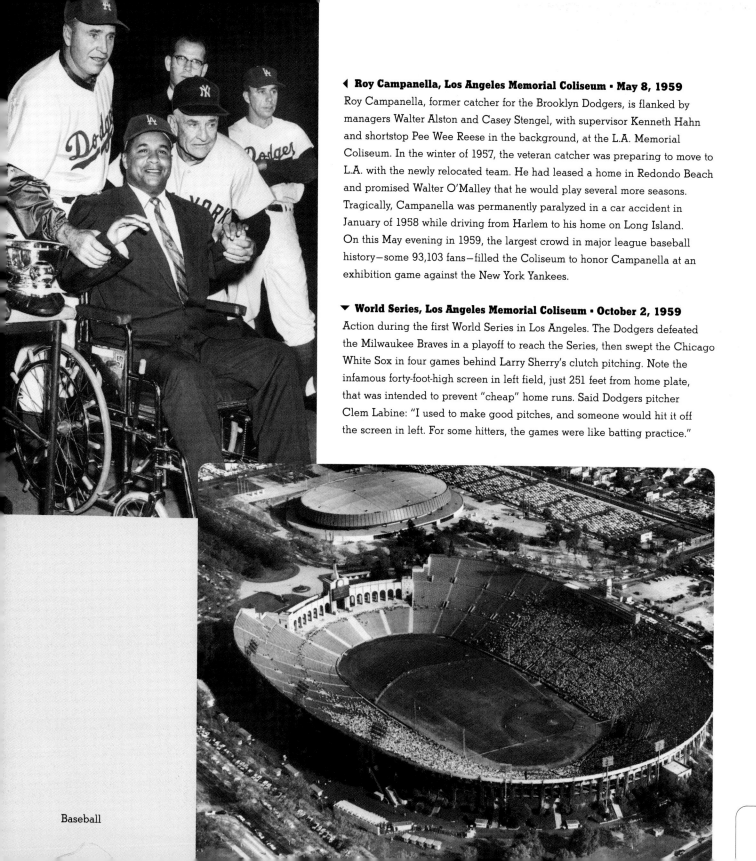

◄ Roy Campanella, Los Angeles Memorial Coliseum • May 8, 1959

Roy Campanella, former catcher for the Brooklyn Dodgers, is flanked by managers Walter Alston and Casey Stengel, with supervisor Kenneth Hahn and shortstop Pee Wee Reese in the background, at the L.A. Memorial Coliseum. In the winter of 1957, the veteran catcher was preparing to move to L.A. with the newly relocated team. He had leased a home in Redondo Beach and promised Walter O'Malley that he would play several more seasons. Tragically, Campanella was permanently paralyzed in a car accident in January of 1958 while driving from Harlem to his home on Long Island. On this May evening in 1959, the largest crowd in major league baseball history—some 93,103 fans—filled the Coliseum to honor Campanella at an exhibition game against the New York Yankees.

▼ World Series, Los Angeles Memorial Coliseum • October 2, 1959

Action during the first World Series in Los Angeles. The Dodgers defeated the Milwaukee Braves in a playoff to reach the Series, then swept the Chicago White Sox in four games behind Larry Sherry's clutch pitching. Note the infamous forty-foot-high screen in left field, just 251 feet from home plate, that was intended to prevent "cheap" home runs. Said Dodgers pitcher Clem Labine: "I used to make good pitches, and someone would hit it off the screen in left. For some hitters, the games were like batting practice."

Baseball

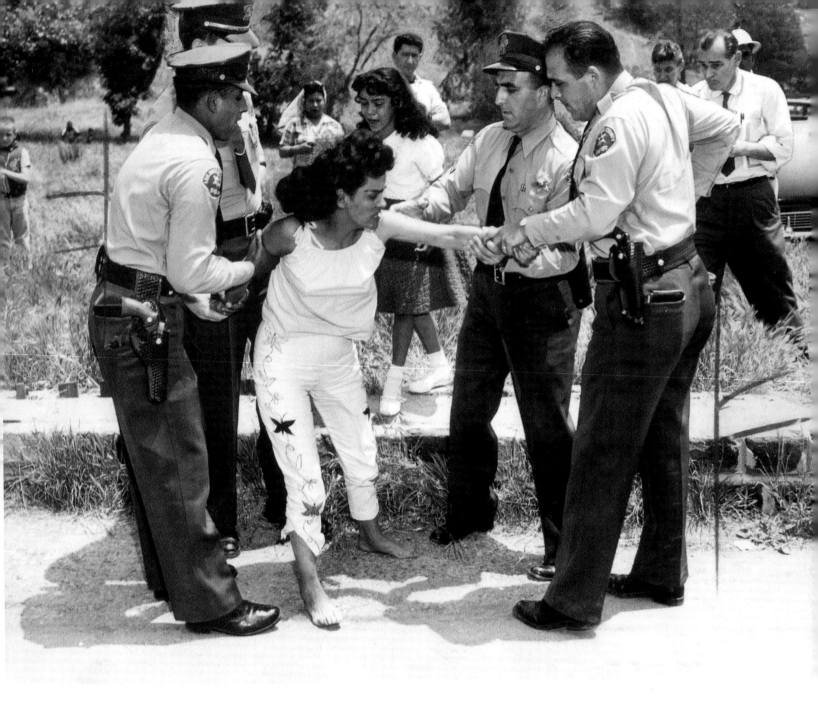

Aurora Vargas, Chavez Ravine • May 8, 1959

Most Chavez Ravine residents left their homes peacefully after they were evicted, but the
Arechiga family fought until the bitter end. One family member, Aurora Vargas, vowed "they'll
have to carry me [out]." Here, L.A. County sheriffs forcibly remove Vargas from her home.
Bulldozers knocked over the remaining dwellings, including her family's; four months later,
groundbreaking for Dodger Stadium began.

Play by Play

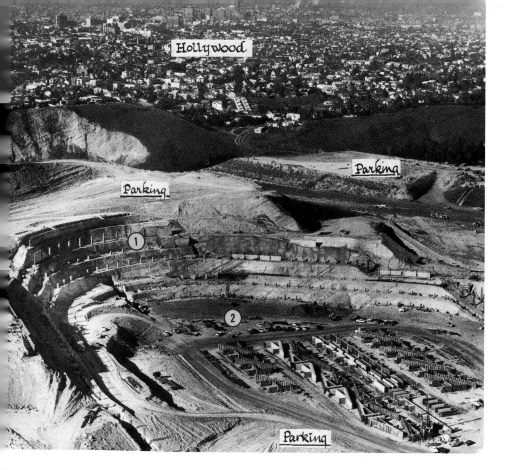

◄ Dodger Stadium · February 25, 1961

Construction of Dodger Stadium is underway, and it becomes the first privately financed major league baseball stadium since Yankee Stadium was built in the 1920s. The Dodgers reported that 8,000,000 cubic yards of earth were moved and 80,000 tons of asphalt were used to construct the stadium, the parking lots and roads. With his engineering background, Walter O'Malley (tossing the baseball) delighted in the experience of constructing a state-of-the-art stadium from scratch, especially one with seating for 56,000 fans. According to *Herald Examiner* sports columnist Morton Moss, O'Malley transformed Chavez Ravine into a "vast monument of multicolored steel, concrete and terraced asphalt surrounding a barbered acreage of scalloped greenery." The construction of the stadium cost twenty-three million dollars.

Walter O'Malley, Dodger Stadium March 11, 1962 ▼

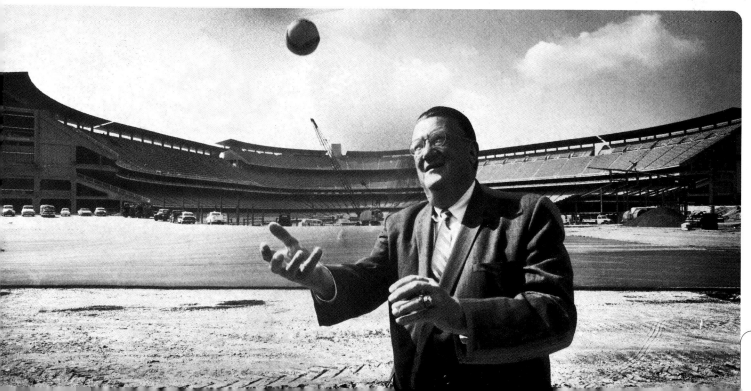

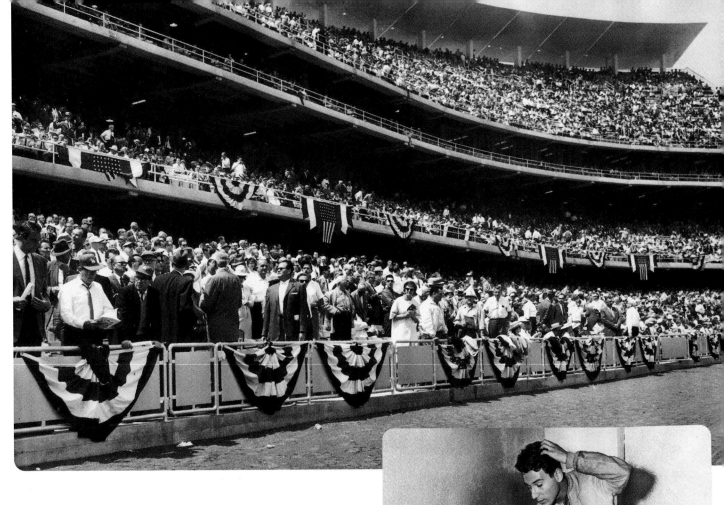

▲ Opening Day, Dodger Stadium • April 10, 1962

With 52,564 fans anxiously waiting, tenor Alma Pedroza sang the national anthem, then Walter O'Malley's wife, Kay, threw the ceremonial first pitch. Unfortunately, with Johnny Podres on the mound, the Dodgers lost 6–3 to the Cincinnati Reds, the defending National League champs. That year the Dodgers set a major league baseball attendance record, drawing more than 2.7 million fans. The team's Opening Day lineup at Dodger Stadium featured Maury Wills at shortstop, Jim Gilliam at second base, Wally Moon in left field, Duke Snider in right field, John Roseboro catching, Ron Fairly at first base, Darryl Spencer at third, Willie Davis in center and Podres pitching.

Restroom, Dodger Stadium • 1962 ▶

Thirsty fans drink water from restroom faucets. When Dodger Stadium first opened, no drinking fountains existed in the stadium. After many complaints, management installed water fountains.

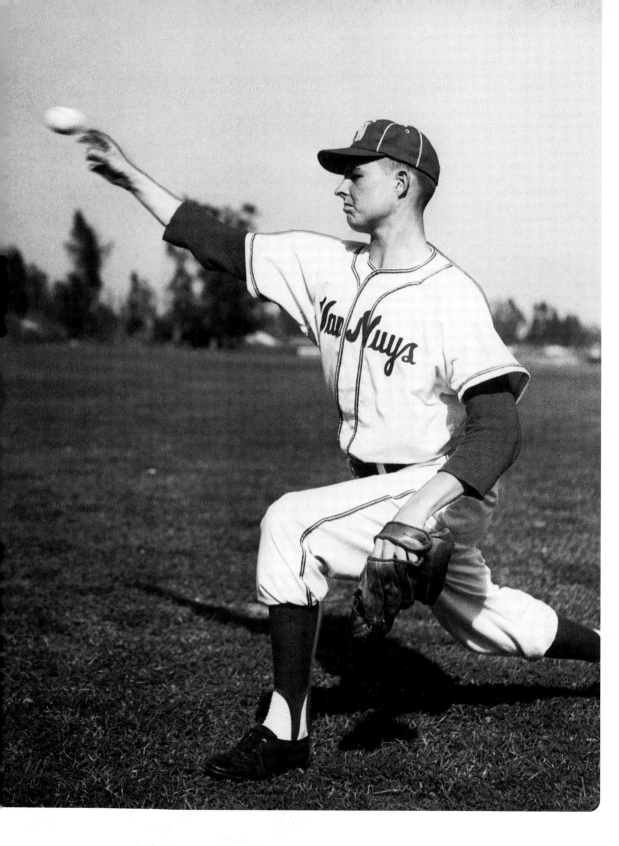

Don Drysdale
Van Nuys High School
April 16, 1954
Straight out of high
school, Don Drysdale
signed with the Dodgers
after a meeting at Otto's
Pink Pig restaurant in
Sherman Oaks. "Big D"
started with Brooklyn in
1956, but his best years
were spent in L.A. Known
for his brushback pitches
and competitive fire,
Drysdale broke Walter
Johnson's record by
pitching 58 2/3 consecutive
scoreless innings in 1968.
A year later, he was forced
to retire with a torn rotator
cuff; he became part of
the Dodgers' broadcast
team. He died in 1993.

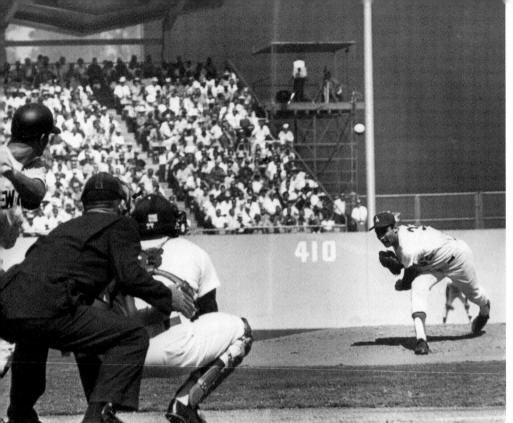

◀ Sandy Koufax, Dodger Stadium · 1963

Sandy Koufax pitches during the 1963 World Series as the Dodgers beat the New York Yankees. Like Drysdale, Koufax began his career in Brooklyn. Like Drysdale, he came into his own in L.A. And, like Don Drysdale, he retired because of an arm injury. Beginning in 1961, Koufax won twenty-five or more games three times and led L.A. to three World Series titles. One of the few Jewish professional athletes, he refused to pitch the opening game of the 1965 World Series because it fell on Yom Kippur. With the Series tied at 3-3, Koufax pitched the seventh and deciding game on two days rest—and beat the Minnesota Twins, 2-0. The "Left Hand of God," indeed.

Sandy Koufax and Ron Fairly ▶
Los Angeles International Airport
1966

Sandy Koufax and Ron Fairly return to L.A. after the team won the 1966 National League title. After winning 27 games in 1966, Koufax never won another game: The Dodgers were swept in the World Series by the Baltimore Orioles, and Koufax announced his retirement that fall.

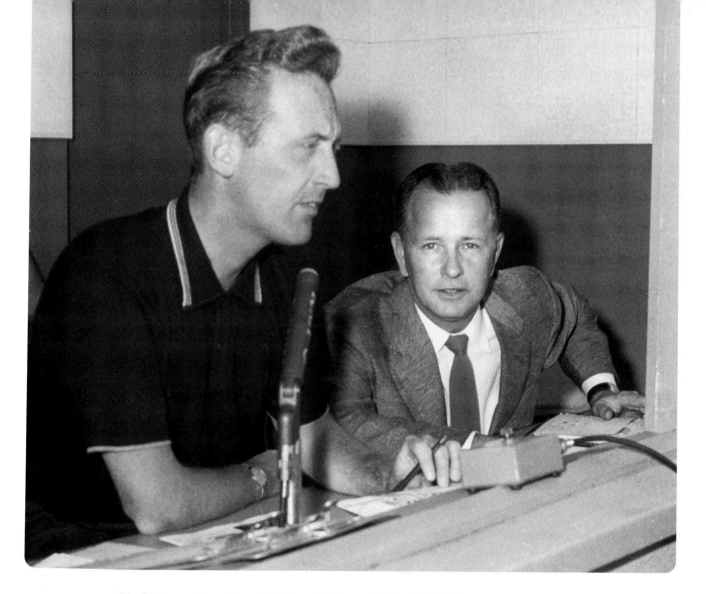

Vin Scully and Jerry Doggett, Dodger Stadium • October 14, 1960

Vin Scully, left, and his longtime partner at the microphone, Jerry Doggett, give the play by play. Scully became the mellifluous voice of the Dodgers, a word-poet whose storytelling style so captivated Angelenos that many brought transistor radios to the stadium. Here is his description after Sandy Koufax pitched a perfect game:

> On the scoreboard in right field it is 9:46 P.M. in the City of the Angels, Los Angeles, California. And a crowd of 29,139 just sitting in to see the only pitcher in baseball history to hurl four no-hit, no-run games. He has done it four straight years, and now he caps it: On his fourth no-hitter he made it a perfect game. And Sandy Koufax, whose name will always remind you of strikeouts, did it with a flurry. He struck out the last six consecutive batters. So when he wrote his name in capital letters in the record books, that 'K' stands out even more than the O-U-F-A-X.

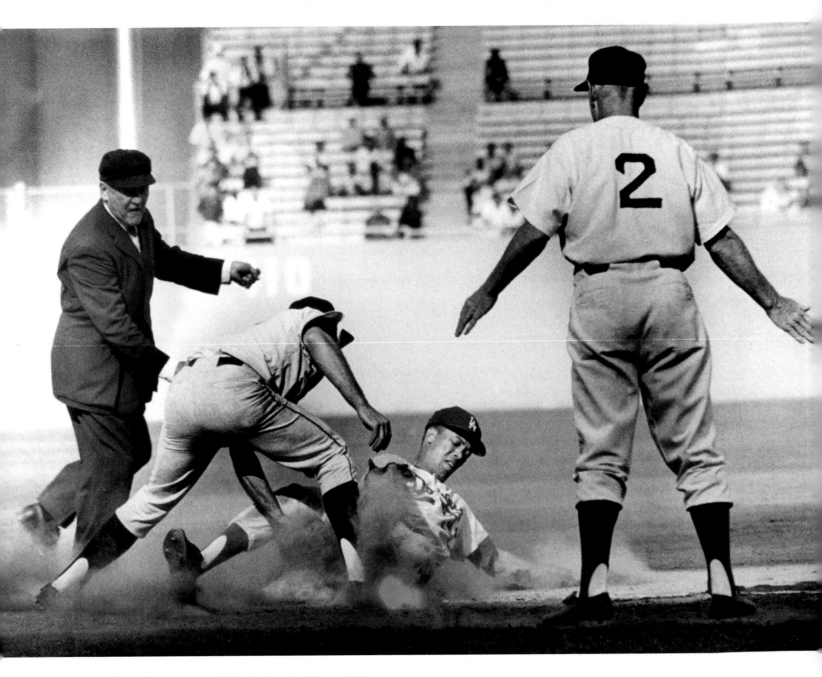

Maury Wills, Dodger Stadium • 1962

Maury Wills slides safely into third under the watchful eyes of third base coach Leo Durocher.
During the Dodgers' first years in L.A., shortstop Wills sparked the team's meager offense.
He led the National League in stolen bases from 1960 to 1965, and shattered Ty Cobb's forty-
seven-year-old record of ninety-seven stolen bases by swiping 104 in 1962. Despite the fact that
L.A. lost its lead over the rival Giants in the 1962 pennant race, Wills won MVP.

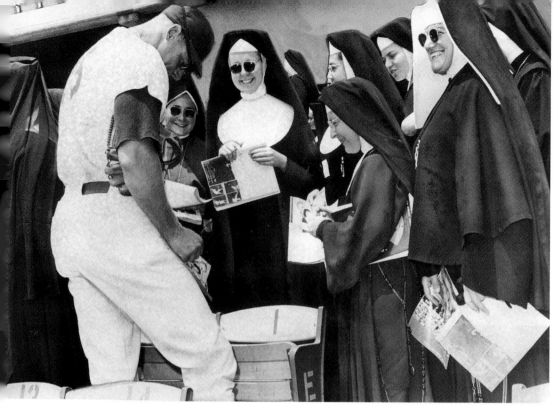

◀ **Frank Howard and Fans**
Dodger Stadium
July 7, 1963
Outfielder Frank Howard signs for the "True Blue" faithful at one of the team's most unusual promotions: Nuns Day. God bless the home team.

▼ **Wrigley Field**
March 19, 1969
A view of the demolition of Wrigley Field. After the Dodgers gave Wrigley Field to the city, the stadium fell into disrepair. The site is now occupied by a community recreation center.

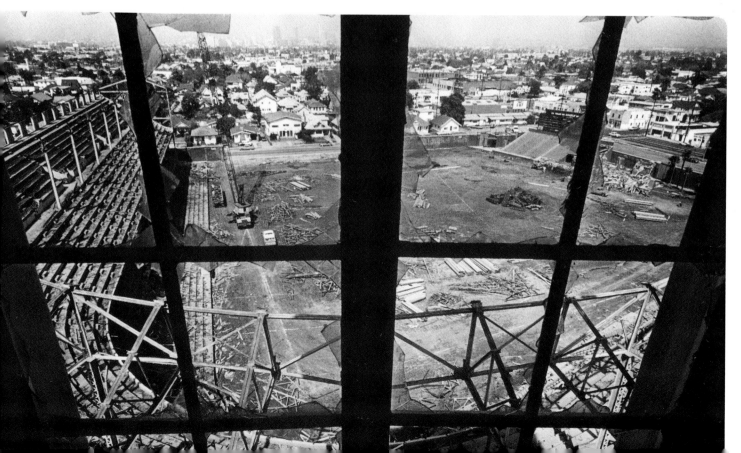

Basketball

Long overshadowed by baseball, football, and even boxing, basketball came into its own in L.A. in the 1960s. First, the Lakers moved to Los Angeles from Minneapolis and established the first NBA franchise on the West Coast. Then, John Wooden created a dynasty at UCLA, winning ten NCAA titles and putting Pauley Pavilion on the national sports map. Since then, Los Angeles has turned into a hoops haven— for men and women—in the high school, collegiate and professional ranks.

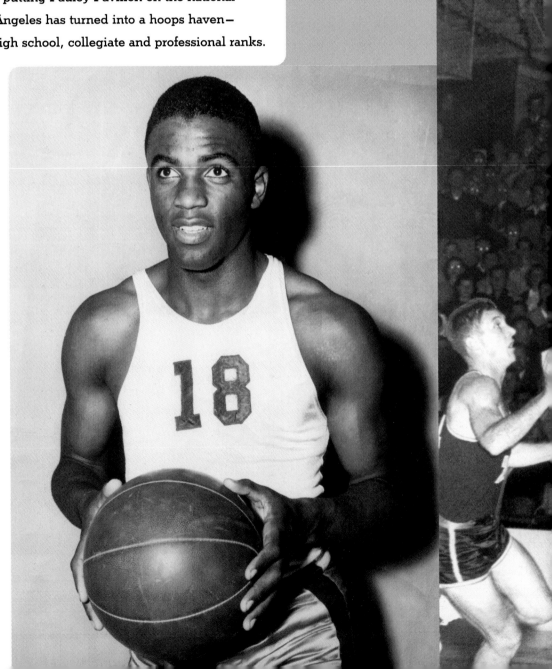

Jackie Robinson, UCLA · 1940
After transferring to UCLA from Pasadena Junior College, future Brooklyn Dodgers star Jackie Robinson showed his versatility by becoming the only Bruin to letter in four sports: football, basketball, track and baseball. According to eyewitnesses, the five-foot-ten Robinson was one of the first players to dunk a basketball.

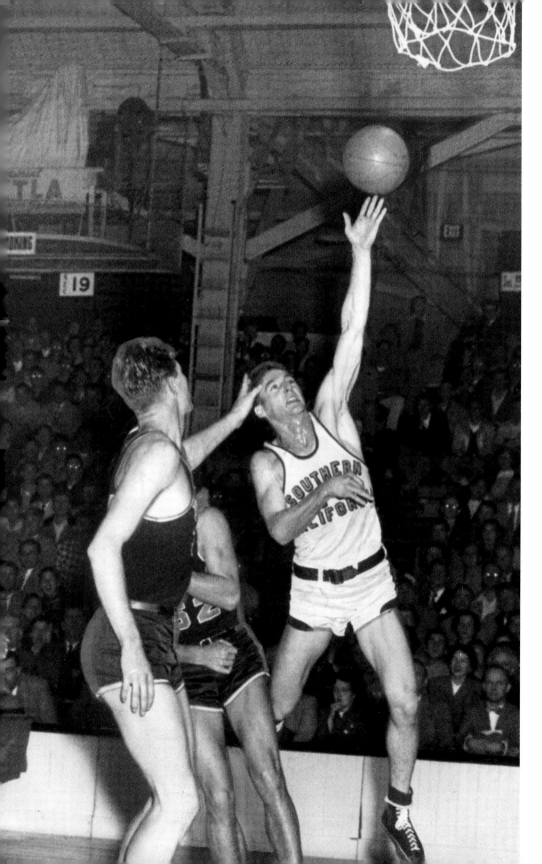

**Bill Sharman
Pan Pacific Auditorium
January 14, 1950**

USC's Bill Sharman drives past three UCLA opponents, exhibiting the type of moves that would later land him in the Basketball Hall of Fame (where he was honored as both a player and a coach). Sharman was also a star outfielder on the Trojans' first national championship baseball team. Drafted by the Brooklyn Dodgers, he decided instead to concentrate on basketball. Teamed in the backcourt with Bob Cousy, Sharman won four titles with the Boston Celtics. Later, he coached three championship teams in three different leagues, including the Lakers' first title in L.A. in 1972, when the team won a record thirty-three consecutive games.

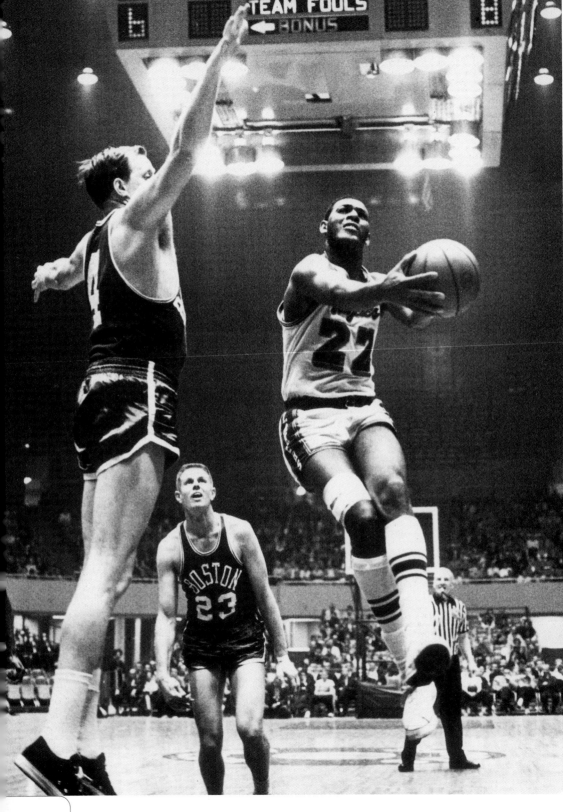

**Elgin Baylor, Sports Arena
January 5, 1963**

Elgin Baylor captivated fans
and bedeviled opponents with
power drives like this one;
hovering forever, he practically
invented "hang time."
Originally selected by the
Minneapolis Lakers, Baylor
moved west with the team in
1960 and was L.A.'s first pro
hoops superstar. He remained
an offensive force throughout
his career, but eventually was
slowed by knee injuries and
retired during the 1971–72
season. He went on to become
general manager of the
Clippers.

**Jerry West and Bob Cousy
Sports Arena
April 18, 1963**

No. 44 Jerry West attempts a
lay-up over the Celtics' Bob
Cousy. "Mr. Clutch" spent his
entire Hall of Fame playing
career with the Lakers (1960–
1974). After his retirement
and a short stint as coach,
he became the Lakers' general
manager and shaped teams
that won multiple champion-
ships. His image endures as
the silhouetted figure on the
NBA logo.

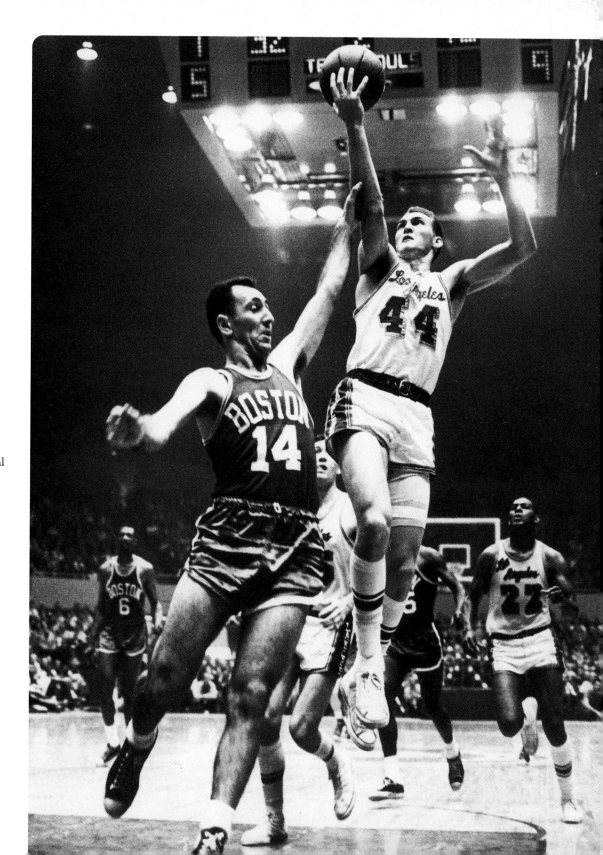

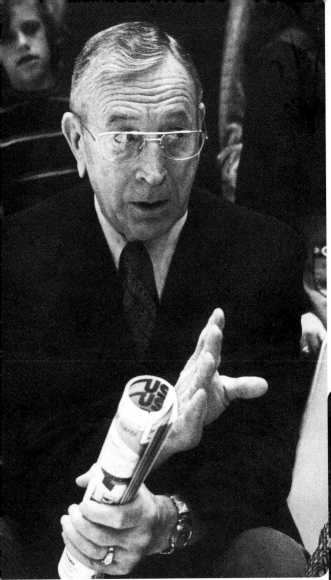

◀ John Wooden, Pauley Pavilion · circa 1972

With his trademark rolled-up program, John Wooden directs the UCLA Bruins.
His coaching milestones were considerable—seven consecutive NCAA titles,
a 149-2 record at Pauley Pavilion and four 30-0 seasons—but college basketball
fans revere the "Wizard of Westwood" for his teaching skills, fierce competitive-
ness and homespun philosophy. His "Pyramid of Success" articulated his belief
that fundamentals and teamwork will win the day. His highest salary during
his twenty-seven-year career (1948-1975) at UCLA? A whopping thirty-five
thousand dollars.

UCLA Basketball Team, San Diego · 1975 ▼

UCLA's basketball team celebrates its 92-85 win over the Kentucky Wildcats,
in the final game coached by John Wooden (front row, holding basketball).
The victory gave the Bruins their tenth NCAA title under Wooden. A three-time
All-American at Purdue University, Wooden is one of just three people to be
inducted into the basketball Hall of Fame as a coach and a player (along with
Bill Sharman and Lenny Wilkens).

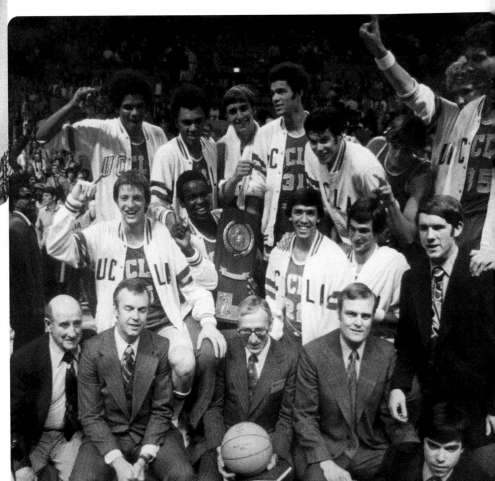

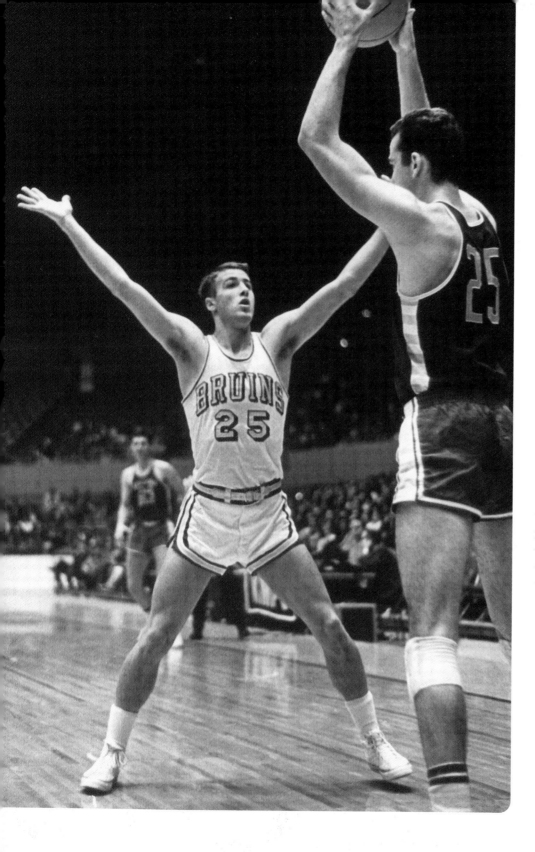

Gail Goodrich • December 12, 1964

Considered too small for college and too frail for the pros, six-foot-one Gail Goodrich proved everyone wrong— and even played some tenacious defense along the way. After leading Polytechnic High to the city title in 1961, at UCLA Goodrich helped Wooden earn his first two NCAA titles (1964, 1965). A southpaw with a sweet outside shot, he was the leading scorer on the Lakers' 1972 championship team. When L.A. traded Goodrich to the New Orleans Jazz toward the end of his career, he again proved useful: one of the draft picks the Lakers obtained in exchange for Goodrich was used to select Earvin "Magic" Johnson.

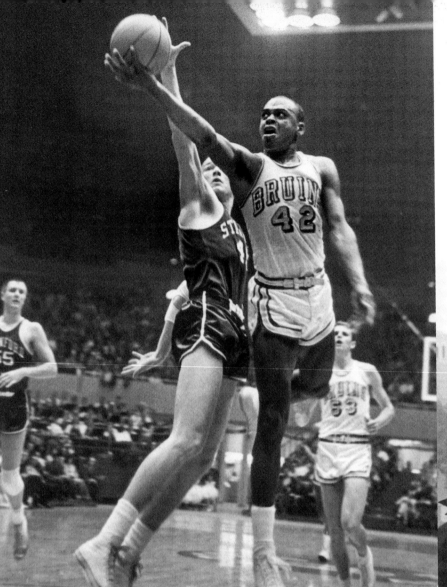

◀ Walt Hazzard • January 18, 1964

Walt Hazzard, going up and under versus Stanford. As a UCLA senior, Hazzard was the leading scorer on John Wooden's first undefeated (30-0), NCAA-winning team. No one on the roster stood taller than six-foot-five; the undersized squad won by employing a "Bruin Blitz" zone press that devastated opponents. Hazzard enjoyed a ten-year professional career (including three years with the Lakers) before becoming a head coach with UCLA.

Lew Alcindor, UCLA Campus • June 15, 1969 ▶

San Francisco had the Age of Aquarius; Westwood had the Age of Alcindor. In three varsity seasons at UCLA, from 1967 through 1969, Lewis Ferdinand Alcindor, Jr. (who changed his name to Kareem Abdul-Jabbar in 1971) led the Bruins to an 88–2 record and three national titles. Here, the school's only seven-foot-two history major attends graduation.

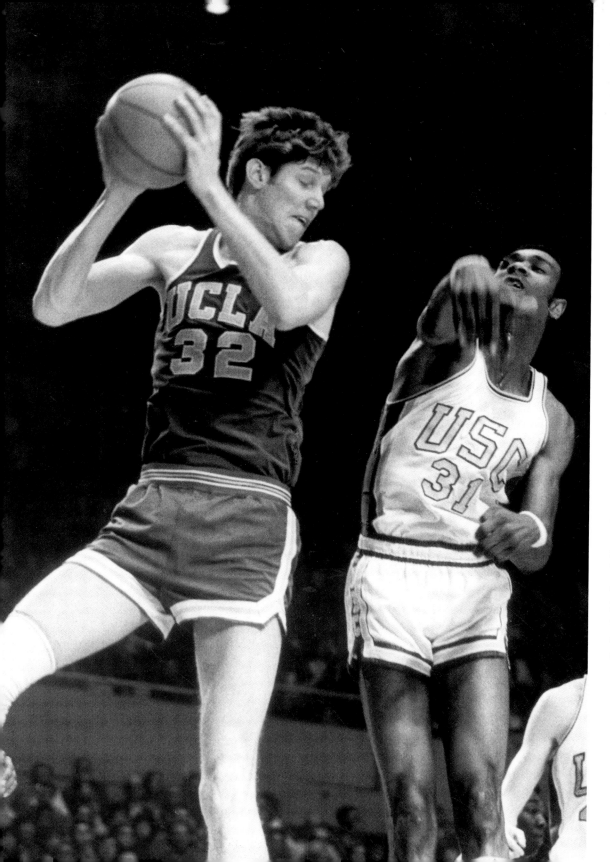

**Bill Walton and
Ron Riley
Sports Arena
March 11, 1972**
Bill Walton grabs a
rebound from USC's
Ron Riley. The big
redhead from
San Diego was an
integral part of the
Bruins' record
88-game winning
streak. His brilliant
performance during
the 1973 NCAA title
game—when he
converted twenty-one
of twenty-two shots
in the win over
Memphis State—
remains a collegiate
best. Injuries
curtailed his
professional career,
which included
several seasons
with the Clippers.

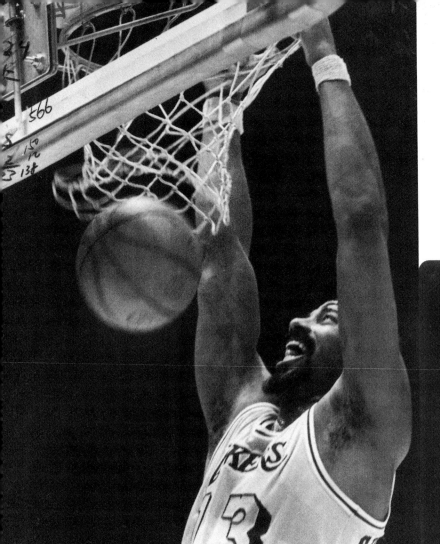

◄ Wilt Chamberlain, The Forum · 1971

Wilt Chamberlain slams one home. In 1968, Lakers owner Jack Kent Cooke obtained Chamberlain in a lopsided trade with the Philadelphia 76ers. The first of L.A.'s dominant centers, Chamberlain ended a decade of heartbreak in 1972 by leading the Lakers to their first NBA title. A high school track star who later became an avid beach volleyball player, Chamberlain was, as the *Herald Examiner*'s Mel Durslag put it, "the Matterhorn with muscles." He died in 1999.

Wilt Chamberlain and Kareem Abdul-Jabbar, The Forum ► circa 1971

Wilt Chamberlain and the Lakers meet Kareem Abdul-Jabbar and the Milwaukee Bucks. In 1975, two years after Chamberlain retired, the Lakers traded for Abdul-Jabbar and his deadly accurate sky hook. He played fourteen seasons with the Lakers, helped them win five NBA titles and retired as the NBA's all-time leading scorer.

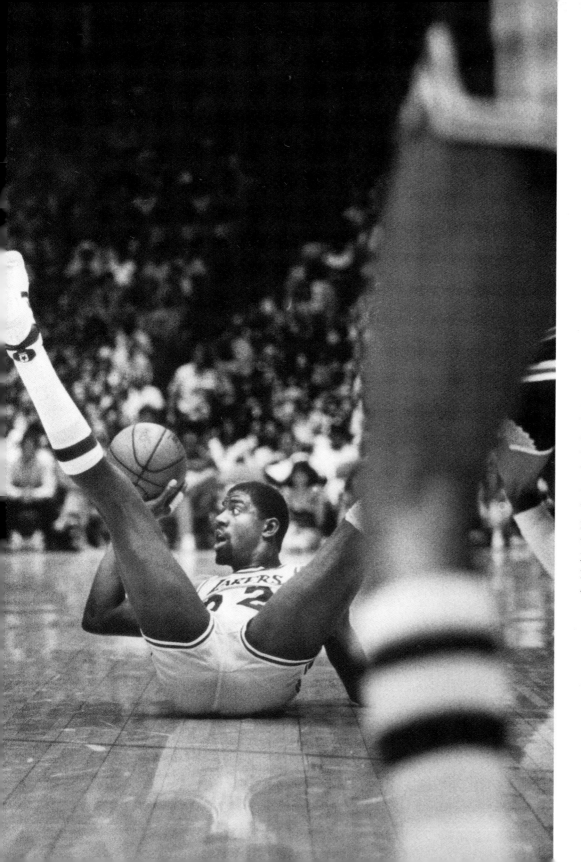

**Earvin "Magic" Johnson
The Forum
1984**
Earvin "Magic" Johnson
makes another ho-hum,
routine pass. When Johnson
arrived in Los Angeles in
1979, he had won at every
level: his high school team
took the state championship
and his Michigan State
team took the NCAA title.
With his irrepressible grin
and no-look passes, he
transformed the Lakers into
perennial winners: L.A.
took five NBA crowns with
Johnson at point guard.
He retired in 1991 after he
was diagnosed with HIV.

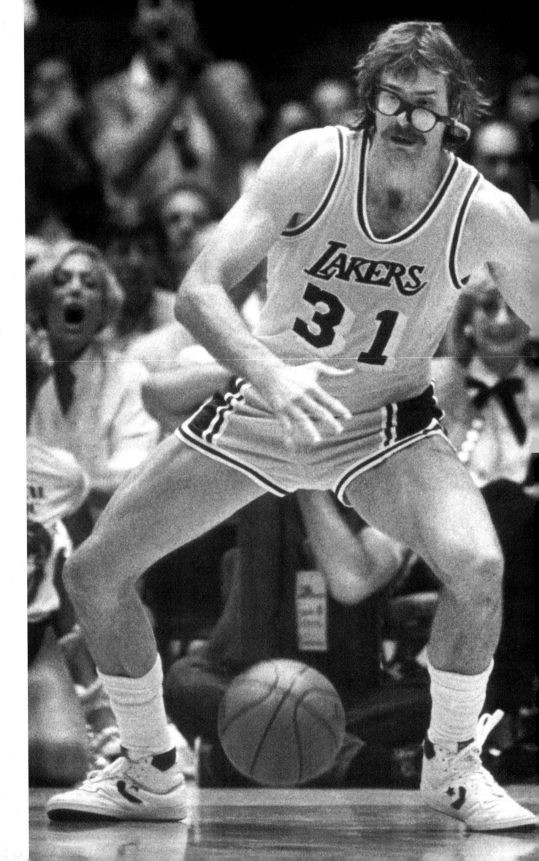

▶ **Kurt Rambis · June 9, 1985**
With Earvin "Magic" Johnson and
Kareem Abdul-Jabbar leading the
way, the 1980s Lakers teams became
a running-gunning, entertaining
juggernaut. Under owner Jerry Buss,
the "Showtime" Lakers won five
NBA titles and turned L.A. (and
The Forum) into purple-and-gold
nation. The teams included power
forward Kurt Rambis (shown during
the 1985 NBA Finals) and silky
smooth forward James Worthy, here
challenging Kevin McHale of the
Boston Celtics during the 1984
NBA Finals.
**James Worthy, The Forum
June 11, 1984 ▶▶**

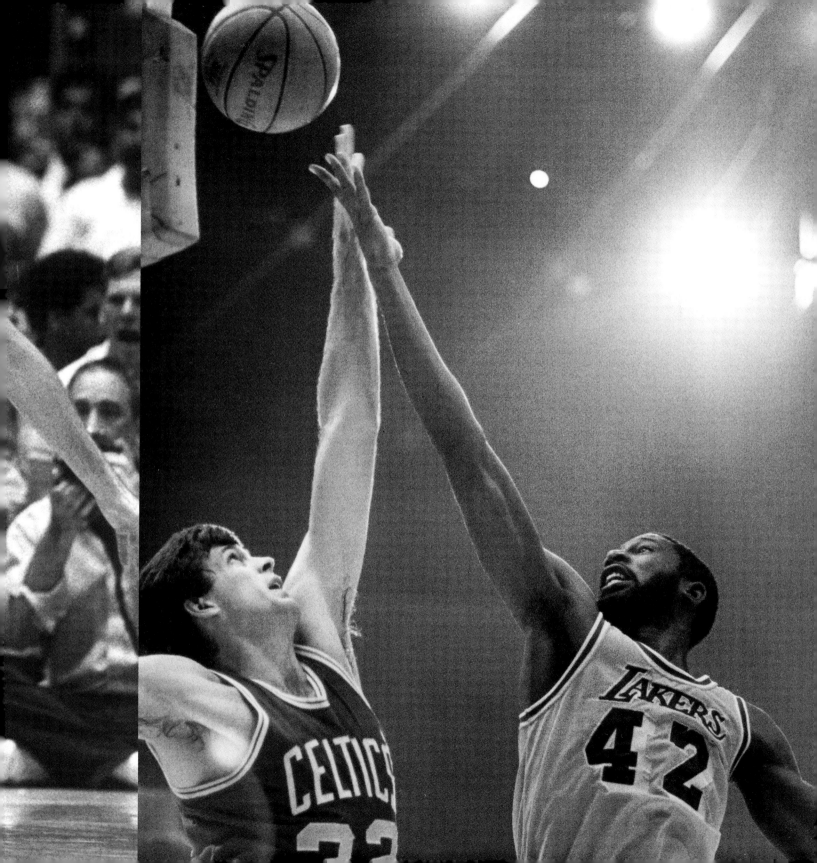

Chick and Marge Hearn, The Forum · March 21, 1981

Francis "Chick" Hearn, here acknowledging Laker fans at The Forum, became the team's play-by-play broadcaster when the Lakers moved from Minneapolis to L.A. in 1960. From 1965 to 2001, he called a record 3,338 consecutive games, his "word's eye view" and rapid-fire cadence thrilling radio listeners and TV viewers alike. He was renowned for his Chick-isms: he created or popularized such expressions as "slam dunk" and "no harm, no foul." And when he was certain that the Lakers had clinched the contest, he uttered the memorable phrase: "You can put this one in the refrigerator. The door's closed, the light's out, the eggs are cooling, the butter's getting hard and the Jell-O is jiggling." He died in 2002.

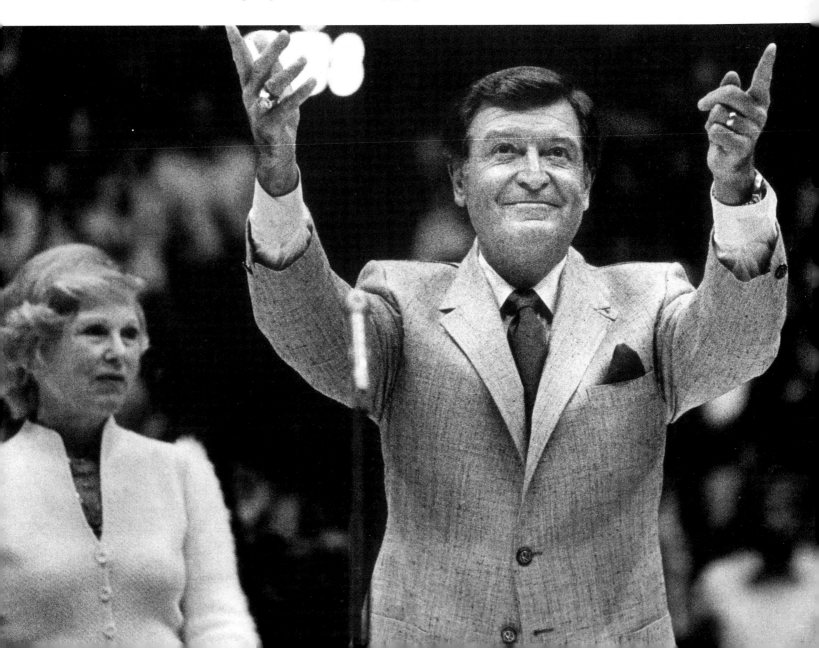

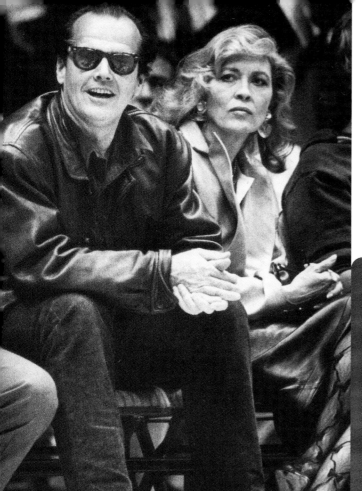

Jack Nicholson and Faye Dunaway, The Forum · 1985
The Lakers' most passionate fan sits in his usual courtside seat,
accompanied by his *Chinatown* co-star. Nicholson first purchased
season tickets in the 1960s, along with music producer Lou Adler,
and has used basketball in two films. In 1971, he directed *Drive,
He Said,* a film about a rebellious college basketball player that has
become a cult favorite. In *One Flew Over the Cuckoo's Nest,* for
which he won the Academy Award for best actor in 1975, he played
the game with insane-asylum patients in a brief, but memorable, scene.

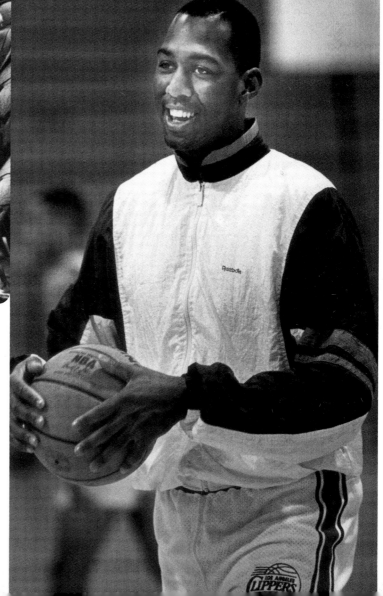

Danny Manning, Pomona · October 7, 1989
Danny Manning in a light moment during warmups.
After Manning led the University of Kansas to the
NCAA title in 1988, the Clippers picked him first in
the NBA draft. He was expected to bring glory to the
franchise, which had moved from San Diego to L.A.
in 1984, but he suffered a devastating knee injury
during his rookie year. While Manning helped the
team make the playoffs, the Clippers never escaped
the shadow of the Lakers.

Basketball

**Cheryl Miller, Riverside
February 9, 1981**

Cheryl Miller, as a senior at Riverside Polytechnic High School, where she once scored 105 points in a game. Credited with popularizing and elevating women's basketball, the 6-foot-2 Miller was a four-time All American in high school and college. At USC, she led the Trojans to two NCAA titles, then helped the U.S. to a gold medal at the 1984 Los Angeles Olympics.

◀ **Ann Meyers • March 26, 1978**

Ann Meyers, after practice at UCLA. The first high school student to make the U.S. National team, the 5-foot-9 Meyers also was the first woman to earn a full athletic scholarship to UCLA. In her final game, she guided the Bruins to their first-ever national title. She also played on the first U.S. Olympic women's basketball team (1976), and was the first women to sign a free-agent contract with an NBA team (the Indiana Pacers). Later, after marrying Dodgers' pitcher Don Drysdale, the two formed the first Hall of Fame couple.

Lisa Leslie, Inglewood • January 5, 1989 ▶

Lisa Leslie practices at Morningside High School. In 1990, Leslie made national headlines during her senior year when she scored 101 points in the first half of a game. She might have broken the record—held by Cheryl Miller—but the opposing team elected not to play the second half. Leslie went on to star at USC and then for the L.A. Sparks, where she became the first WNBA player to dunk in a game.

▼ Hank Gathers and Bo Kimble, USC · April 29, 1986

High school buddies from Philadelphia, Hank Gathers, left, and Bo Kimble originally played for USC. After both transferred to Loyola Marymount University, they flourished under former Lakers coach Paul Westhead's high-scoring system. In 1988-89, Gathers was the nation's leading scorer and rebounder and considered a lock for the NBA. The next season, as Gathers was running upcourt after dunking during a West Coast Conference tournament game, he collapsed and died from heart failure. Kimble led LMU to three wins in the NCAA tourney before the Lions lost to eventual national champ UNLV. Kimble honored the memory of the southpaw Gathers by shooting free throws with his left hand.

▲ Raymond Lewis, Long Beach · March 28, 1985

Schoolyard legend Raymond Lewis shooting hoops at a Long Beach playground, with some serious competition. An all-league guard at Verbum Dei High School, he starred at Cal State L.A. for two years before being drafted by the Philadelphia 76ers in 1973. Despite his jaw-dropping, long-distance shooting range, Lewis never played in the NBA, due to an unfortunate combination of contract disputes, bad advice and hard living. He died in 2001.

Boxing

For years, boxing ranked among the top spectator sports in L.A. because every ranked fighter—from Joe Rivers to Jack Dempsey to Jimmy McLarnin to Henry Armstrong to Archie Moore to Muhammad Ali to Julio Cesar Chavez—fought or sparred here. Boxing's popularity may have faded, but the "sweet science" continues to fascinate its loyal fans.

James Jeffries • 1923

At age seven, James Jeffries moved with his family to Los Angeles. He fought often at Hazard's Pavilion, one of L.A.'s first sports venues and, in 1899, won the heavyweight championship by defeating Bob Fitzsimmons. He retired undefeated in 1904 but was lured back to the ring six years later, in part by racist backers who wanted him to defeat Jack Johnson, the first black heavyweight champ. The original "Great White Hope" proved to be no match for the younger, more powerful Johnson, who delighted in knocking out Jeffries in the fifteenth round. Jeffries then retired permanently and lived out his days in Burbank.

60

Play by Play

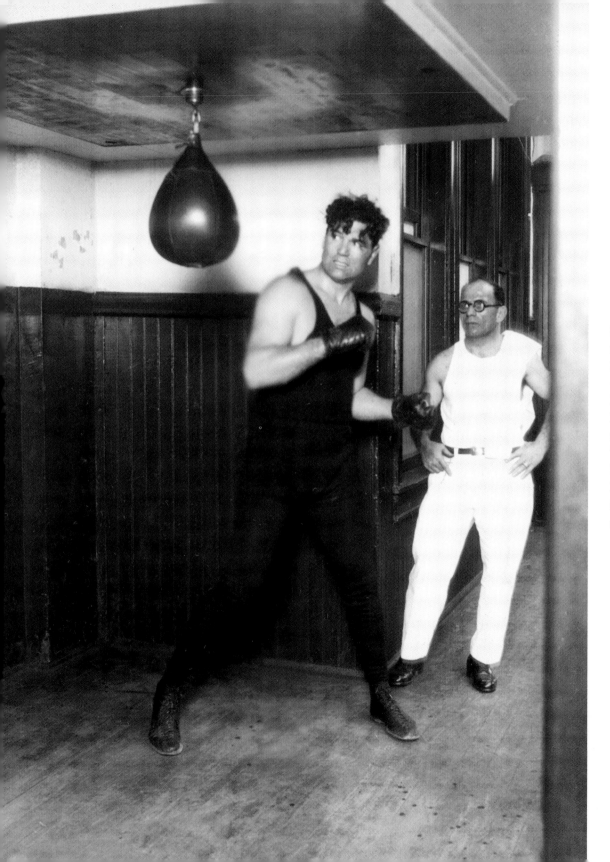

**Jack Dempsey
circa 1924**

Jack Dempsey punches
the speed bag at a
local gym. After the
heavyweight champ
married film star Estelle
Taylor, he moved to
L.A. and went native:
he had his broken nose
fixed and appeared in
several films.

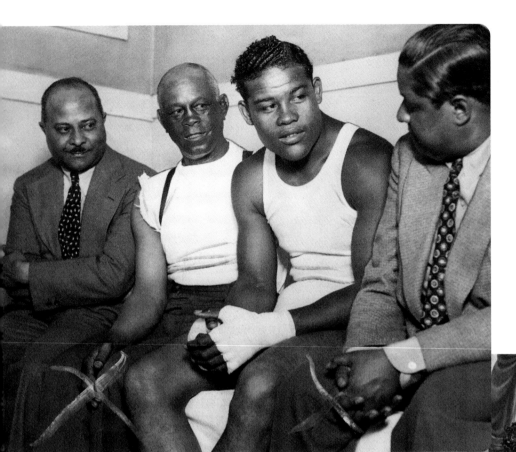

◀ Joe Louis, Main Street Gym
April 10, 1939

Joe Louis talks with his handlers (from left, co-manager John Roxborough, trainer Jack Blackburn and co-manager Julian Black) after a training session at the Main Street Gym. The champ looks relaxed—and with good reason. A week later, in L.A.'s first heavy-weight championship fight of the modern era, Louis knocked out journeyman Jack Roper in the first round at Wrigley Field. As the successor to the Spring Street Newsboys' Gym, the downtown Main Street Gym became the West Coast's premier training gym. Frequented by the world's top fighters, from Louis to Muhammad Ali, it also doubled as the set for the *Rocky* films.

Henry Armstrong and Willie Joyce, Gilmore Stadium ▶
July 24, 1943

Henry Armstrong, right, and Willie Joyce weigh in before their fight at Gilmore Stadium. In the late 1930s, at a time when boxing had only eight weight classes, "Hammerin' Hank" simultaneously held three world titles (in the featherweight, welterweight and lightweight divisions). Later, managed by actor Al Jolson, Armstrong turned Hollywood and starred in "race films" aimed at black audiences. After his retirement, he became an ordained minister. His ring record: 151–21–9, with 101 knockouts. He died in 1988.

"Sugar" Ray Robinson and Carl "Bobo" Olson, Wrigley Field · May 18, 1956

Walker Smith, better known as "Sugar" Ray Robinson, winds up the left hook that knocks out Carl "Bobo" Olson in the fourth round of their middleweight championship fight at Wrigley Field. Acclaimed as the best pound-for-pound fighter, Robinson won the middleweight title on five different occasions. After his retirement, he settled in Los Angeles to run the Ray Robinson Youth Foundation. He died in 1989.

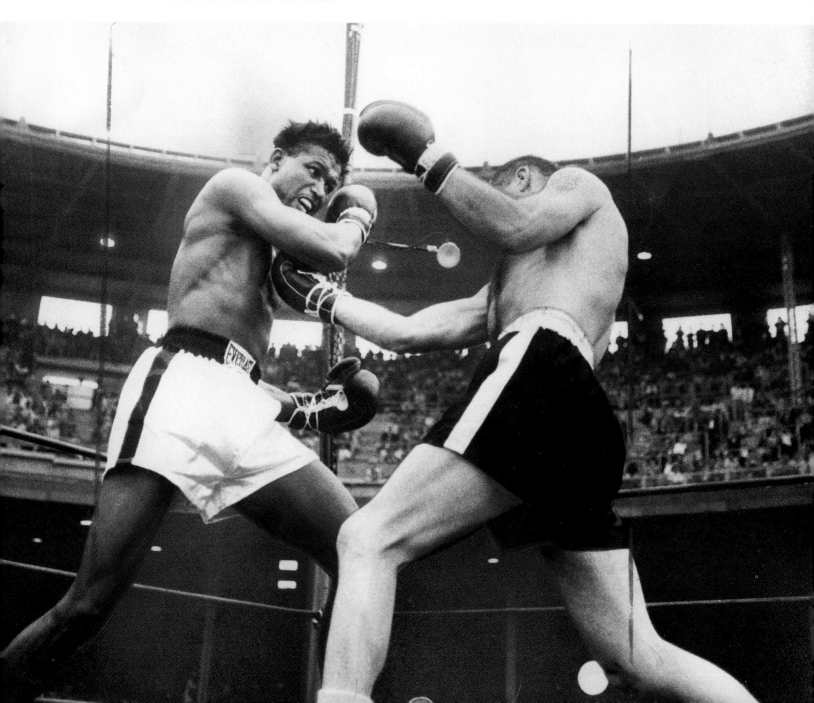

◄ Art Aragon • February 2, 1958

Art Aragon poses after a workout. Aragon was L.A.'s original "Golden Boy," long before Oscar De La Hoya was given the moniker. A graduate of Roosevelt High, Aragon never became a champion, but he drew huge crowds because of his excellent fighting skills and because controversy always seemed to find him. He was accused of fixing fights, his messy divorces were aired in public and his quick-to-the-punch one-liners were fodder for journalists. When asked about his retirement plans, he quipped: "I'm going to open a big liquor store, play lots of golf, insure myself for plenty and get held up twice a year."

▼ Cassius Clay and Alejandro Lavorante, Sports Arena • July 20, 1962

Argentine heavyweight Alejandro Lavorante looks at the scale as Cassius Clay weighs in before their fight. "Lavorante will fall in five," proclaimed the twenty-year-old Clay, nicknamed "The Mouth." That night, Clay knocked out Lavorante with a left hook in—of course—the fifth round. Later that year, Lavorante fought John Riggins at the Olympic Auditorium. Knocked out in the sixth round, Lavorante slipped into a coma and died.

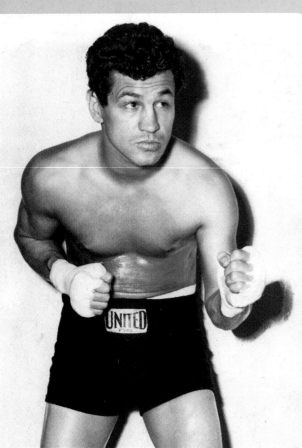

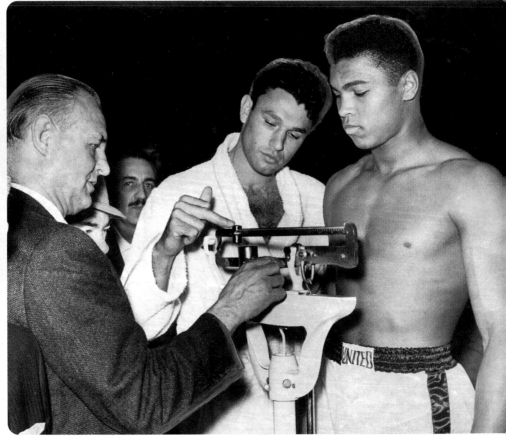

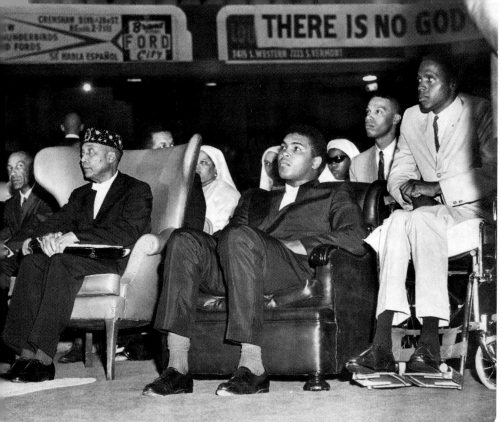

◀ **Elijah Muhammad and Muhammad Ali**
Olympic Auditorium
August 9, 1964

After defeating Sonny Liston to become the heavyweight championship of the world, Cassius Clay announced that he had joined the Nation of Islam. He also changed his name; he was forever to be known as Muhammad Ali. Here, on stage at the Olympic Auditorium, Ali, center, sits next to Nation of Islam leader Elijah Muhammad.

Jerry and Kathy Quarry, Olympic Auditorium ▶
July 17, 1965

After beating Willie Davis for his fifth professional win, Jerry Quarry kisses his wife Kathy. From the mid-1960s through the early 1970s, the "Bellflower Bomber" and his brawling brothers, Mike and Bobby, were top local drawing-cards. The undersized Quarry fought the best heavyweights of his day, including Muhammad Ali, Joe Frazier and George Foreman, but he never won the title. After he retired, he suffered from *dementia pugilistica*—severe brain damage from repeated blows to the head—testament to the physical dangers of boxing. He died in 1999.

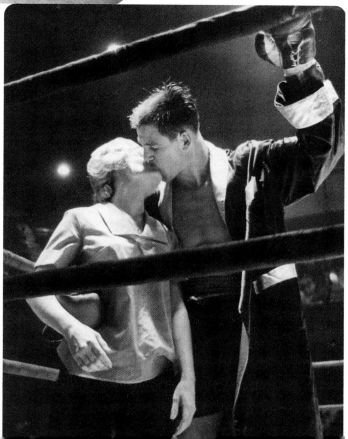

Boxing

Bobby Chacon and Rafael "Bazooka" Limon ▶
The Forum • March 22, 1980

Pacoima's Bobby Chacon, left, never ducked a punch.
One of the gutsiest Mexican American champs, the junior
lightweight fought the best—including Danny "Little Red"
Lopez, Ruben Olivares and Alexis Arguello. Chacon is
pictured in the third of an epic four-fight set with Rafael
"Bazooka" Limon, a series remembered as one of the
great brawls in boxing history. Like Quarry, Chacon
absorbed much punishment in the ring and suffers
from brain damage.

Canto Robledo, The Forum • July 11, 1978

Trainer Canto Robledo, left, gives instructions to one
of his fighters between rounds at The Forum. Raised in
Pasadena, Robledo won the Pacific Coast bantamweight
crown in the early 1930s. The cost was severe: he suffered
eye injuries and lost his sight. Robledo never abandoned
the sport he loved; he built a gym in the backyard of his
home and trained fighters by what he called his sense
of touch. He died in 1999.

▼ **Francisco "Kiko" Bejines, Olympic Auditorium**
September 1, 1983

Francisco "Kiko" Bejines is carried out on a stretcher
after being knocked out by Pomona's Albert Davila
during their bantamweight championship fight. Days later,
the twenty-year-old Bejines passed away.

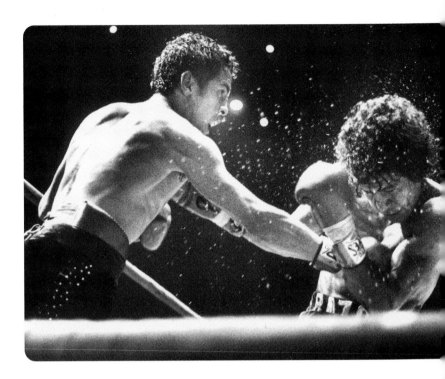

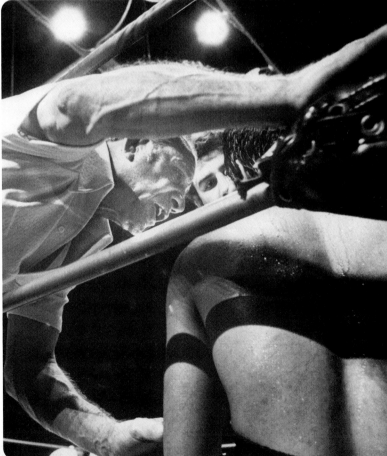

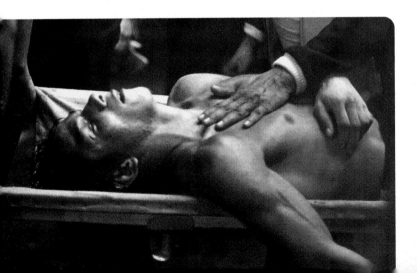

Aileen Eaton and Boxers • July 24, 1977

Aileen Eaton celebrates her birthday with three champs: from left, Carlos Palomino, Danny "Little Red" Lopez and Richie Sandoval. In the early 1940s, the Los Angeles Athletic Club asked Eaton (then Aileen LeBell) to figure out why the Olympic Auditorium was unprofitable. Her solution: hire Cal Eaton as the promoter. Six years later, after the two had married, Aileen took on management chores. With significant help from match makers Babe McCoy, George Parnassus, Mickey Davies and Don Chargin, she instituted Tuesday Night Fights and promoted the likes of boxers Jimmy Carter, Archie Moore and Mando Ramos. "I have never met a boxer who was a cad," she once said," but I've met plenty of stockbrokers who were." She died in 1987.

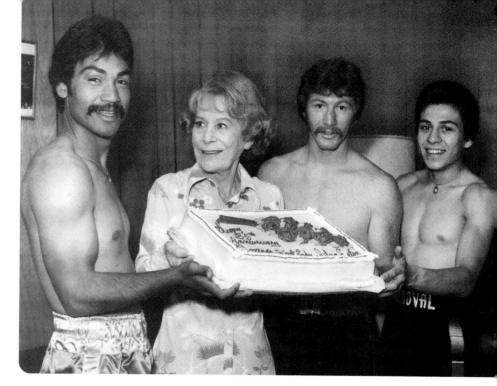

Lilly Rodriguez • February 20, 1980

Lilly Rodriguez poses in the gym. Fighting is in Rodriguez's blood: her brother is kick-boxing legend Benny "The Jet" Urquidez. In the 1970s and 1980s, as more women began to lace up the gloves, Rodriguez led the way. The pioneer featherweight fought on the first all-women card in California.

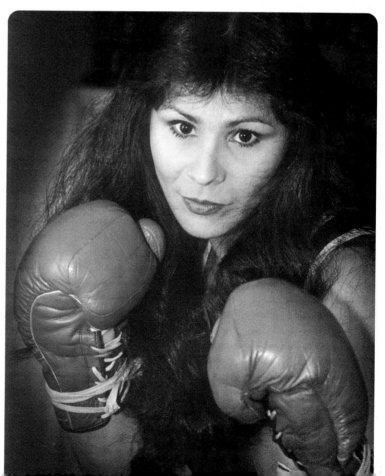

Fitness

From Muscle Beach to Gold's Gym to aerobics, southern California is considered the birthplace and the capital of the modern-day fitness movement.

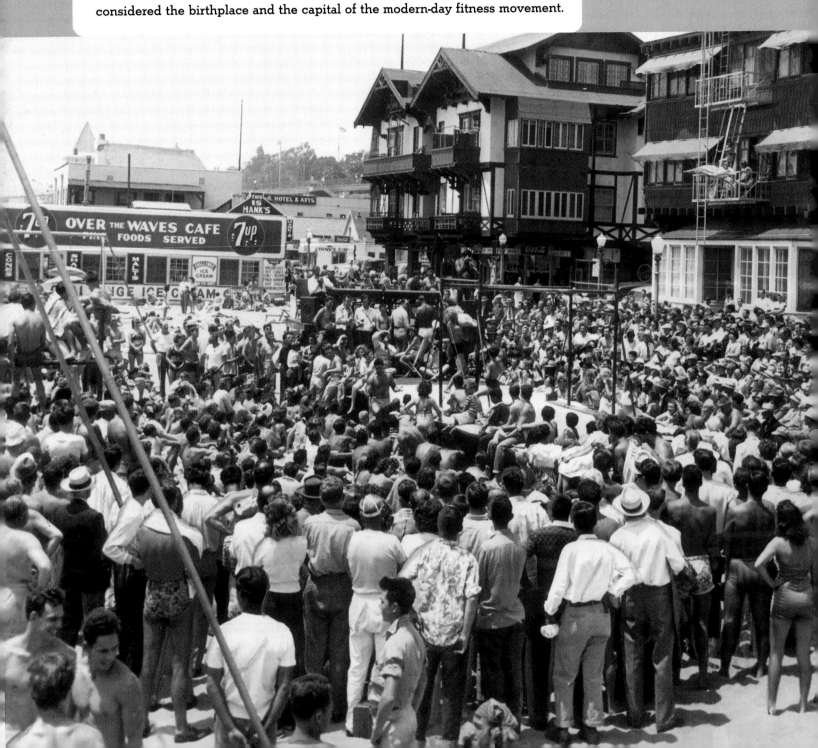

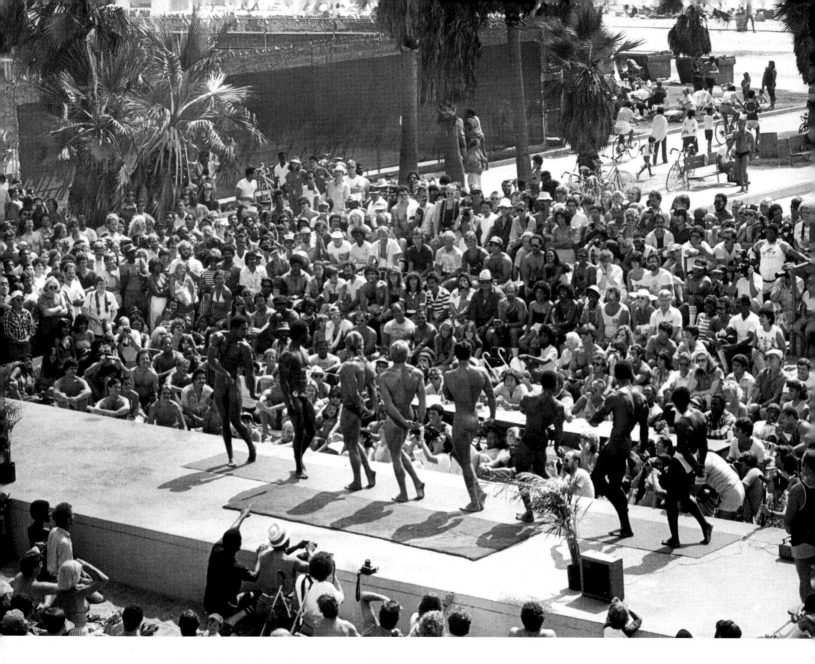

◀ **Muscle Beach, Santa Monica • circa 1950s**

▲ **Muscle Beach, Venice • 1981**

The original Muscle Beach was located south of the Santa Monica Pier, where a wooden
performance platform was constructed by the Works Progress Administration in the late 1930s.
There, the body was celebrated in its athletic glory as young men (and more than a few young
women) showed off their physical prowess by performing acrobatic and gymnastic feats.

The first Muscle Beach was bulldozed by the City of Santa Monica after a 1955 sex scandal;
a present-day incarnation is now located at Venice Beach, the site of this body-building contest.

Fitness

Pudgy Stockton
Santa Monica
December 10, 1949

When Abbye Eville
wanted to shed some
pounds, her then-
boyfriend Les Stockton
encouraged her to lift
weights at Santa Monica's
Muscle Beach. The
"Queen of the Barbelles"
soon was the poster girl
of fitness, and as one wag
put it, her nickname,
"Pudgy," became "a
libel." In the 1940s, she
organized the first all-
female weightlifting
contest and opened the
first all-women gym in the
United States. She and
Les, by then her husband,
later popularized working
out on the Fourth Street
stairs in Santa Monica.

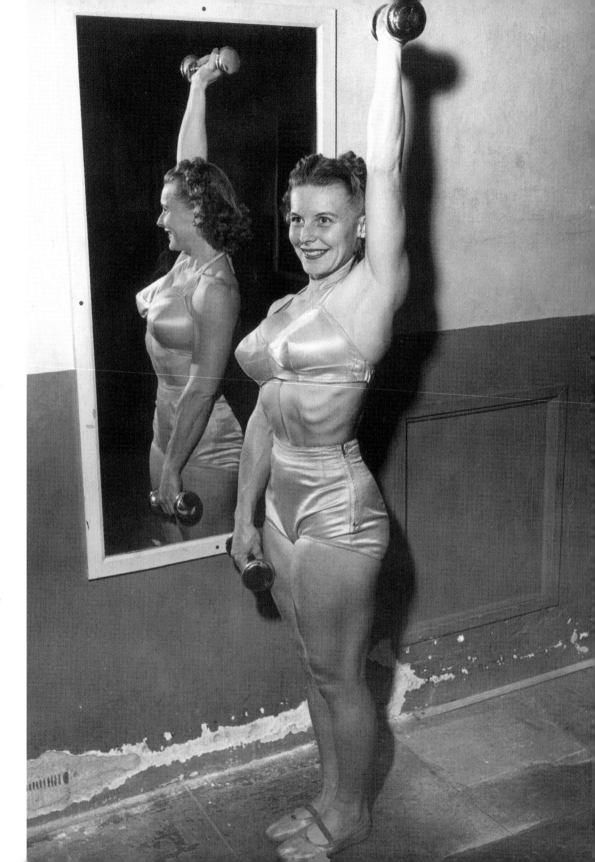

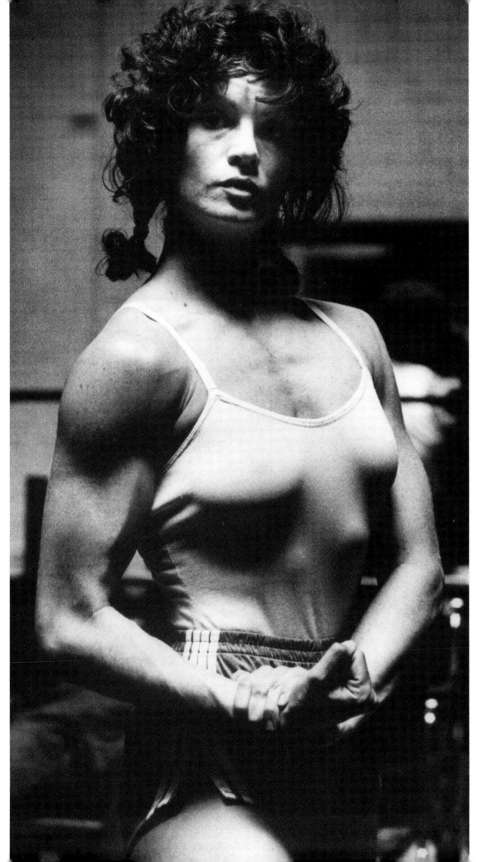

**Lisa Lyon, Venice
August 2, 1979**

Lisa Lyon strikes a pose around the time she won the first women's professional bodybuilding contest in the modern era. Born in L.A. and a UCLA graduate, Lyon struck a balance between well-defined muscularity and feminine grace. Later Lyon became a favorite subject of photographer Robert Mapplethorpe.

Jane Fonda • December 13, 1981

For her role in the film *California Suite* (1978), Jane Fonda decided she needed to tone her body. She took exercise classes at Gilda Marx's studio in Century City and became a convert to Marx's "aerobic exercise" techniques. In the early 1980s, Fonda parlayed her movie-star fame into the popularity of *Jane Fonda's Workout*, a best-selling book and video, as well as her own exercise studio in Beverly Hills, where dressing in Spandex for working out led to a street-wear trend.

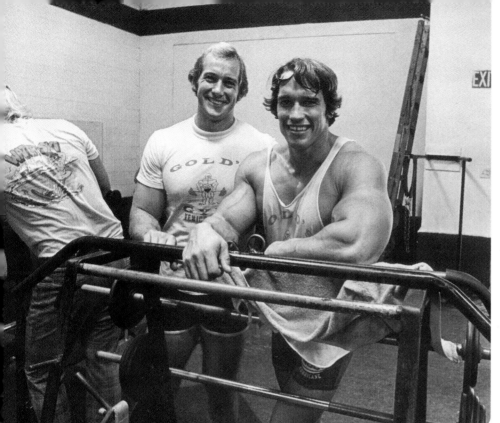

◀ **Arnold Schwarzenegger**
Gold's Gym in Venice · circa 1975
The thirty-eighth governor of California, right (with Ken Sprague), takes a breather during a workout at Joe Gold's original gym in Venice. Backed by Woodland Hills-based publishing mogul Joe Weider, Arnold Schwarzenegger appeared on numerous magazine covers and won seven Mr. Olympia bodybuilding titles. He wasn't the first muscle man to become a movie star; his idol, Steve Reeves, was featured in numerous "sword-and-sandal" epics produced in Italy. But after showing off his amazing physique in the acclaimed documentary *Pumping Iron* (1977), Schwarzenegger soon became the world's most bankable action-hero star.

Bodybuilder · circa 1988 ▶
Backstage at a local contest. In the decade before this photo was taken, steroids began to permeate the bodybuilding world. These and other illicit drugs enabled bodybuilders to hone and enlarge their physiques to super-human size. As the medical dangers of such substances became apparent, some athletes eschewed steroids and returned to building their bodies the old-fashioned way—through proper diet and pumping iron.

Fitness

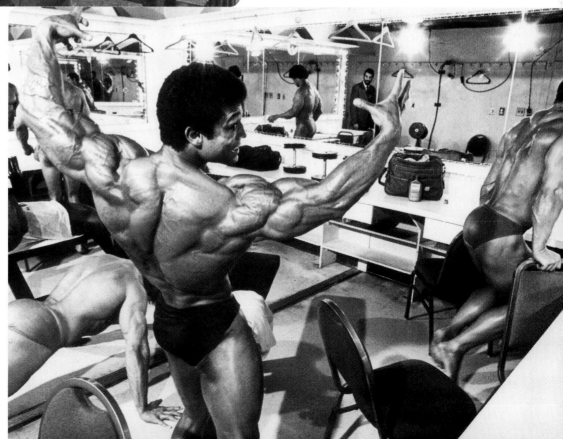

Football

For the first half of the twentieth century, college and high school football teams ruled the local scene, with USC the dominant squad and the annual Rose Bowl the most significant game. In the second half of the century, the NFL staked its claim: the Cleveland Rams moved west, the Oakland Raiders moved south, and southern California hosted numerous Super Bowl games. Only in the 1990s, when the Rams and the Raiders abandoned the region, did the balance shift again.

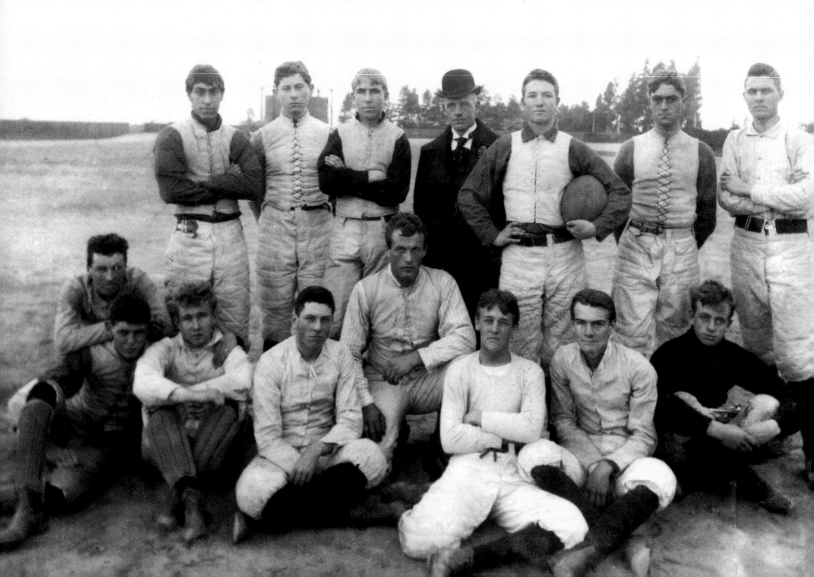

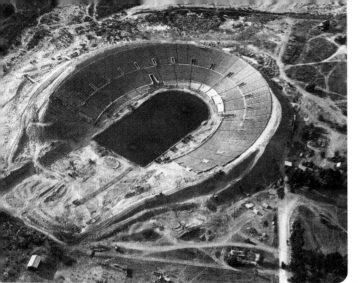

The Rose Bowl, Pasadena · circa 1927

The first New Year's Day football game in conjunction with Pasadena's Tournament of Roses was played on January 1, 1902, as Michigan defeated Stanford 49–0. After a thirteen-year hiatus without football—the sport was replaced by chariot races during those years—the series resumed in 1916. The early games were played at Pasadena's Tournament Park; in 1920, when it became apparent that the crowds had become too vast for the Park, architect Myron Hunt drew up plans for a new stadium in the Arroyo Seco. On January 1, 1923, USC beat Penn State, 14–3, in the first New Year's Day game at the Rose Bowl. The original stadium seated 57,000 spectators; it has been enlarged several times, with the south end filled in in 1928. The Rose Bowl hosted Olympic events in 1932 (cycling) and 1984 (soccer).

◀ **Los Angeles High Football Team · 1894**

As the oldest high school in southern California, Los Angeles High fielded one of the first football squads in the area. (They even played USC and other local colleges.) Here, the Romans pose for their team photo.

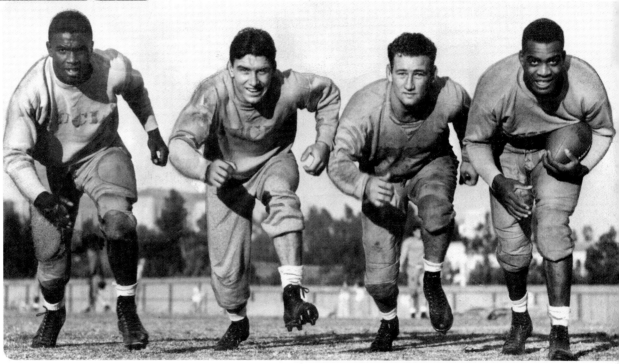

▲ **UCLA Backfield, Westwood · circa 1940**

Jackie Robinson poses with teammates at UCLA: from left, Ned Mathews, Bill Overlin and Kenny Washington. When Robinson came to UCLA, he teamed with Lincoln High's Washington to form what *Herald Examiner* columnist Mel Durslag called "the best backfield twosome of that era." When the Cleveland Rams moved to L.A. in 1946, the team signed Washington and another UCLA player, Woody Strode, thus breaking the color barrier in the modern era of the NFL. The next year, Robinson made his first appearance with the Brooklyn Dodgers.

USC vs. UCLA Rivalry

The Trojans played their first football game in 1888, and the Bruins played theirs in 1919. The two teams first competed against each other in 1929, with USC winning 76-0. After suspending the series for five years because of the Trojans superiority, the two clashed again in 1936. Although USC has maintained a significant lead over the decades, the rivalry between USC and UCLA remains one of the country's most intense.

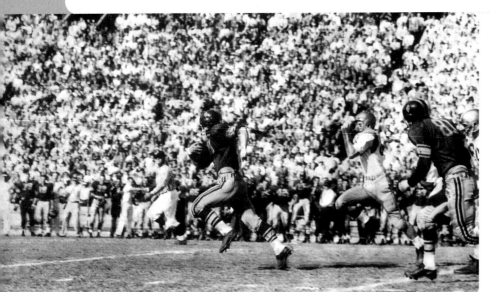

Jon Arnett, Los Angeles Memorial Coliseum
November 19, 1955

Jon Arnett breaks loose against UCLA, but the run was called back on a penalty. The Bruins led the entire game, winning 17–7. After Arnett's All-American career at USC, the Rams selected "Jaguar Jon" with the second pick of the first round of the 1957 draft. A Manual Arts High grad, Arnett had a superb professional career, making five All-Pro teams, but by selecting Arnett, the Rams passed on eight future Hall of Famers, including running back Jim Brown, quarterbacks Len Dawson and Sonny Jurgenson, and receiver Don Maynard.

Marcus Allen, Los Angeles Memorial Coliseum ▶
November 22, 1981

Though a Bruin defender upends Marcus Allen in this photograph, the running back gained 219 yards that day, and the Trojans blocked a last-second field goal attempt to win the game, 22–21. In 1981, after rushing for a record 2,342 yards, Allen became the fifth Trojan running back to win the Heisman Trophy, following Mike Garrett, O.J. Simpson, Anthony Davis and Charles White. Later, Allen started his Hall of Fame NFL career with the Raiders, leading them to their only Super Bowl win while they were based in L.A.

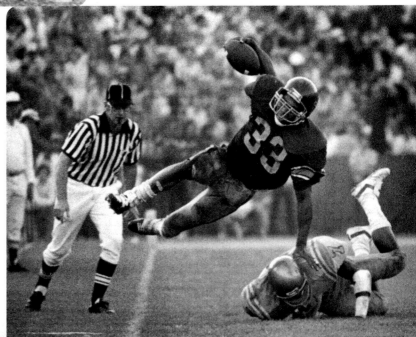

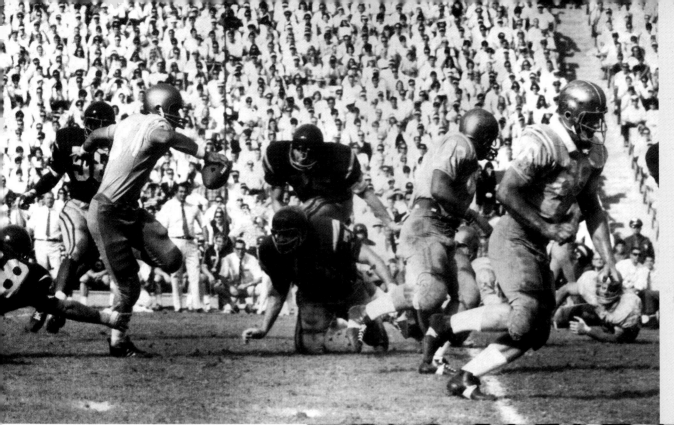

▲ **Gary Beban**
▶ **O.J. Simpson**
Los Angeles Memorial Coliseum
November 18, 1967

When USC met UCLA in 1967, UCLA's
team was undefeated and ranked first
in the nation. Ranked fourth, USC had
suffered only one loss. Early in the fourth
quarter, as UCLA quarterback Gary
Beban scrambled for a first down, the
Bruins took a 20–14 lead. But on a third-
and-eight play late in the fourth quarter,
USC's O.J. Simpson broke loose on a
sixty-four-yard touchdown run for the
Trojans' come-from-behind 21–20 win.
Afterwards, USC fans raced onto the
field to lift Simpson aloft. Beban won
a major consolation prize: he beat out
Simpson for the Heisman Trophy.

Football

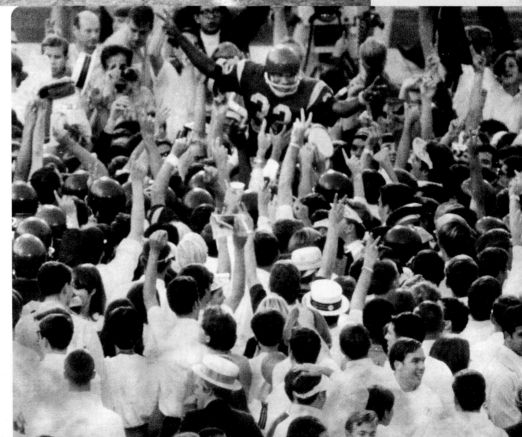

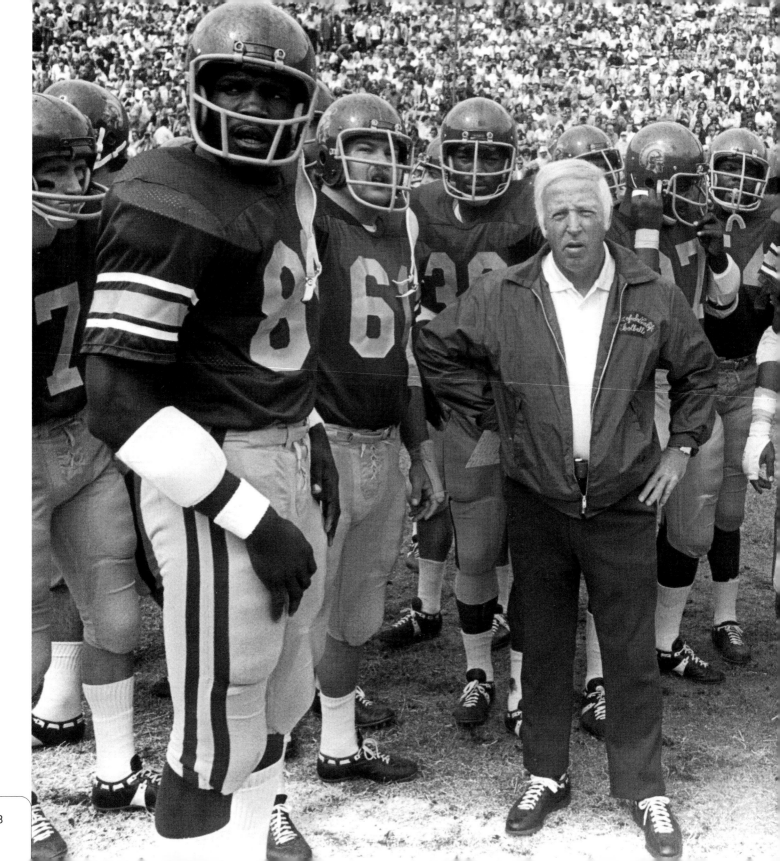

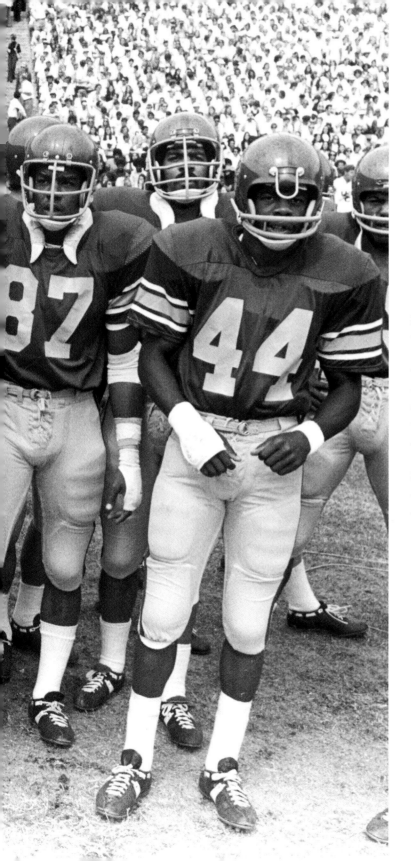

**John McKay and USC Team, Los Angeles Memorial Coliseum
October 2, 1972**

In sixteen years as head coach, John McKay won four national
titles and five Rose Bowls, compiled a 127-40-8 record and
coached two Heisman Trophy winners. He also had a sly sense
of humor: "I'll never be hung in effigy," he once said. "Before
every season I send my men out to buy all the rope in Los
Angeles." Here, the "Silver Fox" stands with his undefeated
1972 squad (including, far right, #87 Ed Powell and #44
Manfred Moore) considered one of the greatest teams in school—
and college football—history. The team's unofficial mascot?
A stray mutt that McKay and the players adopted and nicknamed
"Turd." McKay died in 2001.

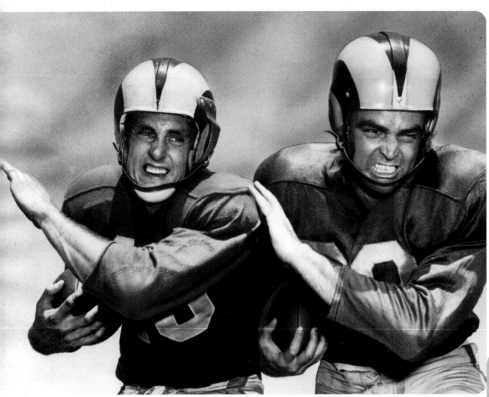

Elroy "Crazy Legs" Hirsch and Tom Fears
August 21, 1952

Hall of Fame receivers Elroy "Crazy Legs" Hirsch, left, and Tom Fears joke around for a team publicity photo. The Rams won division titles in 1949 and 1950 before capturing the NFL championship in 1951. Hirsch later played himself in the film *Crazylegs* (1953) and served as the Rams general manager. A Manual Arts High and UCLA standout, Fears caught the game-winning, seventy-three-yard touchdown pass in the 1951 title game at the L.A. Memorial Coliseum—the Rams' first and only title during their L.A.-Anaheim stint (1946–1994). Fears later became the first Hispanic American head coach in the NFL and the first Hispanic American to be elected to professional football's Hall of Fame. Fears died in 2000; Hirsch died in 2004. Note the players' head gear: the Rams were the first professional team with a helmet insignia.

The "Fearsome Foursome," Fullerton · 1967 ▶

In 1963, the Rams traded for Rosey Grier, giving them a front quartet of, from left, Lamar Lundy, Grier, Merlin Olsen and David "Deacon" Jones. One of the NFL's most storied defensive lines, the so-called "Fearsome Foursome" played together for four seasons. Nicknamed the "Secretary of Defense," Jones head-slapped his way into opposing teams' backfields and popularized the phrase "sacking the quarterback." After his Hall of Fame career, Olsen starred in the long-running TV series *Little House on the Prairie*. Grier would figure importantly in another L.A. story. As Robert F. Kennedy's bodyguard during the 1968 race for the Democratic Party's presidential nomination, Grier helped subdue Kennedy's assassin, Sirhan Sirhan, immediately after the shooting at the Ambassador Hotel. "What made us special," Lundy once said, "was how we worked together."

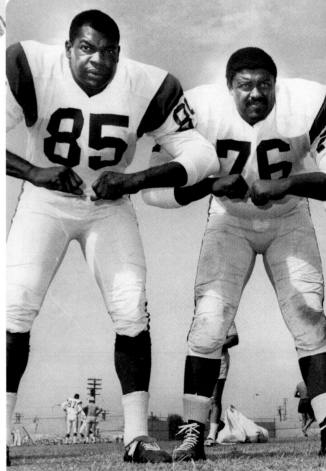

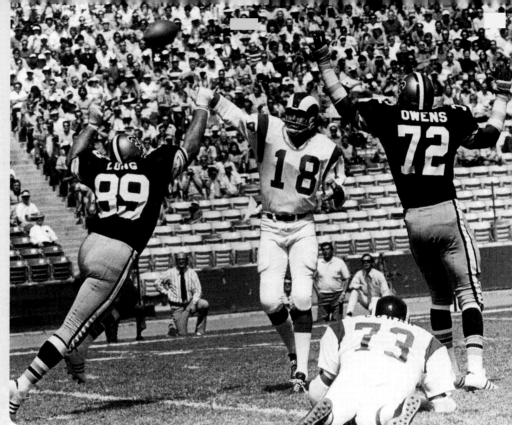

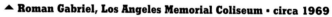

▲ **Roman Gabriel, Los Angeles Memorial Coliseum • circa 1969**

Rams quarterback Roman Gabriel avoids the rush and throws downfield. After the Rams selected Gabriel as their first-round pick in 1962, he struggled to make the transition from college to the pros. But when the Rams hired head coach George Allen in 1966, he orchestrated the franchise's turnaround by installing Gabriel as the starting quarterback. The Rams became perennial playoff contenders as the Filipino American Gabriel, behind a stellar offensive line anchored by Tom Mack, teamed with receivers Jack Snow, Billy Truax and Les Josephson to set numerous team passing records. The Rams made the Western Conference championship game in 1967 and 1969; Gabriel was the NFL's MVP in 1969.

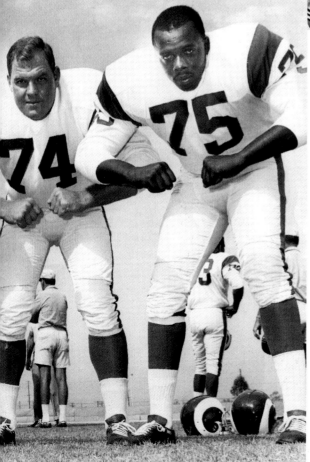

**Jack Youngblood
Anaheim Stadium
1983**

Defensive end Jack
Youngblood suffers
through a Ram
defeat. How gritty
was Youngblood?
In 1980, during the
Rams' playoff run,
Youngblood broke
his left leg. He
played through the
pain for three games,
including the L.A.
Rams' only Super
Bowl appearance.
After his retirement,
the sackmaster who
replaced Deacon
Jones ended up in
the Hall of Fame.

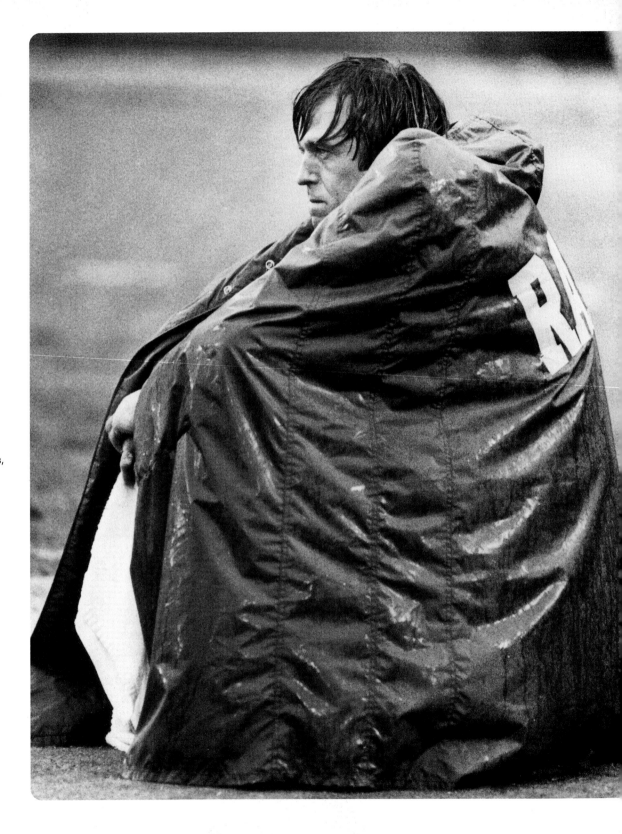

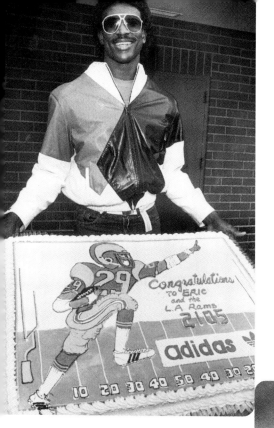

Eric Dickerson • June 19, 1985

The Rams drafted Eric Dickerson in 1983, and in just his second year the be-goggled, long-striding Dickerson broke O.J. Simpson's single-season rushing record with 2,105 yards. In this picture he shows off a celebratory cake for the occasion. In 1987 a contract dispute soured relations between Dickerson and the Rams, and the NFL's premier running back was dealt to the Indianapolis Colts in a trade that offensive lineman Jackie Slater called "one of the darkest days in NFL history."

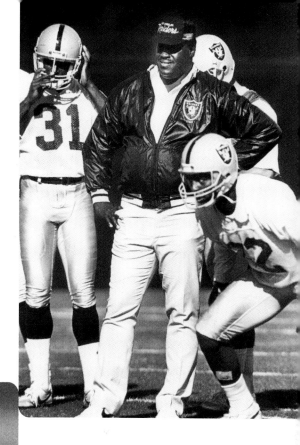

Al Davis • May 18, 1984

A former assistant coach at USC and the AFL's Los Angeles Chargers, Al Davis served as AFL commissioner before the league merged with the NFL. He then became the Oakland Raiders' managing general partner, building the team into one of the sport's most successful franchises. He moved the Raiders to L.A.'s Coliseum before the 1982 season. Then, after negotiating to build new stadiums in Irwindale and Inglewood, Davis relocated the Raiders to Oakland after the 1994 season, leaving L.A. without an NFL team for the first time since 1945.

Art Shell, El Segundo October 4, 1989

Art Shell directs his first practice. He was the first African American head coach in the NFL's modern era. (Fritz Pollard was the first African American coach in the NFL, coaching the Akron Pros from 1921 to 1926.) Hired by Al Davis to replace Mike Shanahan, Shell had previously served as the Raiders' offensive line coach. As a player, Shell had excelled at offensive tackle, teaming with guard Gene Upshaw to form an impregnable left side and lead the Raiders to two Super Bowls. Shell was fired after the 1994 season.

Football

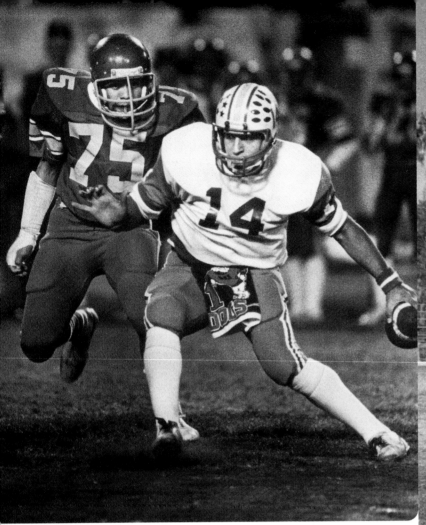

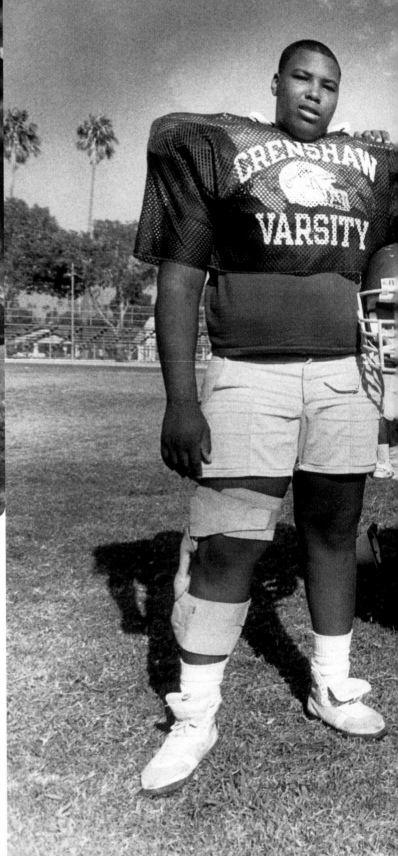

▲ **The East L.A. Classic • November 14, 1981**
Roosevelt High's Roughriders vs Garfield High's Bulldogs.
Here, in the annual East L.A. Classic, Roosevelt's Jose
Aguilar moves in to tackle Garfield's Carlos Ayala.
The Bulldogs won, 31-12 .

Offensive Line, Crenshaw High • September 27, 1985 ▶
Made up of five 300-pounders, Crenshaw High's 1985
offensive line is an imposing sight. The players, from left,
Patrick Johnson, Larry Netherly, Anthony Usher, Mike
Gamble and Francis Hines.

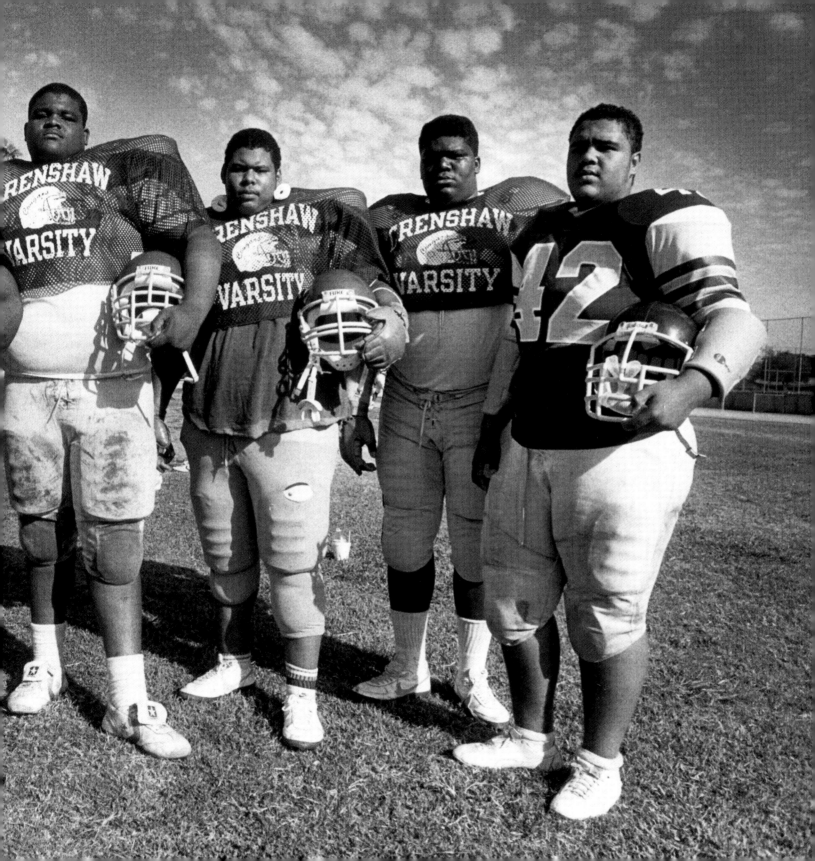

Super Bowls

After the National Football League and the American Football League agreed to merge, NFL commissioner Pete Rozelle inaugurated a championship game between the two former leagues. It was left to Kansas City Chiefs owner Lamar Hunt to come up with a catchy name for the event. Inspired by the high-bouncing "Super Ball" his daughter played with, he decided to call it the Super Bowl. The L.A. area has hosted seven Super Bowls, including two at the L.A. Memorial Coliseum and five at the Rose Bowl.

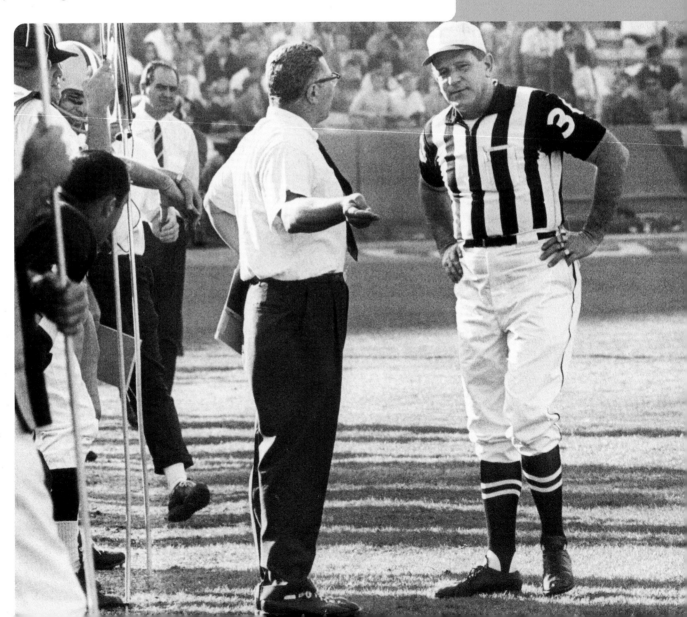

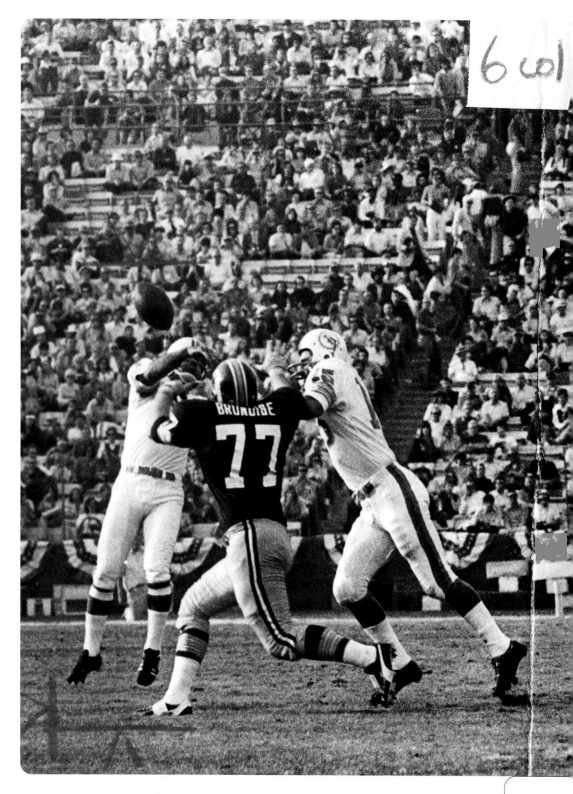

◀ Vince Lombardi, Super Bowl I
Los Angeles Memorial Coliseum
January 15, 1967

Vince Lombardi makes a point to an official during the first Super Bowl. Lombardi's Green Bay Packers defeated the Kansas City Chiefs, 35–10, with quarterback Bart Starr and receiver Max McGee leading the way. The game didn't come close to selling out— only 61,946 people attended— while television networks CBS and NBC simultaneously broadcast it.

Dolphins vs Redskins ▶
Super Bowl VII
Los Angeles Memorial Coliseum
January 13, 1973

Don Shula's Miami Dolphins were undefeated entering the game against the Washington Redskins. Late in the fourth quarter, with the Dolphins ahead 14–0, the Dolphins' Garo Yepremian lined up to kick a field goal. The kick was blocked, and after Yepremian foolishly tried to pass the ball, Washington's Mike Bass recovered and ran forty-nine yards for a touchdown. Miami held on, 14–7, to complete its perfect 17–0 season.

Football

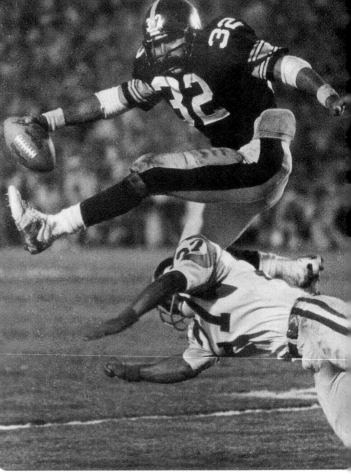

▼ John Madden, Super Bowl XI, The Rose Bowl • January 9, 1977

Raiders coach John Madden celebrates after Oakland beat the Minnesota Vikings, 32-14, in Super Bowl XI. The Silver and Black were sparked by wide receiver Fred Biletnikoff, who won MVP honors, and running back Clarence Davis, who rushed for 137 yards. In 1984, as the L.A. Raiders, the team won Super Bowl XVIII, the only time an L.A.-based team won the big game.

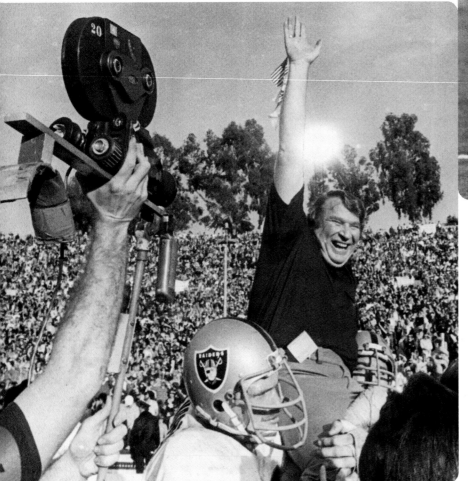

▲ Franco Harris, Super Bowl XIV, The Rose Bowl January 20, 1980

Pittsburgh Steelers running back Franco Harris avoids a tackle during the Steelers' 31-19 victory over the Los Angeles Rams in Super Bowl XIV. The Rams had endured a traumatic season, finishing just 9-7 following the death of owner Carroll Rosenbloom. In the Rams' first Super Bowl appearance, they took a 13-10 half-time advantage and led going into the fourth quarter. Behind quarterback Terry Bradshaw and his corps of wondrous receivers (including John Stallworth and former USC star Lynn Swann), the Steelers dominated the fourth quarter to take their fourth Super Bowl title.

Play by Play

▼ **Lawrence Taylor, Orange Coast College • January 20, 1987**

New York Giants linebacker Lawrence Taylor endures the annual ritual known as "Media Day," before Super Bowl XXI. Five days later, the Giants won their first Super Bowl, defeating the Denver Broncos at the Rose Bowl, 39-20. Five years later, the Super Bowl returned to Pasadena for the last time in the twentieth century as the Dallas Cowboys defeated the Buffalo Bills 52-17.

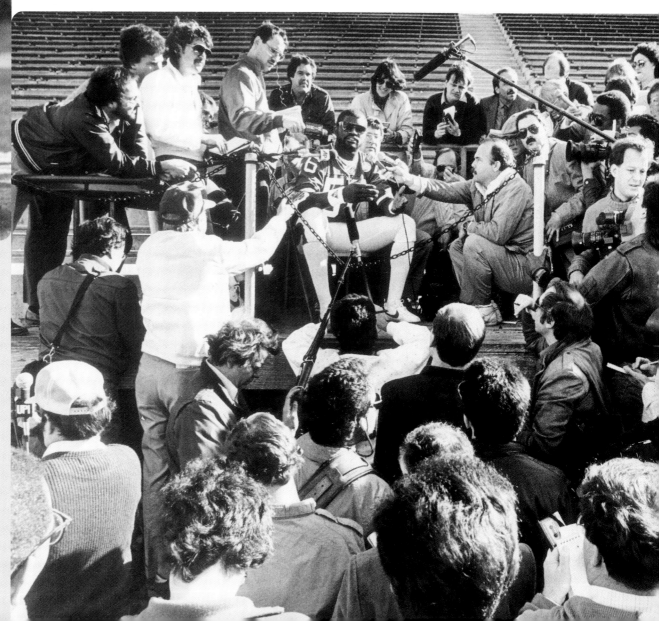

Football

Golf

Golf traces its L.A. origins to the late nineteenth century, when course-building fever swept the area. The elite country clubs came first, followed by public courses. With the inaugural L.A. Open in 1926, professional golf found a local home.

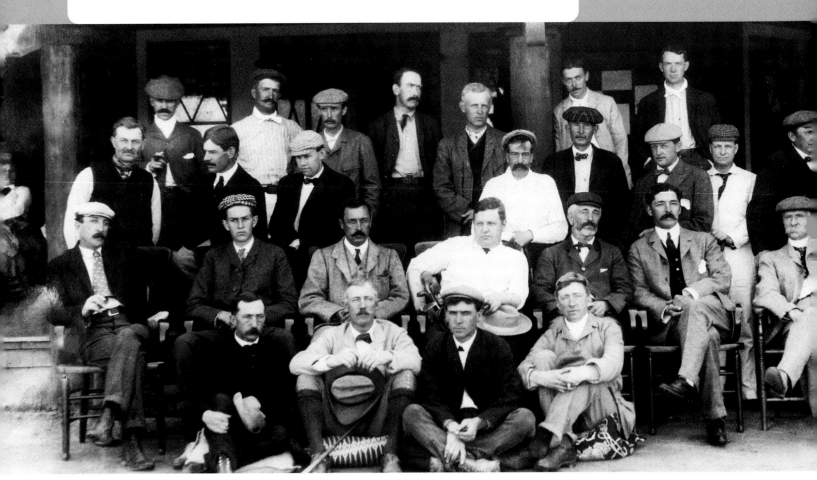

Golfers, Los Angeles Country Club · circa 1900

Members of the Los Angeles Country Club pose in front of the clubhouse located near the intersection of Pico and Western. Chartered in 1897, the LACC built its first course—a nine-holer—on a vacant lot at Pico and Alvarado streets. The exclusive club settled at its present-day location along Wilshire Boulevard in 1921, after architects G. Herbert Fowler and George Thomas, Jr., designed two sublime courses. The LACC hosted the first L.A. Open in 1926; the club's longtime president, Joe Sartori, is seated in the front row, far left.

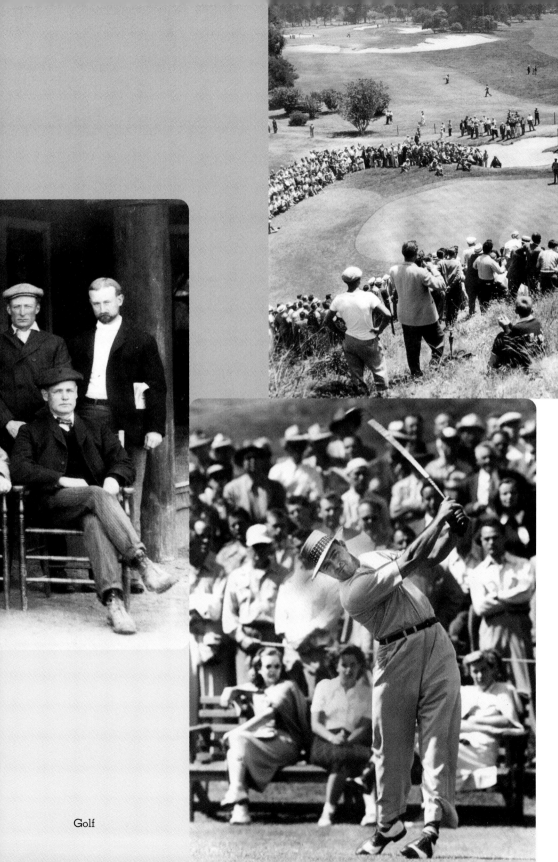

▲ Ben Hogan
◀ Sam Snead
Riviera Country Club · 1948
The 1948 U.S. Open at Riviera,
as Ben Hogan (putting) defeated
a field that included Sam Snead
(driving). In 1932, Hogan played
his first tournament of the PGA
Tour at Riviera, finishing thirty-
eighth and earning $8.50.
Hogan won the L.A. Open at
Riviera in 1947 and 1948;
coupled with his U.S. Open win,
it's no surprise that Riviera has
been dubbed "Hogan's Alley."
In 1950, recovering from
a near-fatal car accident, Hogan
chose Riviera as the site of his
comeback, but Snead beat him.

Golf

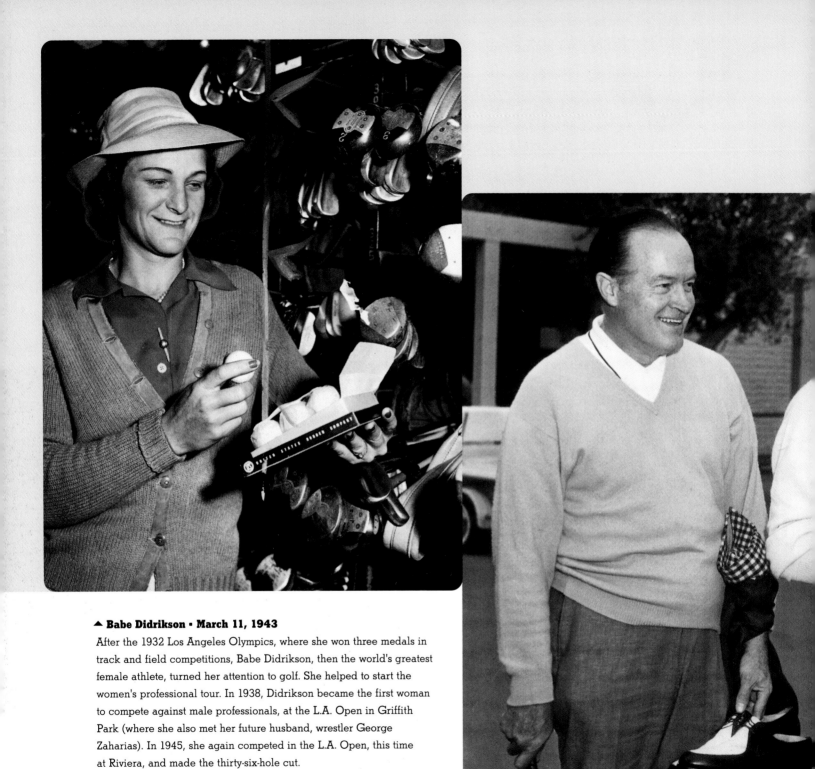

▲ Babe Didrikson • March 11, 1943

After the 1932 Los Angeles Olympics, where she won three medals in track and field competitions, Babe Didrikson, then the world's greatest female athlete, turned her attention to golf. She helped to start the women's professional tour. In 1938, Didrikson became the first woman to compete against male professionals, at the L.A. Open in Griffith Park (where she also met her future husband, wrestler George Zaharias). In 1945, she again competed in the L.A. Open, this time at Riviera, and made the thirty-six-hole cut.

**Bob Hope, Frank Sinatra and Dean Martin, Palm Springs
September 29, 1963**

Bob Hope, Frank Sinatra and Dean Martin gather outside the
Canyon Country Club in Palm Springs for the Frank Sinatra
Invitational. Though the tournament took place only once—in 1963—
it sparked a trend among sports-minded entertainers. In 1965,
Hope lent his name to the Palm Springs Golf Classic, a five-day
tourney that continues to be an important PGA tour stop.

▼ **Jack Nicklaus • November 2, 1963**

Jack Nicklaus was a highly-touted twenty-one-year-old
when he made his professional debut at the 1962
L.A. Open at Rancho Park. He finished tied for fiftieth
and earned $33.33. Nicklaus would soon fare better—
later that same year he won his first pro tourney, the
U.S. Open, beating Arnold Palmer in a playoff and
earning $17,500—but he never won the L.A. Open.

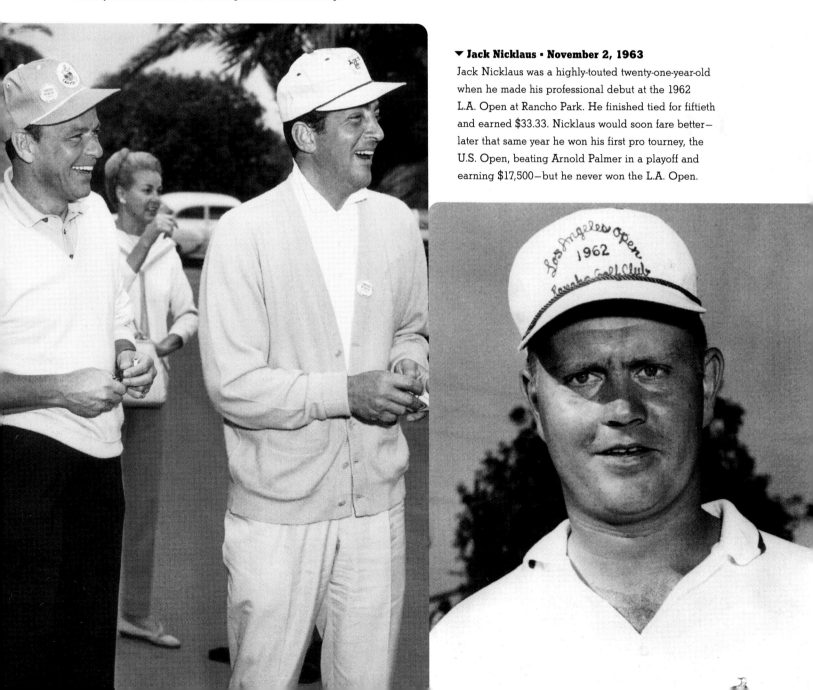

Arnie Palmer and His Army, Rancho Park Golf Club · 1963
Surrounded by his "army" of fans, Arnold Palmer warms up at Rancho Park. Palmer won the
L.A. Open three times—in 1963, 1966 and 1967. But his misfortune during the 1961 tourney, at
Rancho Park, cemented his place in L.A. Open lore. On the par-five ninth hole, trying to hit to
the green in two, Palmer hit four balls out of bounds—two into the nearby driving range and
two into the street—to card a twelve.

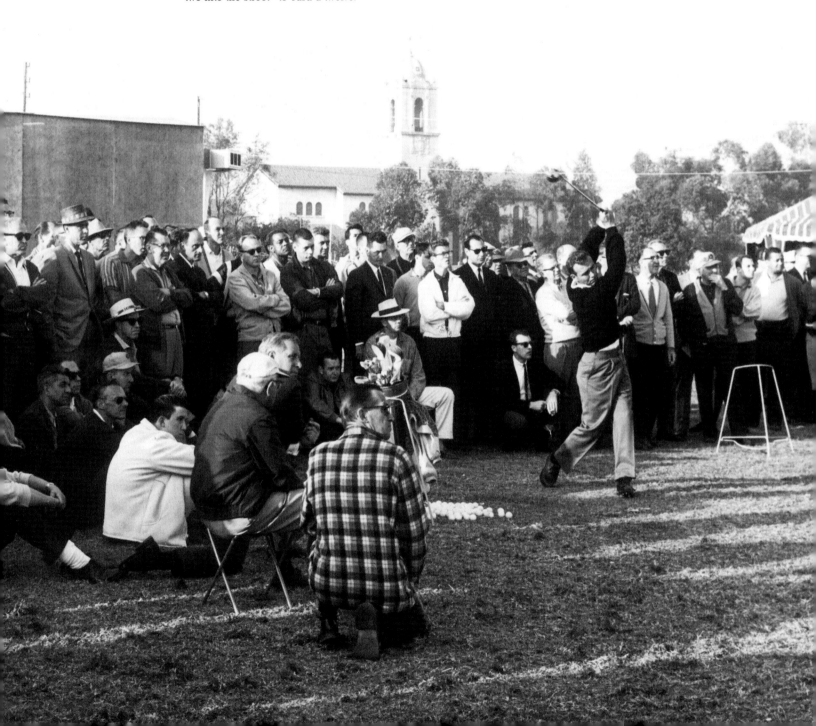

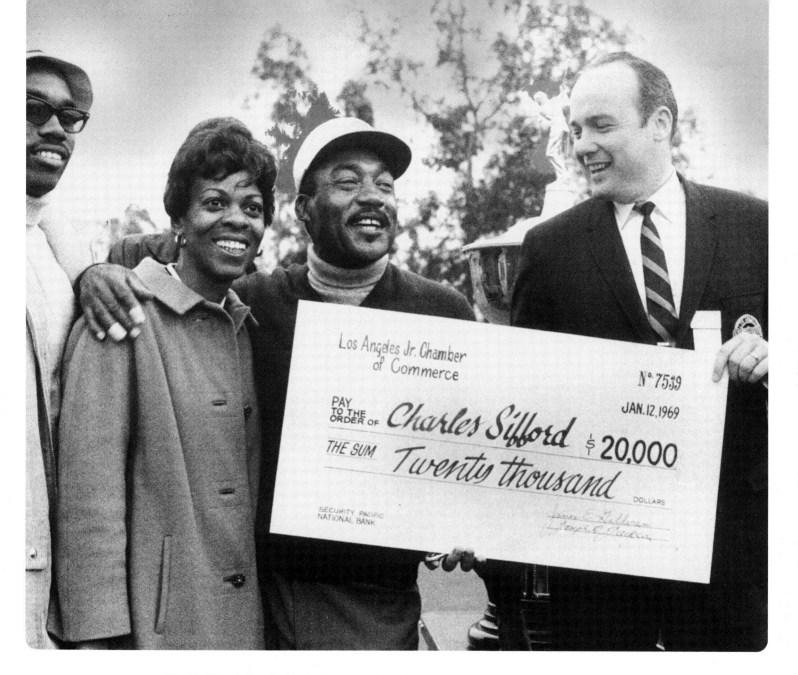

Charlie Sifford, Rancho Park • January 12, 1969

Forty-six-year-old Charlie Sifford and his wife Rose display the ceremonial winner's check after he won the L.A. Open in a playoff over Harold Henning. Before 1960, the PGA of America had a "Caucasian only" clause that denied African American golfers the right to play at most professional tournaments. With pressure from many, including California Attorney General Stanley Mosk, the PGA finally dropped the clause in 1961. Sifford, who was formerly bandleader Billy Eckstine's golf teacher, became the first African American to compete full-time on the tour.

Golf

Ice Hockey

For decades, ice hockey flourished in L.A. primarily because of East Coast and Canadian transplants. Minor league hockey teams created their own fan base, but the Kings' debut in 1967—and the team's subsequent trade for superstar Wayne Gretzky in the late 1980s—established ice hockey as a major professional sport.

Red Oakley · circa 1925

Red Oakley, captain of the Hollywood Athletic Club team, in a publicity shot. Club teams played throughout southern California before minor league hockey came to L.A. in 1927.

▶ **Gordie Bell, Pan Pacific Auditorium February 21, 1947**

Gordie Bell, goalie for the Hollywood Wolves, stymies an attack by the New Westminster Royals. These two squads competed in the Pacific Coast Hockey League, which existed from 1945 to 1952.

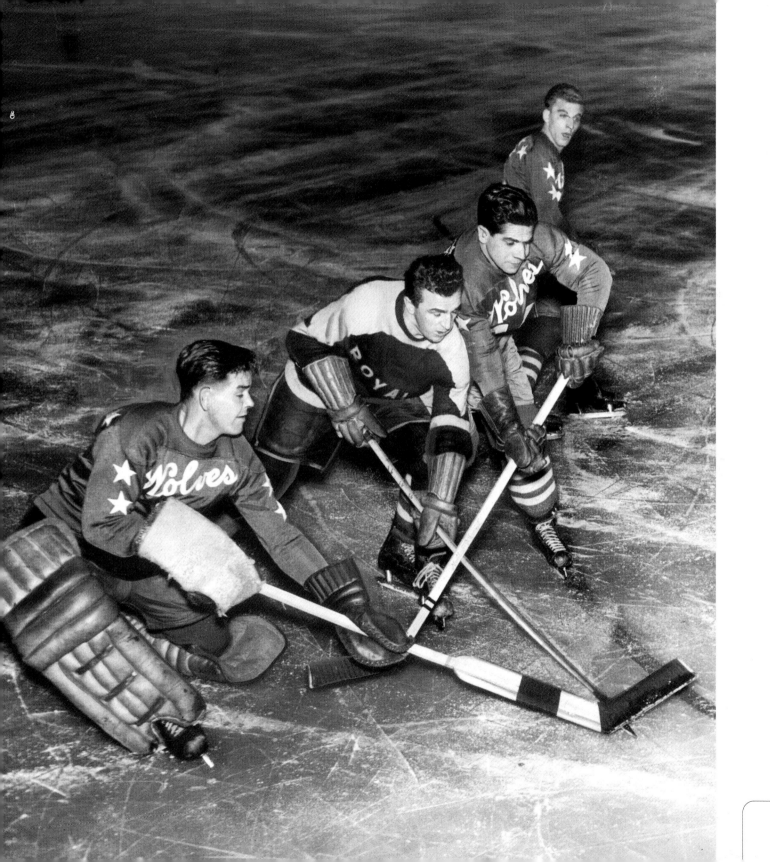

Willie O'Ree, Sports Arena • March 17, 1962

Los Angeles Blades winger Willie O'Ree backhands the puck (encircled) on goal. When O'Ree made his debut with the Boston Bruins in 1958, he became the first African American to play in the NHL. Three years later, after he was sent to the minor leagues, he began a six-season stint with the Los Angeles Blades. Despite an injury that left him nearly blind in one eye, the speedy winger led the Western Hockey League in scoring in 1964, with thirty-eight goals. The Blades, which began play in 1961, folded in 1967 to make way for the L.A. Kings; O'Ree played for another Western League team, the San Diego Gulls, before retiring in 1978 at age forty-three.

◀ Jack Kent Cooke and Charles Luckman, The Forum March 5, 1967

Jack Kent Cooke, right, and architect Charles Luckman observe construction of The Forum in Inglewood. A former door-to-door encyclopedia salesman, the Canadian-born Cooke bought the Lakers in 1965 for $5.2 million. After acquiring the rights to an NHL expansion team, Cooke couldn't reach a deal with the Coliseum Commission, which controlled the Sports Arena (home to the Lakers). Cooke then built the seventeen-thousand-seat, sixteen-million-dollar Forum across the street from Hollywood Park; the Kings debuted there on December 30, 1967. In 1979, Cooke sold the Lakers, the Kings, The Forum (and his California ranch) to Jerry Buss for a reported $67.5 million.

Rogie Vachon, The Forum · circa 1974 ▶

Goaltender Rogie Vachon, the first Kings player to have his sweater retired, stands outside The Forum, home to the Kings from 1967 to 1999. After helping the powerhouse Montreal Canadiens win three Stanley Cups, the diminutive Vachon used his quick glove to make the Kings competitive, leading them to three consecutive playoff appearances in the 1970s.

Ice Hockey

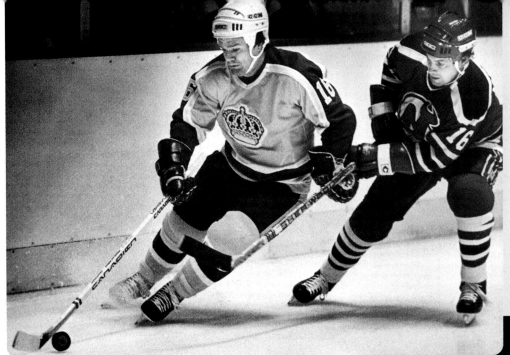

▲ Marcel Dionne, The Forum • November 25, 1984

Center Marcel Dionne stick handles past a New Jersey Devils opponent. When Dionne left the Detroit Red Wings to sign with the Kings in 1975, L.A. had its first bona fide superstar. In twelve seasons with the Kings, Dionne tallied fifty goals six times; he is the team's all-time leader in goals, assists and total points. Alas, while the "Little Beaver" led the Kings to numerous playoff appearances, he is considered the greatest NHL player whose team never won the Stanley Cup.

▶ Dave Taylor, The Forum • November 11, 1986

On his knee defending the goal is Dave Taylor, a 15th-round pick in the 1975 draft. In 1979, he was paired with Marcel Dionne and Charlie Simmer; the fabled "Triple Crown" line meshed into a high-scoring unit, with Taylor setting a then-franchise mark for goals (fifty-six) and Dionne leading the league in scoring. The trio even found time to sing: as Marcel Dionne and the Puck-Tones, they recorded the forgettable "Please Forgive My Misconduct Last Night." Taylor went on to become general manager of the Kings.

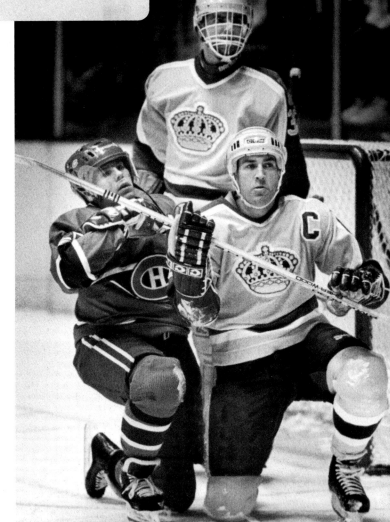

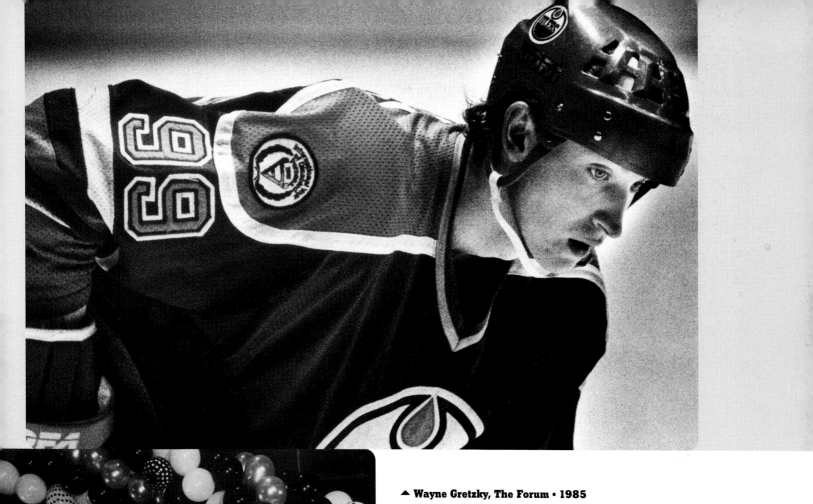

▲ **Wayne Gretzky, The Forum • 1985**
◀ **Wayne Gretzky and Bruce McNall • August 8, 1988**

Shortly after buying the Kings in 1988, Bruce McNall traded two players, three first-round draft picks and cash for Edmonton Oilers center Wayne Gretzky (shown here at the press conference to announce the deal). The trade remains one of the most momentous transactions in sports history, comparable to the Boston Red Sox trade of Babe Ruth to the New York Yankees. In L.A., Gretzky produced. After breaking Gordie Howe's all-time goal record, he led the Kings to their first (and only) Stanley Cup Finals appearance in 1993. Attendance soared: the 1991-92 Kings were the first L.A. franchise to sell out every regular season game. But Gretzky's importance extended beyond L.A.: he helped to transform the NHL from a league dominated by Canadian teams to one that moved to Sunbelt locales, including Anaheim, Arizona and Florida. McNall, the coin-dealer-turned-millionaire who brokered the trade, was later convicted of bank fraud.

Racing Cars

Southern California's fascination with cars (and car culture) has long extended to racing. Race tracks have come and gone—from L.A. to Beverly Hills to Gardena to Ontario—but the thrill of the chase remains.

Barney Oldfield, Ascot Track • circa 1913

Barney Oldfield races his front-drive Christie against a Curtis biplane at the original Ascot track, located at Central and Florence Avenues. (This was the first of four southland tracks called "Ascot.") The first mile-a-minute race-car driver, Oldfield helped to popularize automobiles at the turn of the twentieth century. (It was said that his success enabled Henry Ford to finance the Model T.) He drove with a cigar clamped between his teeth—he said it served as a shock absorber on jaw-rattling rides.

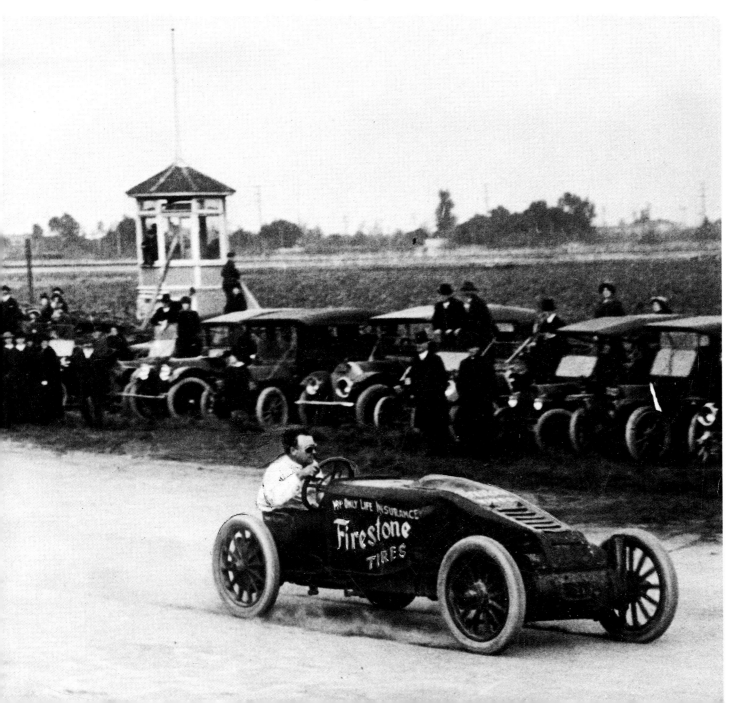

◀ Parnelli Jones
November 22, 1964

Parnelli Jones, middle, gets last-minute instructions from his crew. A San Pedro High School dropout, Jones drove jalopies on the dirt track of Gardena Stadium before graduating to the Indianapolis 500 and the NASCAR circuit. He was the first to break the 150 mile-per-hour barrier at Indy, then won the race in 1963 while driving for owner J.C. Agajanian, right. He also won the Indy 500 as an owner (1970, 1971), with Al Unser at the wheel.

Dan Gurney ▶
Riverside International Raceway
May 23, 1968

Dan Gurney makes last-minute adjustments to his vehicle before the race. Gurney began drag racing as a teenager in Riverside. He turned into a Renaissance driver: in 1967, he became the first driver to win driving Grand Prix, Indy cars, stock cars and sports cars. After winning the twenty-four hour race at LeMans with teammate A.J. Foyt in 1967, Gurney inaugurated the tradition of spraying champagne into the crowd from the winner's podium.

Shirley Muldowney
Pomona Speedway
October 10, 1976

Shirley Muldowney is
strapped into her hot-pink
dragster at Pomona Speedway.
Muldowney delighted in
beating male opponents in the
macho sport of top-fuel drag
racing. At speeds of more
than 300 miles per hour along
the quarter-mile track, she
won the National Hot Rod
Association world champion-
ships three times (1977, 1980,
1982). In 1983, Muldowney's
life became a biopic in the
film *Heart Like a Wheel*
(starring Bonnie Bedelia).
She retired in 2003, after one
final race in Pomona.

Long Beach Grand Prix
April 5, 1987

Spectators take in the Grand Prix action in downtown Long Beach. When travel agent Chris Pook organized the first Long Beach Grand Prix in 1975, few experts thought he would succeed. Pook's dream has become an annual event that transforms the streets of Long Beach into a speed-freak haven.

Paul Newman, Riverside International Raceway · May 15, 1986

Paul Newman takes a break during practice runs at Riverside International Raceway. Opened in 1957, the track featured NASCAR racing on a twisting, 2.6-mile course before it closed in 1988. After portraying an Indianapolis 500 race-car driver in the film *Winning* (1968), Newman began racing for real in 1972. "I was a bad boxer, a bad football player, a bad tennis player, a bad badminton player, a bad skier, a bad hockey player," he once said. "Racing is the first thing that I ever found I had any grace in. I'm not a very graceful person."

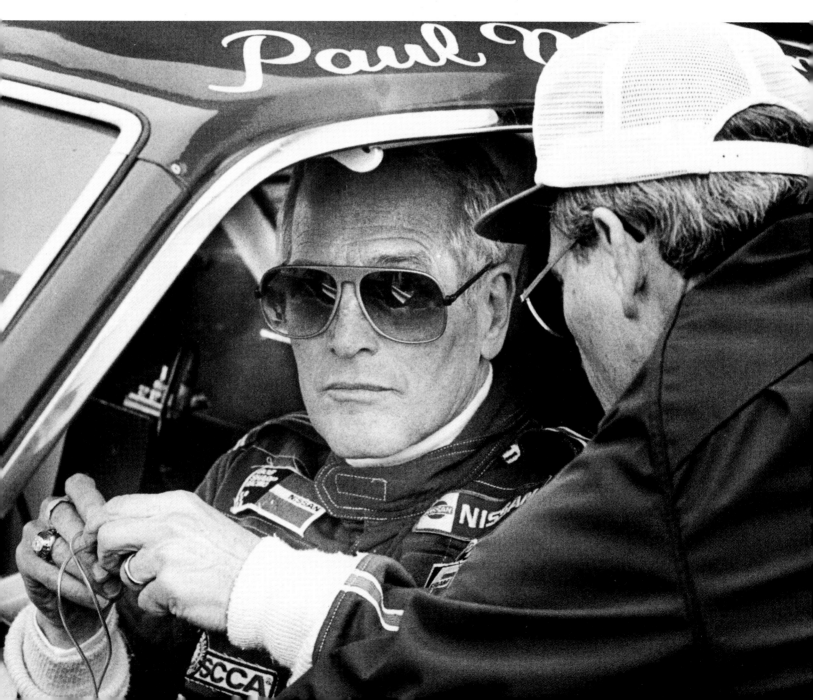

Racing Horses

From "Lucky" Baldwin to Seabiscuit to Willie Shoemaker, horse racing has had a fabled history in L.A. The longstanding popularity of the sport of kings can also be traced to the area's three superb tracks—Santa Anita, Hollywood Park and Del Mar.

Volante, Arcadia · circa 1886

In 1875, Elias Jackson Baldwin—known to all as "Lucky"—purchased approximately eight thousand acres of *Rancho Santa Anita* and began training thoroughbred horses. In 1885, with Volante, he won the American Derby at Washington Park, then the most prestigious race in the country for three-year-old horses. Baldwin also built the first Santa Anita Park on his estate in 1907; two years later, following Baldwin's death, horse racing was banned in California and the track was forced to close. The present-day version of Santa Anita opened on Christmas Day, 1934. The remains of Baldwin's four top horses—Emperor of Norfolk, Volante, Silver Cloud and Rey El Santa Anita—can be found in the paddock area, under his trademark Maltese Cross.

Seabiscuit and Charles Howard, Santa Anita Park · circa 1941
Seabiscuit, with owner Charles Howard, poses next to the life-sized bronze statue erected in the horse's honor in the paddock gardens at Santa Anita Park. The West Coast-based 'Biscuit raced often at the Arcadia track; his final race was a victory in the 1940 Santa Anita Handicap (known as the "Big Cap"). He died in 1947.

Racing Horses

Bing Crosby, Del Mar Race Track • circa 1940

Entertainer Bing Crosby (foreground, with pipe) watches the morning workout at the race track he co-founded with actor Pat O'Brien in 1937. Del Mar took off in popularity after Seabiscuit out-dueled Ligaroti (co-owned by Crosby) in a neck-and-neck match race. Crosby also wrote the track's anthem "Where the Surf Meets the Turf" to commemorate Del Mar's opening.

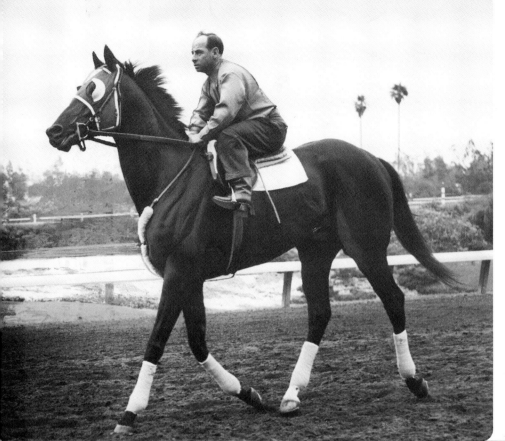

◀ **Johnny Longden and Noor**
July 24, 1950

Johnny Longden exercises Noor. After being purchased by Charles Howard, Noor flourished in California and defeated the mighty Citation, the 1948 Triple Crown winner, in a series of races (including the "Big 'Cap"). Known as "The Pumper," Longden was the only person in thoroughbred history to win the Kentucky Derby as a trainer and jockey. His final ride came in 1966 at Santa Anita Park, when he steered George Royal to a photo finish victory before 60,792 fans; the dramatic farewell, which gave Longden 6,032 career wins, has been voted the greatest moment in the race track's history. He died in 2003.

Gary Stevens and Winning Colors ▶
Santa Anita Park
April 4, 1988

After winning the Santa Anita Derby, Gary Stevens and Winning Colors salute the crowd. A month later, Stevens celebrated again at Churchill Downs, as Winning Colors became one of just a handful of fillies to win the Kentucky Derby. In the film *Seabiscuit* (2003), Stevens made his acting debut as jockey George Woolf, who replaced Red Pollard aboard Seabiscuit in the match race against War Admiral.

Racing Horses

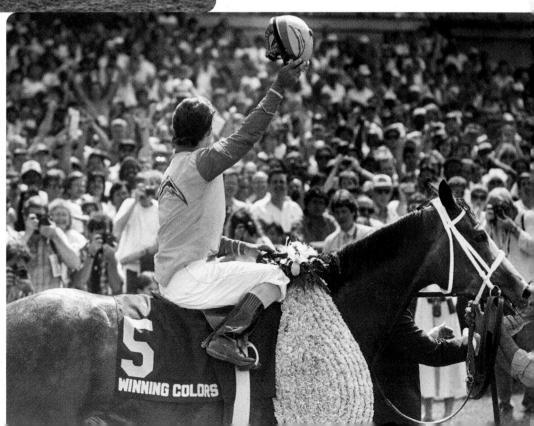

Willie Shoemaker, Santa Anita Park • circa 1985

Willie Shoemaker moved to California as a teenager, then attended El Monte Union and
La Puente high schools. He dropped out when he realized he could make good money as a
jockey and rode to his first win when he was seventeen. All of ninety-five pounds, "The Shoe"
worked primarily in southern California. When he saddled his last horse in 1990, 64,573 fans
showed up at Santa Anita Park to cheer him on; watching him race, said one observer, was like
"listening to a pretty song or reading poetry." His post-jockey career as a trainer ended
prematurely when he was paralyzed in a car accident. He died in 2003.

Laffit Pincay, Jr.
Santa Anita Park
February 19, 1986

Following a muddy ride, jockey Laffit Pincay, Jr., is ready for his close-up. The Panamanian-born Pincay typified jockeys' ultimate sacrifice: for years, he starved himself to make weight. In December 17, 1999, in the sixth race at Hollywood Park, Pincay broke Willie Shoemaker's mark of 8,833 wins to become thoroughbred racing's all-time winningest jockey. In 2003, after breaking his neck in a spill, Pincay retired with 9,530 victories.

Soccer

European ex-pats brought the sport to L.A. and stocked the rosters of the first serious attempts at professional soccer. Since then, the Latino community has dominated the soccer scene in southern California even as women flocked to the sport.

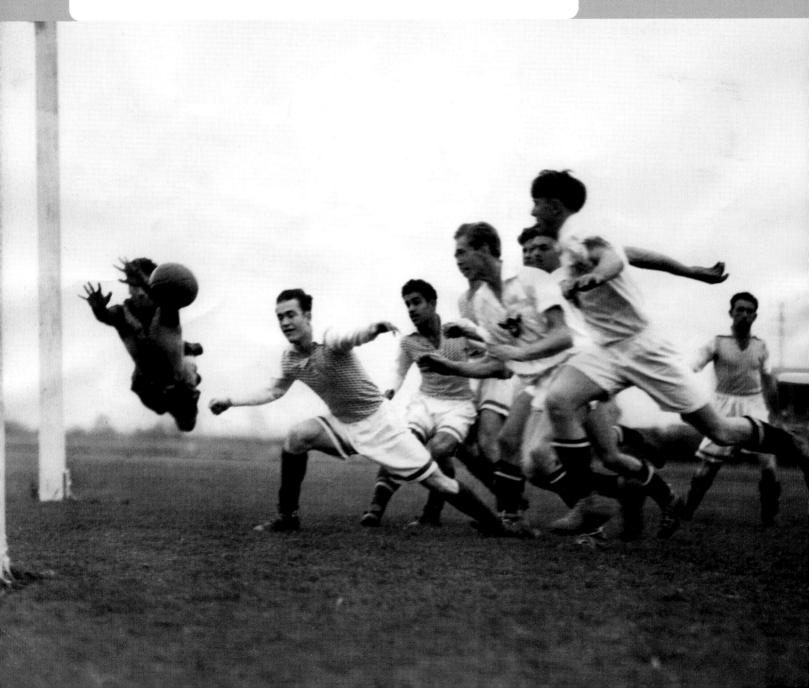

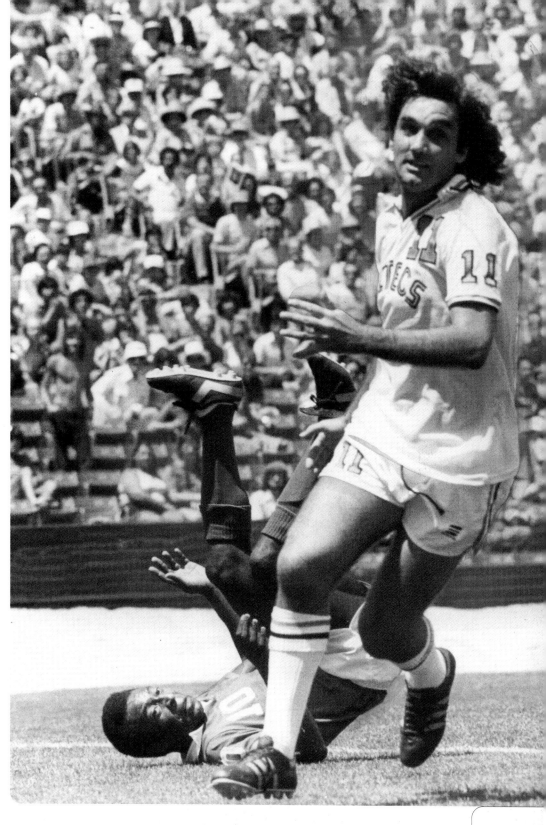

◀ Magyars vs. Pasadena
San Pedro
December 9, 1931

Early action in the Greater Los
Angeles Soccer League: the Magyars
team withstands a rush from
Pasadena A.C.C. Founded in 1903,
the GLASL is thought to be one of
the oldest in the nation; the GLASL
played many of its games at San
Pedro's Daniels Field. During the
league's early years, immigrants
from England, Scotland, Germany,
Hungary, Spain and Holland
brought their love of soccer to L.A.
and dominated the rosters of the
semi-pro teams.

George Best and Pele ▶
Los Angeles Memorial Coliseum
July 3, 1977

Northern Ireland's George Best came
to the U.S. to play for the Los Angeles
Aztecs of the North American Soccer
League, the first serious attempt to
launch professional soccer in the U.S.
The owners' strategy was to hire the
world's best talent, though many of
the players (including the hard-
drinking Best, one of the all-time bad
boys of sports) were past their prime.
Here, in a game against the New York
Cosmos, Best upends the Brazilian
great, Pele.

Soccer

Paul Caligiuri · June 6, 1984 ▶

Paul Caligiuri practices with the 1984 U.S. Olympic team. Throughout his career, Caligiuri was in the right place at the right time. In 1985, he captained UCLA to the NCAA title. Four years later, as a member of the U.S. national team, he scored one of the most important goals in U.S. soccer history: the winning tally against Trinidad and Tobago that propelled the team to the 1990 World Cup competition. It was the first time that the U.S. qualified for the World Cup in forty years. Later, after becoming one of the first Americans to play for a top-flight team in Europe, Caligiuri finished his career with Major League Soccer's Los Angeles Galaxy.

◀ Los Angeles Lazers, The Forum • 1982

The Los Angeles Lazers, L.A.'s first indoor soccer team, make their debut at The Forum in yet another attempt to take advantage of soccer's popularity. The Jerry Buss-owned team, part of the Major Indoor Soccer League, lasted until 1989 and was overshadowed by the successful San Diego Sockers franchise.

▼ Hugo Sanchez, Los Angeles Memorial Coliseum • May 17, 1986

High-scoring striker Hugo Sanchez shows off his moves as the Mexican national team prepares for the 1986 World Cup. The popularity of the sport first resonated during the 1984 Los Angeles Olympics, when games at the Rose Bowl were consistent sell-outs. Since then, soccer transformed itself in southern California because of two factors: The explosion of youth soccer—a boom that included girls—which many experts traced to the city of Torrance, where Hans Stierle and other *futbol*-lovers created the American Youth Soccer Organization. In addition, the popularity of soccer among L.A.'s many immigrant communities boosted the sport's profile as fans flocked to the Rose Bowl and Coliseum to watch their favorite club and national teams from Mexico, Central and South America. By the 1990s—when L.A. hosted two World Cup tournaments—soccer was firmly entrenched in L.A.

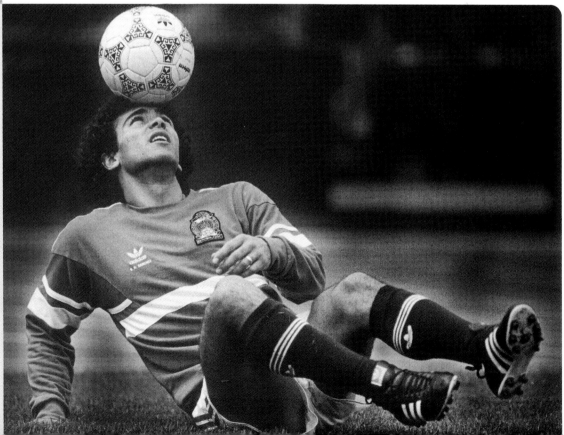

Soccer

Sports and Hollywood

Sports is the original "reality TV" form of entertainment, and Hollywood has long embraced sports stories and athletes.

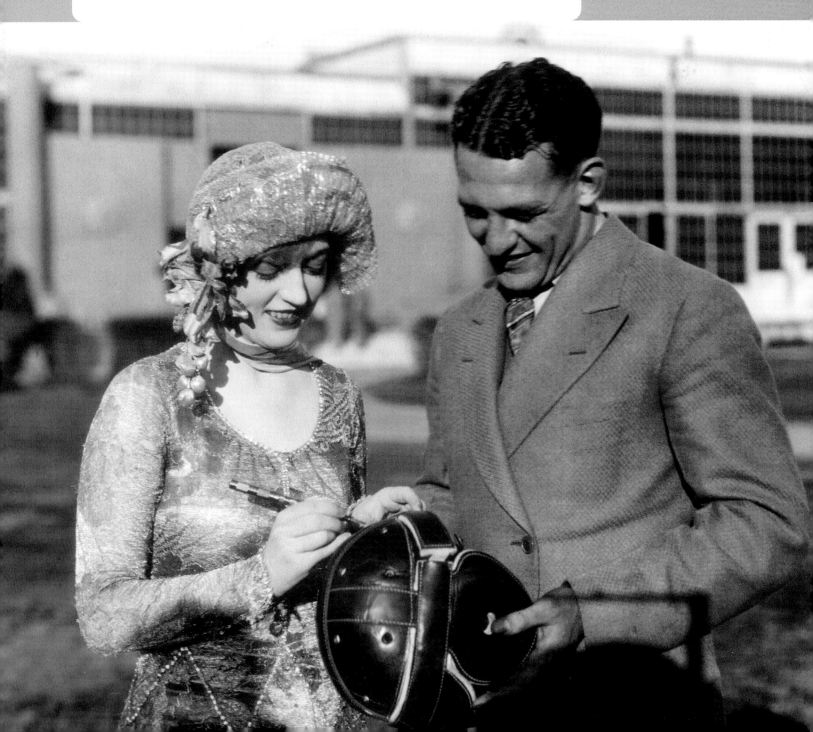

◀ Marion Davies and
Harold "Red" Grange ▪ circa 1925

Marion Davies, left, was the longtime lover of *Herald Examiner* owner William Randolph Hearst, who helped promote her career by routinely publishing photographs of the actress in his magazines and newspapers. Here, she poses with football star Harold "Red" Grange, who turned pro in 1925. At a time when the National Football League was not very popular or lucrative, Grange played for—and toured with—the Chicago Bears, giving the burgeoning league its first gate attraction. When he came west to play in L.A., Grange played himself in a couple of forgettable films, including *One Minute to Play* (1926) and *The Galloping Ghost* (1931).

Douglas Fairbanks, Lester Stoefen,
Bill Tilden, Paulette Goddard and
Judy Garland ▪ June 11, 1940 ▶

Actor Douglas Fairbanks (seated) chats with two mixed-doubles teams: clockwise from far left, tennis players Lester Stoefen and Bill Tilden and actresses Paulette Goddard and Judy Garland. "Big Bill" Tilden dominated tennis during the Roaring Twenties, and was the first American male to win at Wimbledon. Known for his "cannonball" serve (estimated at 150 miles per hour), Tilden retired in Hollywood and gave lessons to film stars. (One of his favorite courts belonged to Goddard's ex-husband, Charlie Chaplin.) Conservative mores of the times demanded that Tilden hide his homosexuality, but he is remembered today as one of the world's elite gay athletes.

Sports and Hollywood

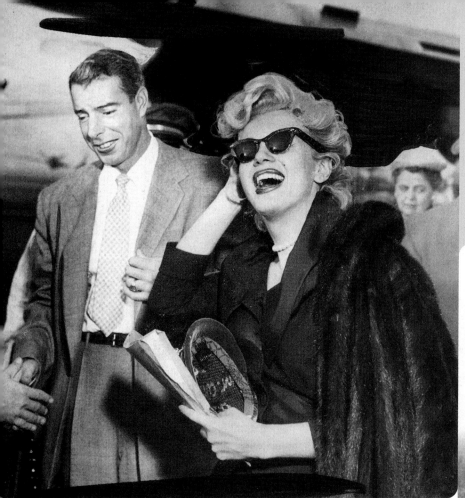

▲ **Joe DiMaggio and Marilyn Monroe**
Los Angeles International Airport · 1954

A smiling, seemingly happy couple returns to L.A. from the set of the
Seven Year Itch (1955). Earlier in the week, while filming a scene for
Billy Wilder's film, Monroe had posed for photographers while standing
on a New York City subway grate, her white dress aflutter around her
hips. The former Yankee centerfielder was furious that his wife had
posed so provocatively. Shortly after this image was taken, Monroe filed
for divorce.

Joe Namath and Alan Carr · June 28, 1970 ▶

Producer Allan Carr and New York Jets quarterback Joe Namath, right,
on the set of *C.C. and Company* (1971), shortly after Namath led the Jets
past the Baltimore Colts in Super Bowl III. The biker-themed film, which
also starred Ann-Margret, did nothing to further Namath's Hollywood
career. Namath ended his playing career with the Rams in 1977.

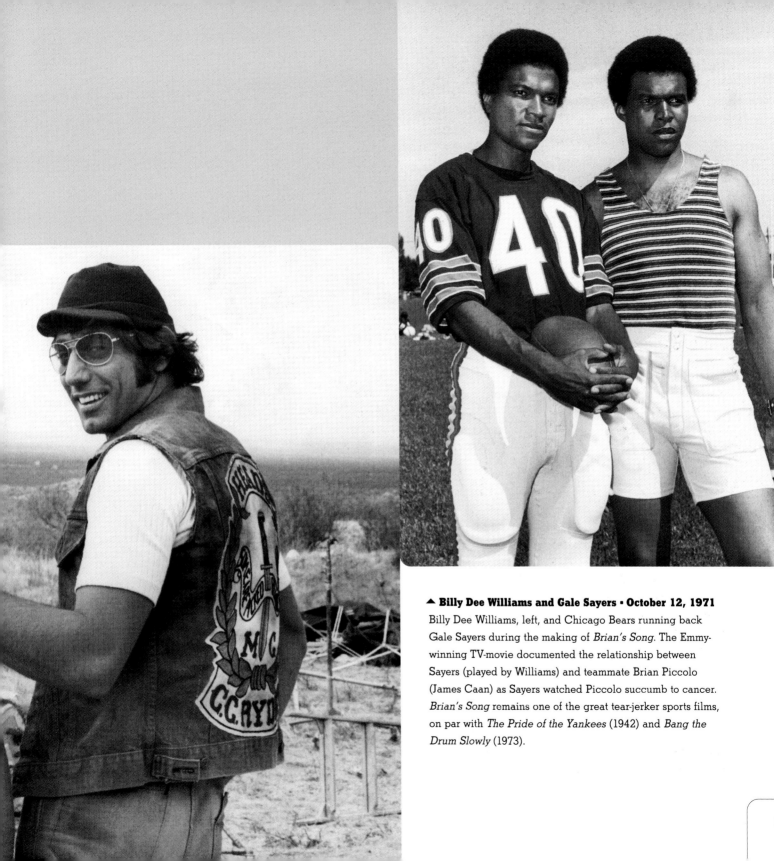

▲ **Billy Dee Williams and Gale Sayers · October 12, 1971**
Billy Dee Williams, left, and Chicago Bears running back
Gale Sayers during the making of *Brian's Song*. The Emmy-
winning TV-movie documented the relationship between
Sayers (played by Williams) and teammate Brian Piccolo
(James Caan) as Sayers watched Piccolo succumb to cancer.
Brian's Song remains one of the great tear-jerker sports films,
on par with *The Pride of the Yankees* (1942) and *Bang the
Drum Slowly* (1973).

Sports Outside the Lines

Outside the lines of traditional sports, alternative sports have flourished in Southern California. From polo to roller derby to beach volleyball, these sports have now established their own roots.

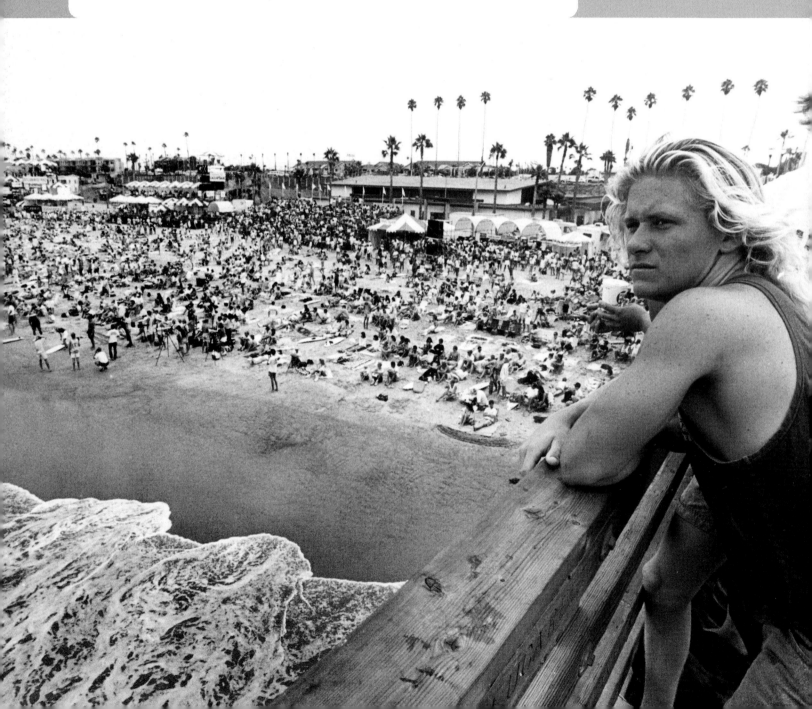

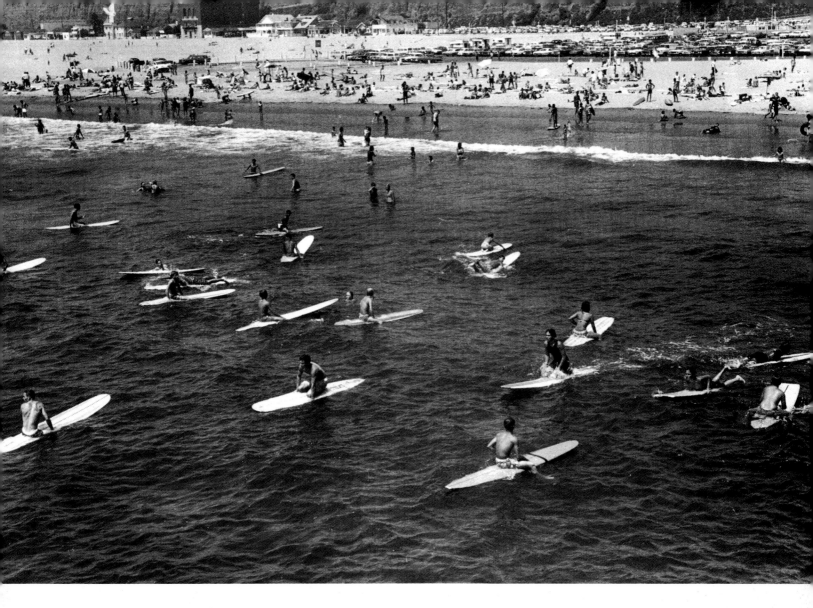

◀ **Surfers, Huntington Beach · 1983**

▲ **Surfers, Santa Monica Beach · 1966**

In 1907, railroad and land baron Henry Huntington hired George Freeth to introduce the ancient Hawaiian sport of surfing to southern California, primarily to promote tourism at Huntington-owned properties in Redondo Beach. Advertised as "the man who can walk on water," Freeth did his job well: by the 1930s, surfers and their long wooden boards were spotted on beaches from San Onofre to Malibu. Surfing took off in the 1960s, after the 1959 release of the first *Gidget* movie, which was filmed in Malibu. Real surfers mocked the film and the subculture it purported to depict, but by then surfing had become more than just a fringe sport. Indeed, by the 1970s, competitions and endorsements brought big money to the sport. Freeth died in 1919; a memorial bronze plaque is located at the Redondo Beach Pier.

Sports Outside the Lines

◀ Sinjin Smith, Santa Monica · August 22, 1983

Former UCLA and Loyola High standout Sinjin Smith, who with longtime partner Randy Stoklos formed one of the top beach volleyball tandems, slams home a point during a tournament. Beach volleyball originated in Santa Monica in the 1920s, and the first tournament featuring two-man teams took place in the late 1940s at State Beach. In the 1970s, prize money became commonplace at major tourneys such as the Manhattan Beach Open; in 1996, beach volleyball was introduced as an Olympic sport.

Skateboarders · August 26, 1965 ▶

An early skateboard contest attracts both boys and girls. The first boards were little more than roller-skate wheels attached to clunky wooden boards. In the late 1950s and early 1960s, with the advent of mass-produced boards, skateboarding grew popular in and around southern California beach cities. After the first contests in the early 1960s, and by the time Jan and Dean scored a hit with "Sidewalk Surfin'" in 1964, skateboard culture was poised to expand worldwide.

◀ Tai Babilonia and Randy Gardner • 1980

Tai Babilonia and Randy Gardner, practicing before the 1980 Lake Placid Olympics. While U.S. skaters have excelled in solo competition, no pairs team has ever won Olympic gold. Paired as youngsters by legendary coach Mabel Fairbanks at a Culver City rink, Babilonia and Gardner were on track to change that: they finished fifth at the 1976 Innsbruck Olympics and then won the 1979 world championships when reigning champs Irina Rodnina and Aleksandr Zaitsev took a leave of absence. The Americans and the Russians were poised to face off at the 1980 Lake Placid Games, but Gardner's groin injury forced the pair's withdrawal.

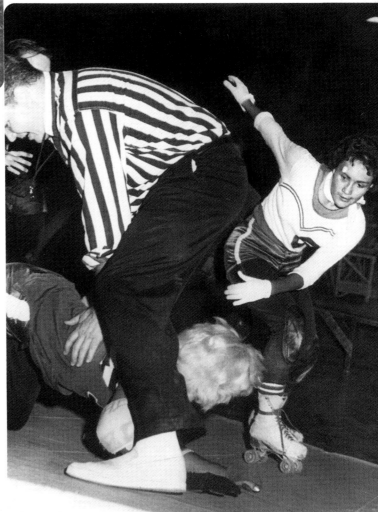

Coco Graves and Ann Calvello, Olympic Auditorium ▶ 1964

Coco Graves battles Ann Calvello on the rail. Invented in the 1930s, the sport reached its prime during the 1950s and 1960s. Contests on oval-banked tracks occurred throughout southern California, from the Valley Gardens in North Hollywood to El Monte's Legion Stadium. But the spot for locals was the Olympic Auditorium, where fans watched the mighty Thunderbirds (featuring Ralphie Valladares, Shirley Hardman, Big John Johnson and Honey Sanchez). Track-side, KTLA-television announcer Dick Lane (and his trademark "Whoa, Nellie!") captured the fast-paced action and helped make roller derby a TV hit.

Swimming & Diving

For decades, the **Los Angeles Athletic Club** sponsored the efforts of amateur swimmers. Many of these athletes became Olympians. Later, with their ability to hand out scholarships, **USC** and other local colleges produced numerous **NCAA** and Olympic champions.

◀ Sammy Lee, Occidental College
June 15, 1940

Sammy Lee dives at Occidental College. On Wednesdays Lee went to Pasadena's Brookside Pool to practice. That was the only day of the week when "non-whites" could use the pool. On Thursdays, Lee remembers, "the pool was emptied after we used it, and fresh water was brought in." After attending Occidental and USC medical school, the Korean American won gold medals in platform diving in 1948 and 1952, becoming the first Asian American to win Olympic gold.

◀◀ Johnny Weissmuller • 1928

Johnny Weissmuller practices his stroke. In 1922, Weissmuller became the first person to swim 100 meters in under one minute. He went on to win three Olympic gold medals in 1924 (plus a bronze in water polo), and two more gold medals in 1928. After his undefeated amateur career, he moved to L.A. and was signed by MGM for the 1932 film adaptation of *Tarzan*, a book by Edgar Rice Burroughs. Donning a skimpy loincloth, Weissmuller yodeled his way to movie stardom. He was the first of many athletes-turned-Tarzan, including swimmer Buster Crabbe, shot-put star Herman Brix and decathlete Glenn Morris.

Pat McCormick • circa 1954

Long Beach's Pat McCormick dives into the water. McCormick won the platform and springboard diving events in two consecutive Olympics (1952, 1956), performing dives attempted only by men (and outlawed for women until 1952). Her daughter, Kelly, won the silver medal in springboard at the 1984 Los Angeles Olympics.

Janet Evans, Placentia · 1988

Seventeen-year-old Janet Evans chats with a friend on the phone after returning home from the 1988 Seoul Olympics. At fifteen, Evans used her "windmill in a hurricane" pace to set her first world records. While attending El Dorado High School in Placentia, she overcame her slight build to whip powerful Eastern Bloc competitors and win three gold medals at the 1988 Games. She took one more gold medal at the 1992 Barcelona Olympics (along with a silver medal); she still holds three world records and six American records.

Swimming and Diving

Tennis

Tennis helped to put Los Angeles on the sports map: May Sutton was the first American to win at Wimbledon. Those who followed—including Jack Kramer, Bobby Riggs, Billie Jean King, and Arthur Ashe—revolutionized the sport in their own ways.

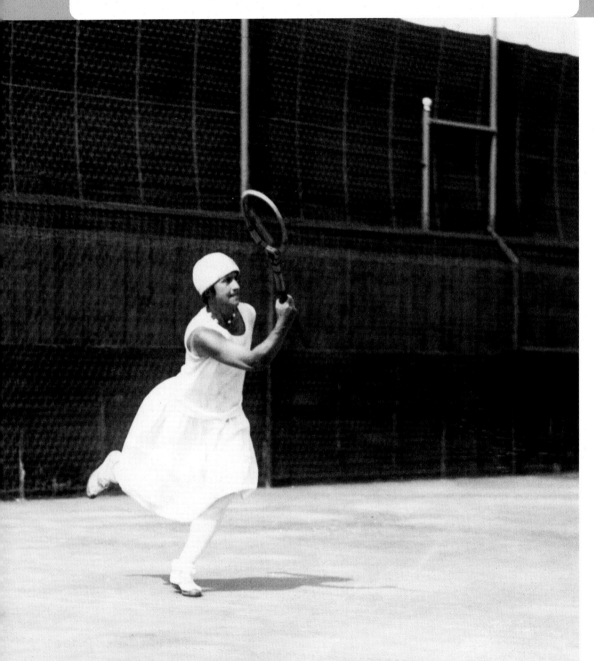

May Sutton · 1920

At the turn of the twentieth century, when tennis was one of the few sports that welcomed female athletes, Pasadena's sixteen-year-old May Sutton won the U.S. Championships, the precursor to the modern U.S. Open. She literally rolled up her long sleeves and won her first singles title at Wimbledon in 1905, becoming the first American—male or female—to win there. In 1908, May became the first sports celebrity to reign as the Tournament of Roses queen. With her husband, Thomas Bundy, she built the Los Angeles Tennis Club, home of the Pacific Southwest Championships, southern California's most prestigious tourney. Later, their daughter, Dorothy Bundy Cheney, became a top-ranked player.

Play by Play

▲ Indoor Tennis, Pan Pacific Auditorium · circa 1945

Players learned to be wary of the hanging clock at center court inside the Pan Pacific Auditorium, located at 7600 West Beverly Blvd. Designed by architects Welton Becket, Walter Wurdeman and Charles Plummer, the Pan Pacific opened in 1935 and hosted all types of sporting events (including UCLA basketball, professional wrestling, and semi-pro ice hockey games). Fire destroyed it in 1989, the same year the *Herald Examiner* folded.

◀ Jack Kramer · circa 1935

Jack Kramer wears the uniform of the times—long pants. A graduate of Montebello High, Kramer dominated the amateur circuit after World War II, winning the U.S. (1946, 1947) and Wimbledon (1947) championships. He parlayed that success as a player-promoter in the professional ranks—at a time when the pros were barred from major tourneys and had to barnstorm across the country. Later, he helped design and market "Jack Kramer" model rackets for Wilson before forging an alliance between amateurs and professionals to create the "open era" of tennis.

◀ Pancho Gonzalez • September 19, 1949

The son of an immigrant auto mechanic, East L.A.'s Ricardo "Pancho" Gonzalez was a high-school dropout who muscled his way into a sport dominated by the wealthy. He learned the game at Exposition Park, then won the U.S. Championships in 1948 and 1949 before renouncing his amateur status at a time when Grand Slam tourneys were closed to pros. Gonzalez spent his prime on tennis's fringe, but those who saw him remember his aggressive, dynamic style. An opponent once described him in action as "A god patrolling his personal heaven." Gonzalez died in 1995.

Billie Jean King • circa 1967 ▶

Billie Jean King attempts a backhand volley. Long Beach Polytechnic High's Billie Jean Moffitt honed her game on the city's public courts before capturing twenty Wimbledon titles. As Billie Jean King, she was the driving force behind the creation and promotion of the women's professional tour in the early 1970s, and gained international renown by defeating Bobby Riggs in a highly publicized "Battle of the Sexes" match. King was co-founder of World Team Tennis and founding editor of *Women's Sports* magazine. In 2000, as coach of the United States women's tennis team, she became the first openly lesbian coach of an Olympic team.

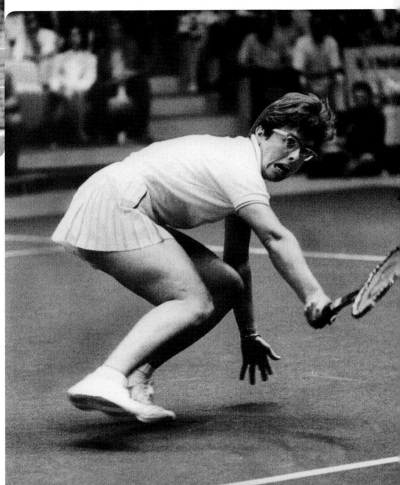

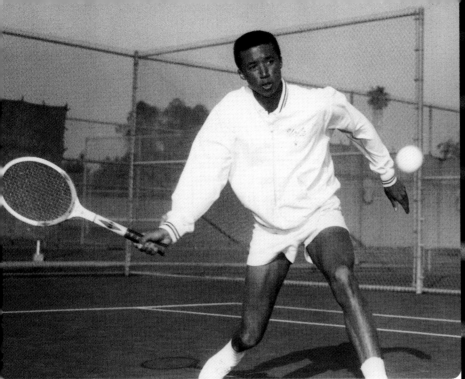

▲ Arthur Ashe · circa 1965

Arthur Ashe practices at UCLA. The NCAA singles champ in 1965,
Ashe led UCLA to the team title. After turning professional, he became
the first African American man to win the U.S. Open and Wimbledon.
Off the court, he raised awareness about South Africa's apartheid policies;
wrote *A Hard Road to Glory* (1988), an influential, three-volume history of
African American athletes; and, after contracting HIV, became an AIDS
advocate. He died in 1993.

Jimmy Connors · circa 1980 ▶

Jimmy Connors towels off between games. After winning the NCAA singles
title as a freshman at UCLA, Jimmy Connors joined the professional ranks
and won five U.S. Open and two Wimbledon crowns. A scrappy, relentless
competitor, he used an unorthodox two-handed backhand to complement
his uncanny service return and fiery, on-court theatrics.

Tennis

Track & Field

Favorable weather conditions, abundant natural talent, and excellent coaching have enabled southern California to produce numerous track and field champions, while L.A.'s hosting of two Olympic Games has increased track and field's considerable profile.

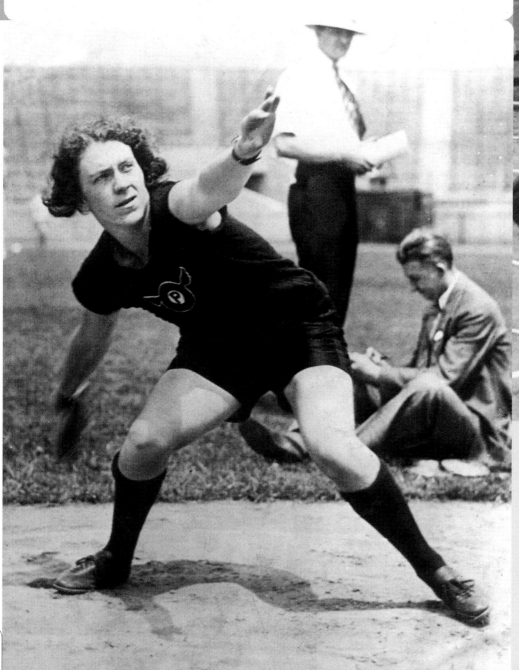

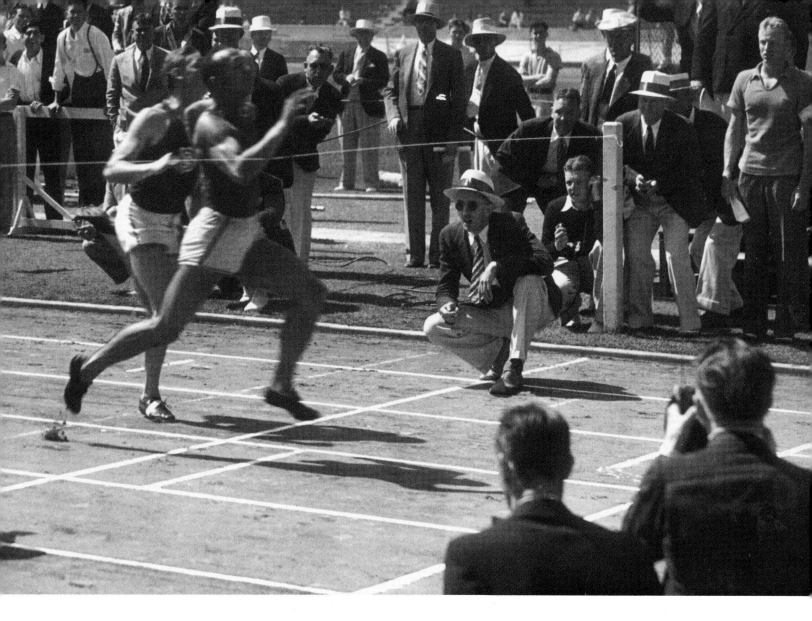

◀ Lillian Copeland · circa 1929

Lillian Copeland throws the discus. Copeland was the first great female weight thrower, setting numerous records in the shot put, javelin, and discus. The L.A. High School and USC grad took the silver medal in the discus at the 1928 Amsterdam Games, the first women's track and field event in Olympic history. Four years later, at the Los Angeles Olympics, Copeland won the gold medal on her final throw. A Jewish athlete, she chose to boycott the 1936 Olympic Games in Nazi Germany.

▲ Jesse Owens, Los Angeles Memorial Coliseum
June 15, 1935

In a blur, Jesse Owens wins the 100 meters in a dual meet between Owens's Ohio State and USC. He won three other events that day, but the Buckeyes lost the meet to the Trojans. A month earlier, Owens had set four world records in a single afternoon. He also won four gold medals at the 1936 Berlin Olympics in a display of athleticism that humiliated and infuriated German dictator Adolf Hitler.

Parry O'Brien • 1951

Parry O'Brien follows through after putting the shot. O'Brien revolutionized shot-put technique. Instead of facing the field, he turned to face the back of the circle. Pivoting his weight, he turned one hundred eighty degrees and used momentum to heave the shot. With his nimble footwork and brute strength, the Santa Monica High and USC graduate became the first man to throw more than 60 feet. He also broke the world record sixteen times and won two Olympic gold medals (1952, 1956).

◀ **Rafer Johnson and C.K. Yang circa 1960**

Rafer Johnson and C.K. Yang circa 1960

One of the greatest duels in decathlon history involved former UCLA teammates, Rafer Johnson and C.K. Yang, competing at the 1960 Rome Olympics. After the first day, Johnson (representing the U.S.) held a slim 55-point advantage. On day two, Yang (representing Taiwan) passed Johnson. The competition was decided in the final event—the 1500-meter run. Johnson finished within seconds of Yang to take the gold medal with a then-Olympic best of 8,392 points. In 1984, Johnson lit the Olympic torch to open the Los Angeles Olympics.

Mary Decker • June 23, 1984 ▶

Mary Decker qualifies for the 3000-meter race at the 1984 U.S. Olympic Trials. At age fourteen, wearing braces and pigtails, "Little Mary" Decker set her first American record. During the early 1980s, she simultaneously held every U.S. record ranging from 800 to 10,000 meters. But Decker's injury-prone career curtailed her Olympic aspirations. Her dramatic fall during the 3,000-meter race at the 1984 L.A. Games, after she became entangled with South Africa's Zola Budd, symbolized her Olympian frustrations.

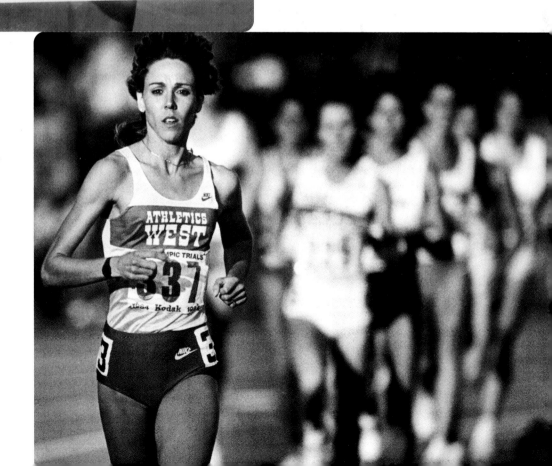

Track & Field

Gail Devers and Jackie Joyner, Westwood · May 29, 1985

Gail Devers, left, and Jackie Joyner, pass the baton while running the 4×100-meter relay at a UCLA–USC meet at UCLA's Drake Stadium. Joyner won two heptathlon gold medals in successive Olympics (1988, 1992), while adding the long jump gold medal in 1988. Devers, best known for the 100-meter hurdles, won Olympic gold in the 100 meters in 1992 and 1996.

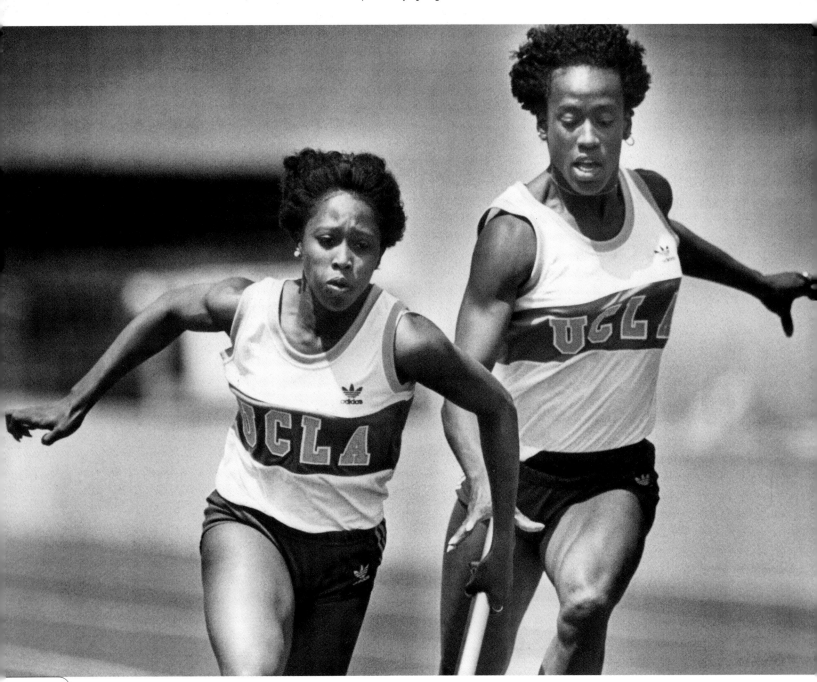

Play by Play

Bob Wieland • March 8, 1988

Using only his arms and shoulders, Bob Wieland completes his first Los Angeles Marathon in just over seventy-four hours. Since the inaugural L.A. Marathon in 1986, thousands of determined runners have conquered the 26.2-mile race. But Wieland is perhaps the most awe-inspiring. He lost both legs after stepping on a mortar round while serving in Vietnam. "'Athlete' is not written in your hamstrings or your grip or your pitching arm," he once said. "It's written in your heart."

Track & Field

Wrestling

Heroes and villains: The allure of wrestling often went beyond the physical demands of sport. Personalities like "Gorgeous George" and "Classy" Freddie Blassie alternately maddened and excited their passionate fans.

**"Gorgeous George" Wagner
Olympic Auditorium
September 6, 1948**

George Wagner wrestled for a decade in near-obscurity before he came up with a gimmick: he grew out his hair and dyed his curly locks platinum blond; entered the ring in an elegant cape to "Pomp and Circumstance;" and had his valet douse the ring with Chanel No. 5. A top draw at the Olympic Auditorium, Gorgeous George infuriated opponents and enlivened the sport, as evidenced in the lyrics of a popular song from the era: "He has an armful of muscle and a head full of curls, He wrestles with the fellows and thrills all the girls." Before his death in 1963, Gorgeous George and his theatrics inspired a future boxing champ named Cassius Clay.

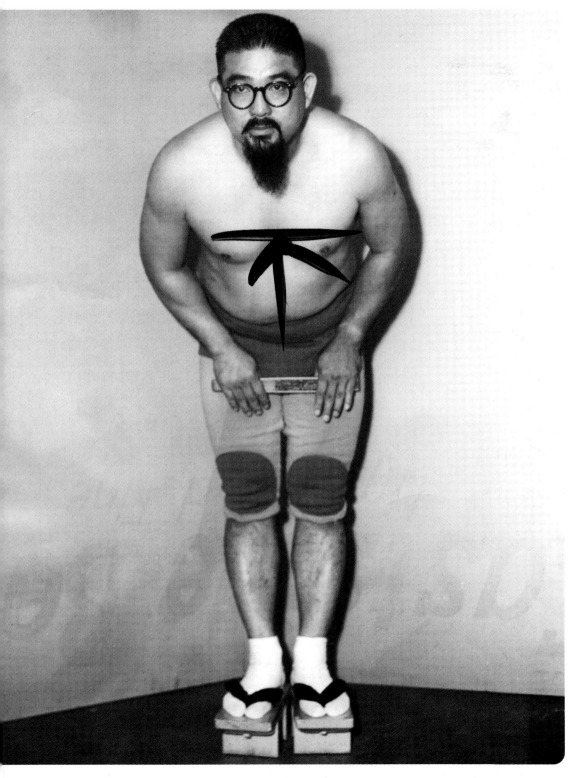

**"Mr. Moto" Iwamoto
October 25, 1952**
Before World War II,
Charles Iwamoto was a top
sumo wrestler in Hawaii.
After the war, he became
"Mr. Moto," one of several
Japanese Americans on
the pro-wrestling circuit.
Typically cast as the "bad
guys" in the ring, these
wrestlers found a lucrative
niche in a postwar society
that remained anti-Japanese
American. In the ring,
Mr. Moto was accompanied
by a valet named Fuji,
performed faux sumo rituals,
and used a "sleeper hold"
to knock out opponents.
He died in 1991.

"Classy" Freddie Blassie and Lou Thesz, Los Angeles Sports Arena • July 22, 1961

"Classy" Freddie Blassie, L.A.'s most enduring heel, performs a few of his usual tricks during this World Wrestling Alliance title fight against Lou Thesz. While choking Thesz, Blassie also manages to pull his opponent's hair. Blassie dubbed his detractors "pencil neck geeks," and recorded a song by that name. Later, he starred with comedian Andy Kaufman in the cult film, *My Breakfast with Blassie* (1983). He died in 2003.

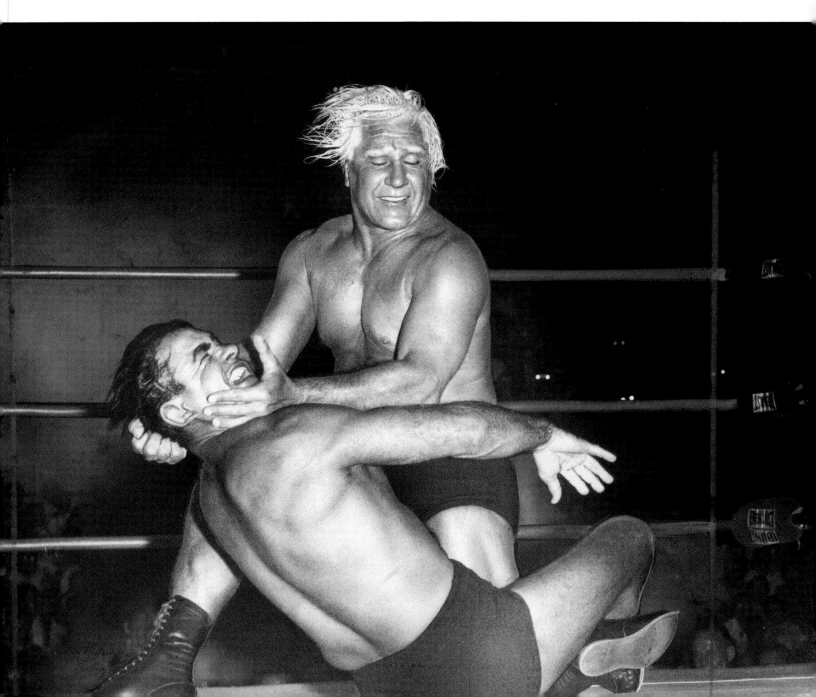

◄ "Andre The Giant" and Willie Shoemaker
January 24, 1982

The seven-foot-four wrestler "Andre the Giant" holds jockey Willie Shoemaker, who was all of four-foot-eleven. In an effort to drum up publicity, wrestling promoters staged photo shoots with other sports greats—in this case, horse racing's Hall of Famer. The "Eighth Wonder of the World" hardly needed publicity; the French-born Andre the Giant was one of wrestling's most popular superstars during the 1970s and 1980s. He also had a brief film career, most notably in *The Princess Bride* (1987). He died in 1993.

▼ Jesse "The Body" Ventura and Jack Armstrong
February 26, 1985

Jesse "The Body" Ventura drags the face of Jack Armstrong along the ropes. After a stint in the Navy during the war in Vietnam, he became an L.A. biker who decided to make use of his exceptional physique and become a wrestler. After his retirement from wrestling and before he was elected governor of Minnesota in 1998, Ventura acted in two 1987 films, *Predator* and *The Running Man*, which starred another strongman-turned-actor who later turned governor: Arnold Schwarzenegger.

Wrestling

1932 Olympics

In the 1920s and 1930s, real estate magnate William May Garland was one of the city's most powerful sports executives: he led the Los Angeles Athletic Club during its infancy and spearheaded construction of the Memorial Coliseum and the Riviera Country Club. In 1924, while serving on the International Olympic Committee, he cemented his legend by persuading the IOC to bring the 1932 Olympic Games to Los Angeles.

The 1932 Los Angeles Olympics took place during the Great Depression, which severely reduced the number of participating athletes and countries. However, the Games were a financial and athletic success, with organizers reporting a million-dollar surplus and athletes breaking or equaling eighteen world records. The U.S. won forty-one gold medals.

Despite the limited participation, elements of the 1932 Olympics were revolutionary. These Games introduced the athletes' village; built in Baldwin Hills, the concept encouraged the intermingling of competitors from around the world. The 1932 Olympics used victory stands for the first time, with the national anthem of the winner's country played during the ceremony, as well as the photo-finish camera for track events. Organizers also staged the competition over sixteen days, tightening what had been an unwieldy schedule.

Traditionally, the leader of the host country opens the Olympic Games. Citing the nation's economic troubles, president Herbert Hoover declined to attend and sent Vice President Charles Curtis in his place.

Eddie Tolan and Ralph Metcalfe, Los Angeles Memorial Coliseum ▶
1932
Eddie Tolan, far right, beats Ralph Metcalfe in a near dead heat, to win the 100 meters in an Olympic record of 10.3 seconds. Officials used the emerging technology of the photo-finish camera to determine the result. Two days later, Tolan returned to the track and won the 200.

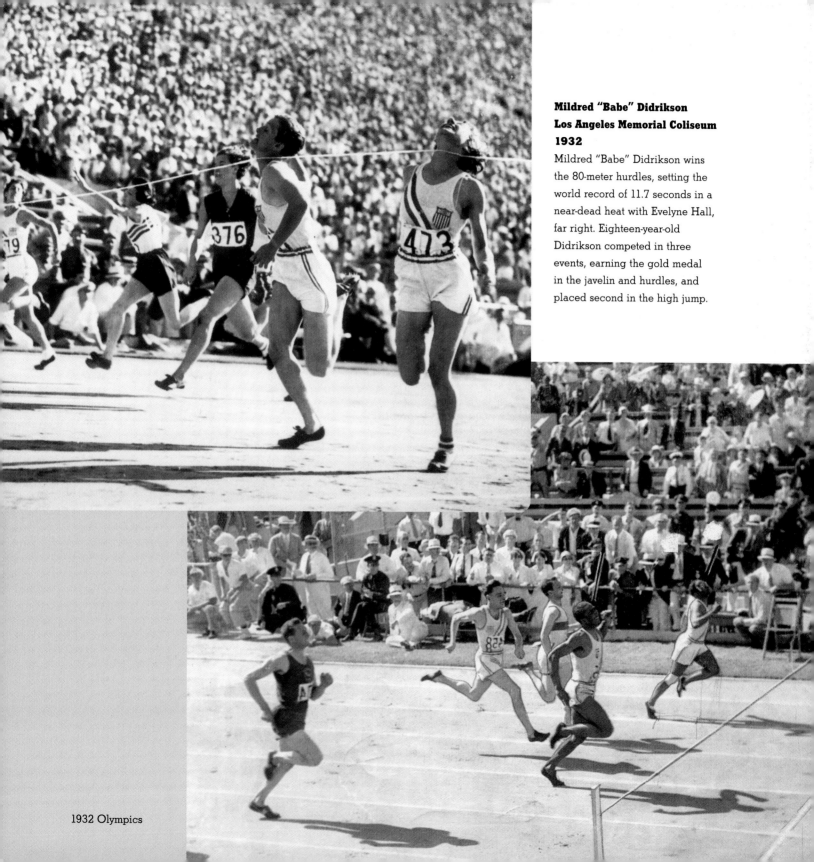

Mildred "Babe" Didrikson
Los Angeles Memorial Coliseum
1932

Mildred "Babe" Didrikson wins the 80-meter hurdles, setting the world record of 11.7 seconds in a near-dead heat with Evelyne Hall, far right. Eighteen-year-old Didrikson competed in three events, earning the gold medal in the javelin and hurdles, and placed second in the high jump.

1932 Olympics

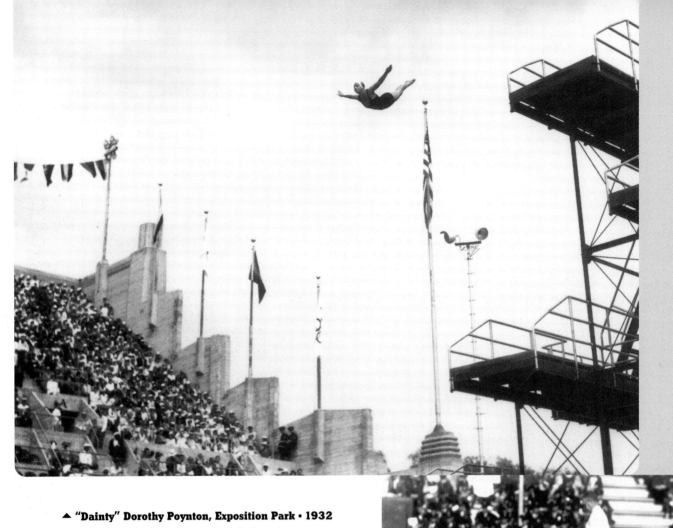

▲ "Dainty" Dorothy Poynton, Exposition Park · 1932

"Dainty" Dorothy Poynton wins the platform diving event with
this perfectly executed dive. She repeated the feat four years
later, at the 1936 Olympics in Berlin. Poynton began diving at
age seven, when her family moved to L.A. She won her first
Olympic medal at the 1928 Amsterdam Olympics, when she
was just thirteen.

Clarence "Buster" Crabbe, Exposition Park · 1932 ▶

A poolside assistant keeps Clarence "Buster" Crabbe posted
about the number of laps left to swim in the 400-meter
freestyle event. USC graduate Crabbe won the gold medal by
the slightest of margins: one tenth of a second. Like another
Olympic gold-medalist, Johnny Weissmuller, Crabbe starred
as Tarzan in the movies, but he gained fame playing two
science-fiction heroes: Buck Rogers and Flash Gordon.

Rowing Competition, Long Beach · 1932

In a close race, Germany defeats Italy for the gold medal at the Rowing Stadium, located on the banks of the Long Beach Marina. Other venues used during the 1932 L.A. Olympics included the Riviera County Club (equestrian), the Rose Bowl (cycling) and the Olympic Auditorium (boxing, wrestling and weightlifting).

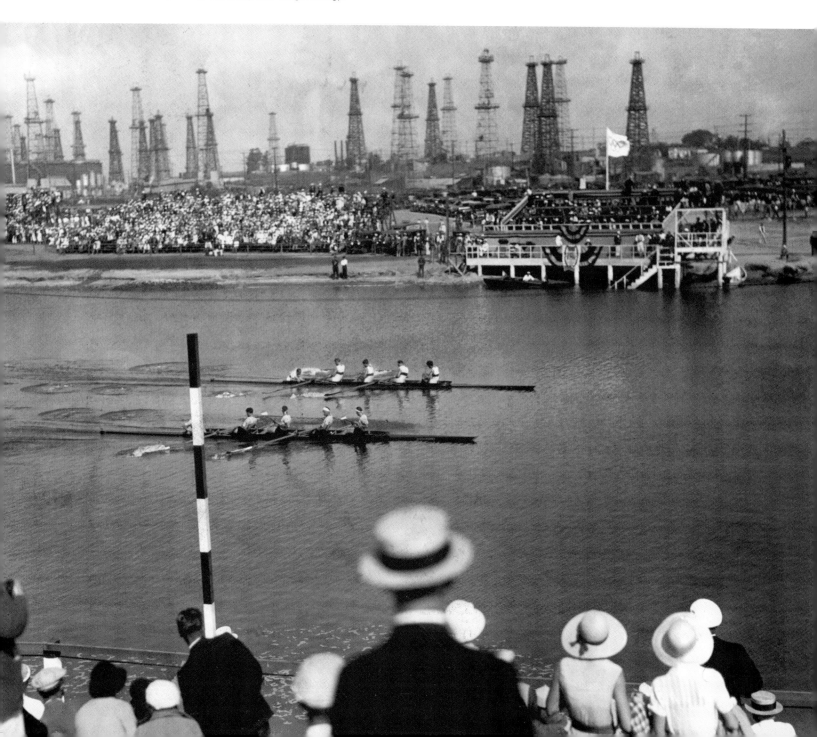

1984 Olympics

In 1977, the Olympic movement was in serious trouble. The world had watched in horror as Palestinian terrorists broke into the Olympic Village and killed numerous Israeli team members at the 1972 Munich Olympic Games. Four years later, host city Montreal incurred staggering debt from staging the Olympics (a debt that Canada would still be paying in the new millennium).

Things were so bad that only one city bid for the 1984 Games: Los Angeles.

The 1984 Games would be radically different from any previous Olympics. Instead of being publicly financed by the City of Los Angeles or the State of California—or, for that matter, by the United States—the Los Angeles Olympic Organizing Committee and the United States Olympic Committee assumed the entire financial risk and created the first privately organized Olympics.

A mix of civic and political leaders led the LAOOC, including John Argue, Paul Ziffren, Howard Allen, Justin Dart, William Robertson, Rodney Rood, David Wolper and Los Angeles Mayor Tom Bradley. The LAOOC's masterstroke was to hire San Fernando Valley-based executive Peter Ueberroth as CEO. Despite naysayers' predictions of chaos—and the boycott by the Soviet Union and other Eastern Bloc countries—Ueberroth (and right-hand man Harry Usher) orchestrated an unprecedented athletic, aesthetic and financial triumph. Organizers reaped a whopping $232.5 million surplus and the Olympic movement gained new-found energy.

Today, the region still benefits from the 1984 Olympics. Financed by the profits from 1984, the L.A.-based Amateur Athletic Foundation has distributed more than one hundred forty million dollars in grants, scholarships and programming for youth sports throughout southern California. Directed by Anita DeFrantz, the AAF also operates the nation's premier sports library, the Paul Ziffren Resource Center, located in the West Adams area.

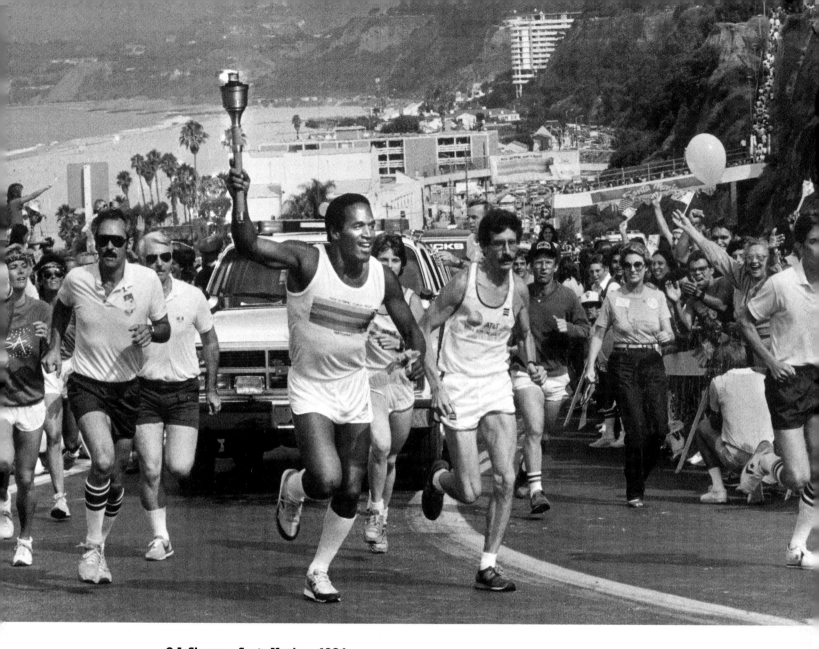

O.J. Simpson, Santa Monica · 1984

One-time USC star, former NFL player, broadcaster and occasional movie star, O.J. Simpson carries a torch in Santa Monica just days before the Opening Ceremonies at the L.A. Memorial Coliseum. Starting in New York City, a chain of 4,200 runners, each running one kilometer, took eighty-two days to deliver the torch to Los Angeles. Jogging with Simpson (behind the group of men on the left) is Nicole Brown, who would become his second wife in 1985. A decade later, Simpson was the defendant in a criminal trial and was found not guilty of the murder of Brown and Ron Goldman; in a subsequent civil trial he was found liable.

1984 Olympics

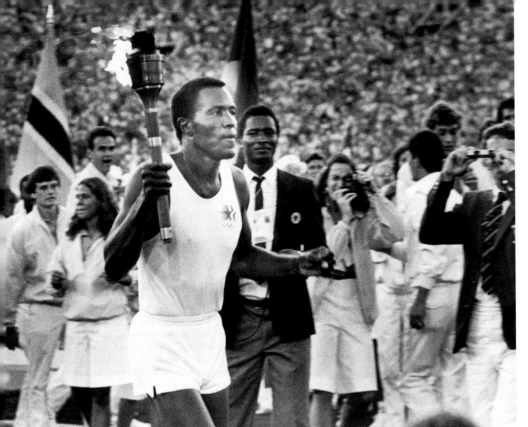

◄ **Rafer Johnson**
Los Angeles Memorial Coliseum
July 28, 1984

Former decathlete Rafer Johnson, the final torch runner, enters the Coliseum. Although he had already run a leg of the torch relay, Johnson was Peter Ueberroth's top-secret choice for the prestigious job of lighting the Olympic flame. After taking the torch from Gina Hemphill, the granddaughter of track star Jesse Owens, Johnson ascended ninety-nine steps to the top of the Coliseum. He then turned to face the world, holding the torch aloft, before lighting the flame.

The Los Angeles Memorial Coliseum ►
July 28, 1984

After Opening Ceremonies, spectators leave the Coliseum beneath the Olympic flame and Robert Graham's bronze statues. Designed by John and Donald Parkinson—and originally built for under one million dollars—the venerable Coliseum opened in Exposition Park in 1923 when USC defeated Pomona College, 23-7, in the first football game. The Los Angeles Memorial Coliseum has hosted two Olympic Games, two Super Bowls, one World Series, numerous professional and college football games, and international soccer matches.

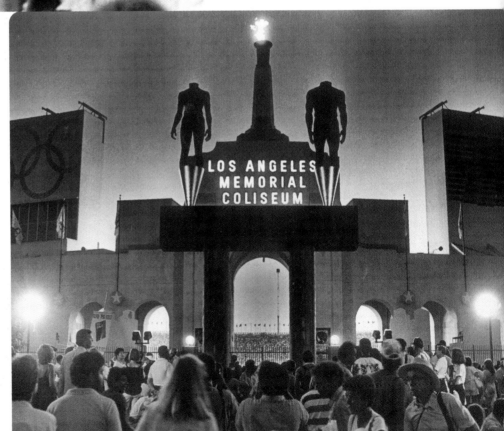

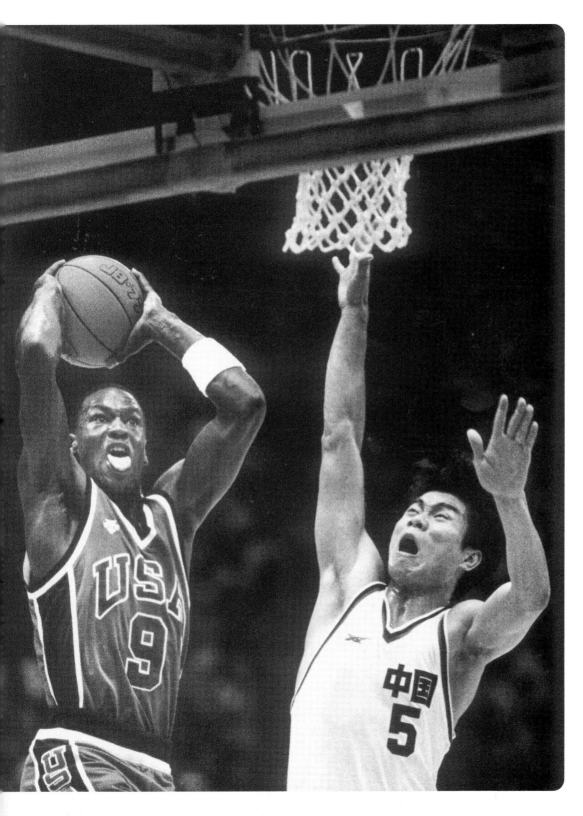

Michael Jordan
The Forum · 1984
College basketball fans
knew all about Michael
Jordan: as a freshman at the
University of North Carolina
his last-second shot in the
1982 NCAA Finals won the
national title for the Tar
Heels. The rest of the world
discovered Jordan—and his
signature tongue-waggling—
at the Olympics, when he
helped the Bobby Knight-
coached team win the gold
medal. The team of college
all-stars, which beat Spain
in the gold-medal game,
included Patrick Ewing,
Wayman Tisdale, Chris
Mullin, and Sam Perkins.
In 1992, at the Barcelona
Olympics, Jordan would
win gold again with a squad
of NBA superstars who
collectively became known
as "The Dream Team,"
including the Lakers' Earvin
"Magic" Johnson and the
Boston Celtics' Larry Bird.

Greg Louganis
Olympic Swim Stadium
1984

The always-elegant, always-precise Greg Louganis, en route to another diving gold medal. By the age of sixteen, Louganis had won his first Olympic medal. Eight years later, at the 1984 Los Angeles Olympics, he won gold in both the platform and springboard events, becoming the first man in fifty-six years to do so. He repeated the feat at the 1988 Seoul Olympics.

◄ Tracie Ruiz and Candy Costie, Olympic Swim Stadium 1984

Tracie Ruiz and Candy Costie, U.S. gold medalists in synchronized swimming (duet). The sport was added to the Olympic program in 1984. A day after she teamed to win gold with Costie, Ruiz won the gold medal in the solo event.

Evander Holyfield, Sports Arena • 1984 ▶

Evander Holyfield punches on the counterattack. The U.S. boxing team took home eight gold medals in L.A., but light heavyweight Holyfield won only a bronze after he was disqualified in his semi-final bout for throwing a punch after the bell. After the Olympics, Holyfield won the heavyweight championship three times.

1984 Olympics

Mary Lou Retton, Pauley Pavilion · 1984 ▶

The darling of the 1984 Los Angeles Olympics, sixteen-year-old Mary Lou
Retton performs on the balance beam. She was fourth in the event, but won
the prestigious All-Around gold medal (which combines competitors' scores
from every event) by scoring 10s in the floor exercise and the vault. Taking
advantage of the absence of the Soviet Union, Retton was the first American
to win the All-Around gold.

▼ Kathy Johnson, Pauley Pavilion · 1984

Kathy Johnson soars on the balance beam. She finished third in the event,
behind Romania's Simona Pauca and Ecaterina Szabo. Johnson, who came
late to the sport, was expected to excel at the 1980 Moscow Olympics.
But the U.S. boycott dashed her hopes; she kept training and managed to
make it to the 1984 Olympics.

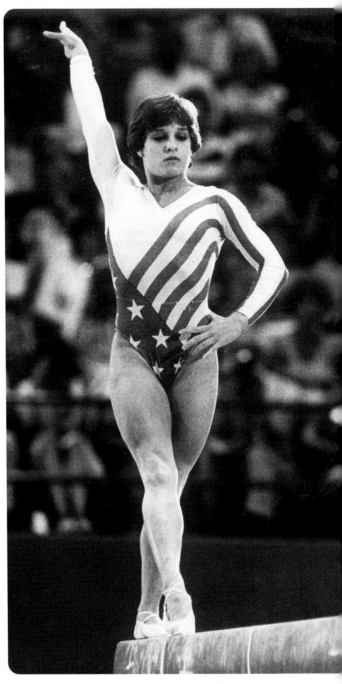

▼ Evelyn Ashford and Jeannette Bolden
Los Angeles Memorial Coliseum · 1984

After winning the 100 meters, Evelyn Ashford, right, collapses into the arms of fourth-place finisher Jeannette Bolden. Coached by Pat Connolly, the former UCLA sprinter also won the gold medal in the 4×100 relay. After 1984, Ashford won two more Olympic gold medals and one silver medal.

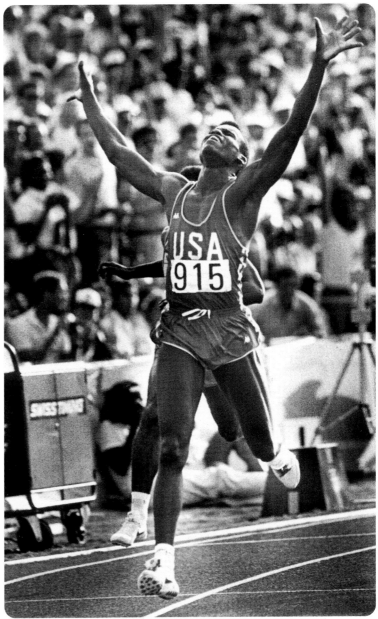

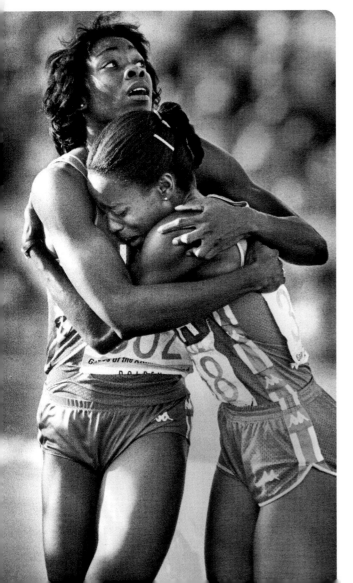

▲ Carl Lewis, Los Angeles Memorial Coliseum · 1984

Carl Lewis wins the 200, one of his four gold medals. A longtime member of the Santa Monica Track Club, Lewis also won the 100 and the long jump, and participated on the 4×100 relay team, equaling the four-gold-medal haul of Jesse Owens at the 1936 Berlin Olympics. After 1984, Lewis won five more Olympic gold medals and a silver.

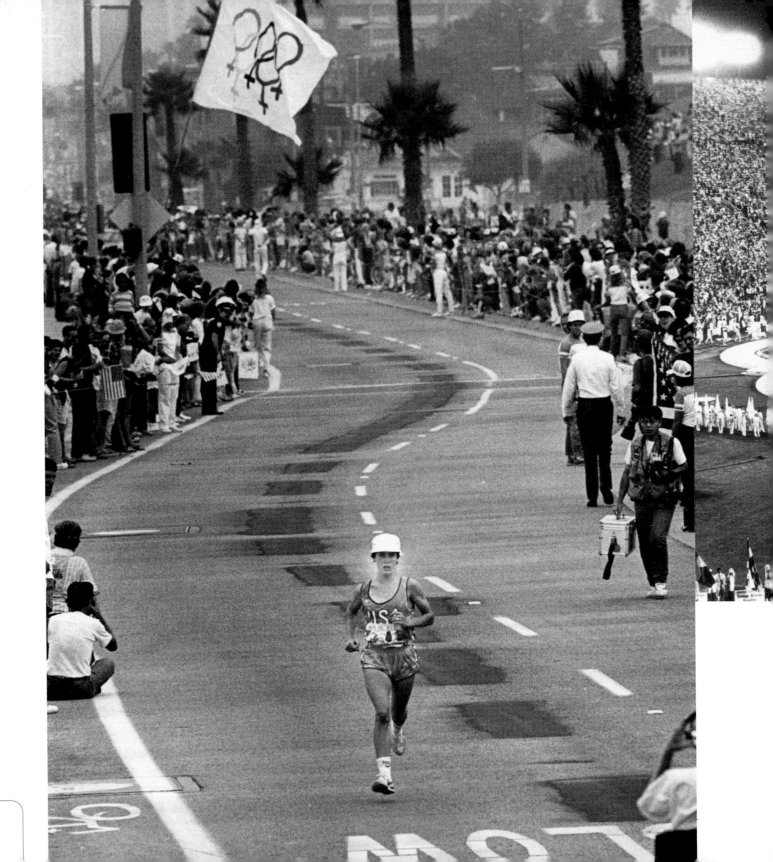

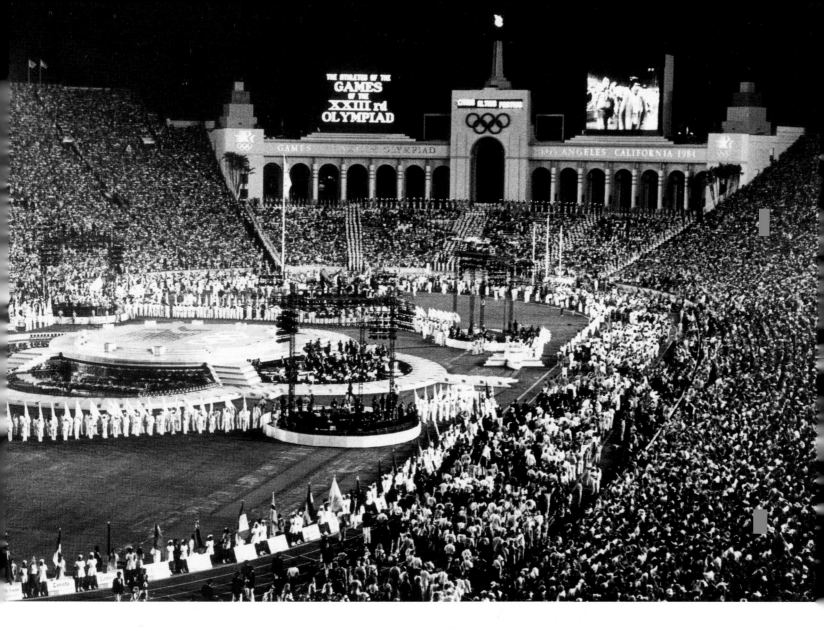

◄ Joan Benoit • 1984

Until 1984, the Olympic program for women did not include running events longer than 1,500 meters because of the misconception that women were too "fragile" for such distances. In the inaugural women's marathon, Joan Benoit put an end to such talk as she raced away from her chief rival, Norway's Grete Waitz, to win the gold medal. As is evident in this photograph, spectators lined most of the 26.2-mile route to cheer on Benoit and the other competitors.

▲ Closing Ceremonies, Los Angeles Memorial Coliseum
August 12, 1984

Produced by David Wolper, the Closing Ceremonies were a spectacular finale to sixteen days of athletic competition. In the absence of the Soviet Union, the United States dominated the medals race with 174 medals (including 83 gold medals), with Germany second in total medals (59), and Romania third (53).

Acknowledgments

I am indebted to Carolyn Cole of the Los Angeles Public Library Photograph Collection. Without her persistence and encouragement, this book—and the exhibit on which it is based—would not exist.

Thanks to the many photographers whose amazing work made *Play by Play* possible.

Thanks to the hard-working folks at the Los Angeles Public Library, including Susan Kent, Toria Aiken, Matthew Mattson, Carol Porter, Bettie Webb, Roselyn Lee, Peter Persic, Norma Villegas, James Brevard and David Strother. Also thanks to Evelyn Hoffman and Laura Gillette of the Library Foundation of Los Angeles. Special thanks to Bob Timmerman and Glen Creason—two of the most knowledgeable sports guys in town.

Thanks to the dynamic team at Angel City Press— Paddy Calistro, Scott McAuley, Amy Inouye, Jackie Green and Andrea Richards—for making this dream come true.

Thanks to the good people at L.A.'s Amateur Athletic Foundation, including Anita DeFrantz, Patrick Escobar, Wayne Wilson, Michael Salmon, Shirley Ito, Daniel Bell, Richard Russell, Bonita Carter and Shannon Boyd. The world's best sports resource center—and the world's best sports librarians-researchers—answered every ridiculous query. Thanks also to David Simon at the Los Angeles Sports Council and to David Carter at the Sports Group.

Thanks to many friends for their support, including Allen Barra, Bruce Bebb, Vince Beiser, Terry and Mary Cannon, Chika, Ed Derse, Paul Feinberg, Lynell George, Emily Green, Steve Kettmann, Ben Kallen, Michael Kaplan, Jeff Z. Klein, Pamela Klein, Jason Levin, Neal McCabe, Kerry Yo Nakagawa, Ben Quinones, Kit Rachlis, Mack Reed and the Reed family, Susan Reifer, Julian Rubinstein, Laura Steele, Stacie Stukin, Bert Sugar and Karen Wada. A deep nod to Donnell Alexander, who was there every step of the way.

Thanks to the East and West Coast crews: Bill Bunke, Mark Cirino, Curtis Claymont, John Downes, Eric Harmon, Alec Lipkind, Daniel Shaw, Joan Spindel, Tom Sweeney, Steve Tager and Tim Toner.

Finally, thanks and love to my family and to Flora Ito. I could not have done this without you.

—DAVID DAVIS

Bibliography

In addition to back issues of the *Los Angeles Herald Examiner* and *Los Angeles Times* newspapers, these works were invaluable:

Gustkey, Earl. *Great Moments in Southern California Sports*. New York, NY: Harry F. Abrams, 1991.

McNeil, William F. *The California Winter League: America's First Integrated Professional Baseball League*. Jefferson, NC: McFarland & Co., 2002.

Nasaw, David. *The Chief: The Life of William Randolph Hearst*. Boston, MA: Houghton Mifflin, 2000.

Nelson, Kevin. *The Golden Game: The Story of California Baseball*. Berkeley, CA: Heyday Books, 2004.

Niiya, Brian, ed. *More Than a Game: Sport in the Japanese American Community*. Los Angeles, CA: Japanese American National Museum, 2000.

Osmer, Harold. *Where They Raced LAP2: Auto Racing Venues in Southern California, 1900-2000*. Calabasas, CA: Harold L. Osmer Publishing, 2000.

Perelman, Richard. *Unforgettable! The 100 Greatest Moments in Los Angeles Sports History*. Memphis, TN: Towery Publishing, 1995.

Pollak, Mark. *Sports Leagues and Teams: An Encyclopedia, 1871 through 1996*. Jefferson, NC: McFarland & Co., 1997.

Solnit, Rebecca. *River of Shadows: Eadweard Muybridge and the Technological Wild West*. East Rutherford, NJ: Viking Books, 2003.

Wallechinsky, David. *The Complete Book of the Summer Olympics: Sydney 2000 Edition*. New York, NY: Overlook Press, 2000.

Wombell, Paul, and Simon Barnes. *Sportscape: The Evolution of Sports Photography*. Harrisburg, PA: Phaidon Press, 2000.

Zingg, Paul, and Mark Medeiros. *Runs, Hits and an Era: The Pacific Coast League, 1903-58*. Champaign, IL: University of Illinois Press, 1994.

Zucker, Harvey Marc, and Lawrence Babich. *Sports Films: A Complete Reference*. Jefferson, NC: McFarland & Co., 1987.

Photo Credits

The fantastic images in *Play by Play* are all from the Los Angeles Public Library Photograph Collection. Except as cited below, the photos are from the LAPL's archive of the *Los Angeles Herald Examiner*. Until the 1950s, the *Herald Examiner* did not credit individual photographers for their work, but work published later has been credited to the photographers as listed below. Photographers' names are marked with asterisks to indicate staff (*) and freelance (**) photographers for the *Herald Examiner*, as well as photographers for the *Valley Times* (***), whose photos are part of the LAPL's Security Pacific Collection. Any information that can be supplied by readers to credit additional images will be greatly appreciated by the author and the Los Angeles Public Library.

Ballew, Howard*, 15 (bottom)
Brich, George***, 42
Brown, Rob*, 25 (right), 27 (top), 76 (bottom)
Chinn, Paul*, 3 (right), 7 (left), 7 (center), 26, 27 (bottom), 29, 55, 56, 58 (right), 89, 113, 124 (top), 129, 133, 155
Courtney, Tom*, 35 (top), 38 (bottom), 43 (top), 45, 97, 98, 142
Dean, Gordon***, 20 (left), 40 (top)
Edwards, Michael*, 82
Ehret, Theo**, 67 (top)
Fowler, Perry*, 63, 80 (top)
Gray, Bud*, 77 (bottom)
Grayson, Steve*, 101 (bottom)
Gulker, Chris*, 43 (bottom), 125 (left), 139
Haering, Michael*, 43 (bottom), 125 (left), 139
Jarzomb, Leo*, 83, 84 (right), 116, 143 (bottom)
Knudsen, Anne*, 58 (center), 59, 137 (top), 152, 153 (left), 154
Martin, Bob***, 49, 50 (left), 65 (bottom), 125 (right)
Mendoza, Javier*, 30 (right), 107, 117, 149
Messinger, Joe*, 50 (right)
Miller, Larry*, 64 (right)
Mullen, Mike*, 6 (left), 30 (left), 66 (lower right), 83 (top left)
Musgrove, Dean*, 28, 157
Nehamkin, Lester**, 92 (right), 94
Ober, Jim*, 19
Papaleo, Ken*, 66 (top), 71
Roark, James*, 6 (right), 21, 24, 48 (bottom), 52, 81, 87, 88 (top), 99, 115
Rothschild Photo (*Herald Examiner* Collection), 70
Ruebsamen, James*, 20 (right), 23, 31, 31, 53, 54, 57, 66 (lower left), 84 (left), 100, 101 (top), 106, 111 (bottom), 116, 137 (bottom), 138, 150 (bottom), 151, 153 (right)
Security Pacific Collection, 2, 3, 10, 17, 46, 47, 61, 74, 75 (top), 90, 108, 145 (top), 146
Sergieff, Mike*, 69
Woods, Jon***, 3 (center)

Index

Los Angeles Dons back Walter Heap.